contemporary
ceramics

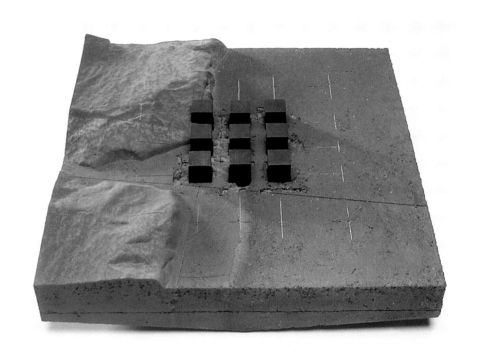

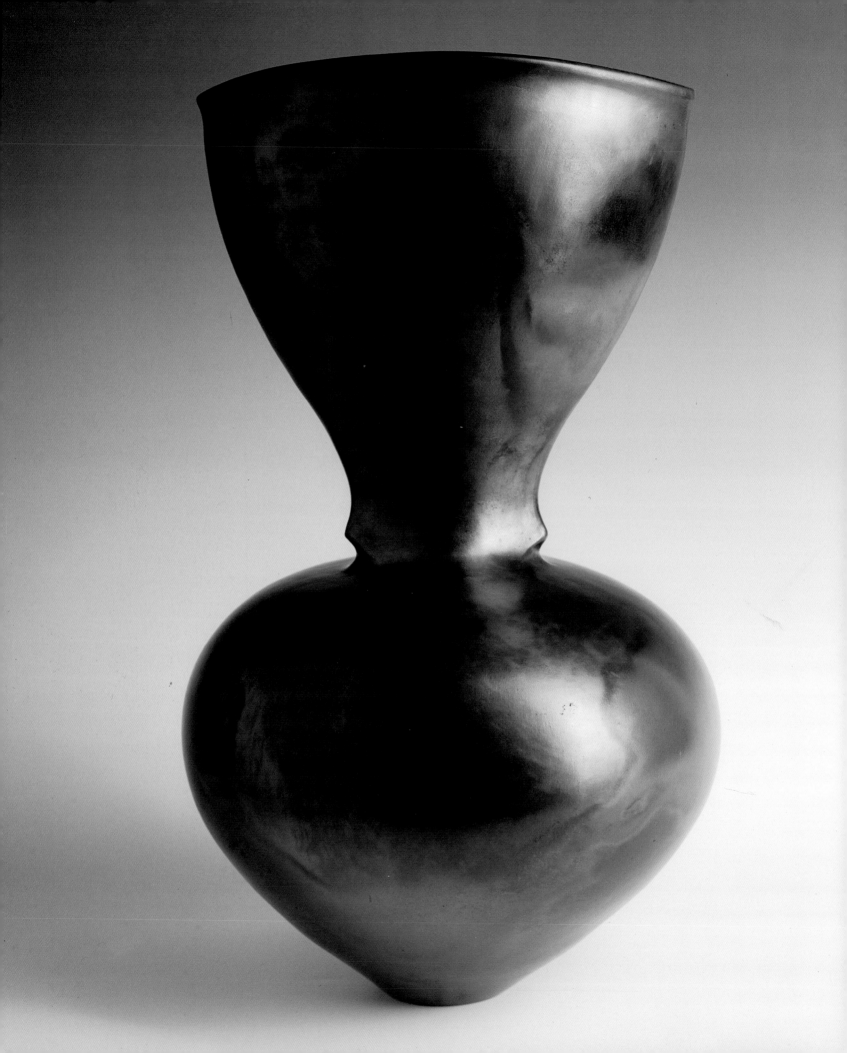

contemporary ceramics

SUSAN PETERSON

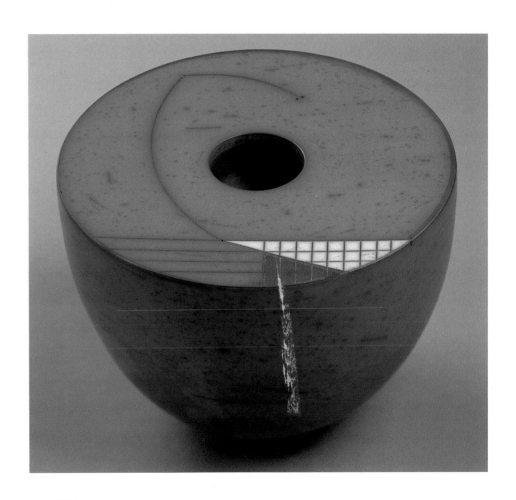

Laurence King

Acknowledgements

My thanks go to the many artists from all over the world who have sent transparencies and data for this book, many more artists than could be included in this space. Thanks also to the galleries that have contributed photographs and other information about their artists (listed on p.176).

In the past several years I have made extensive trips around much of the world, visiting artists and museums and giving many lectures and workshops. I have culled the results of my surveys in this volume. However, in the interests of design and the appearance of the book, the number of images was narrowed considerably from my original choices, and some of you from whom we solicited biographies and statements had to be left out, to my sorrow. I hope that we can do another follow-up book soon. The technical quality and inventiveness of ceramics in the world today is truly astonishing.

My gratitude is, as always, due to my children, Jill, Jan and Taag, my grandchildren Annah, Kayley, Gus, Alexander and Calder, and to my friends everywhere. I appreciate very much the professionalism of Laurence King and his staff who produced the book, especially Philip Cooper, Judy Rasmussen, Janet Pilch, and my accomplished editor Elisabeth Ingles and the talented designer Karen Stafford.

This book is dedicated to my late husband Robert Schwarz, Jr, 1922–1994, with whom I shared many of these friends and travels.

Susan Harnly Peterson
Carefree, Arizona

Published 2000 by Laurence King Publishing
an imprint of Calmann & King Ltd
71 Great Russell Street
LONDON
WC1B 3BN
Tel: +44 0207 831 6351
Fax: +44 0207 831 8356
e-mail: enquiries@calmann-king.co.uk
www.laurence.king.com

Text © 2000 Susan Peterson
This book was designed and produced by Calmann & King Ltd

A catalogue record for this book is available from the British Library

ISBN 1 85669 188 8

Project manager: Elisabeth Ingles
Designer: Karen Stafford
Printed in China

half–title page
Jean Claude LEGRAND, Belgium
Arpents No.3, 16$\frac{1}{2}$ x 16$\frac{1}{2}$ x 4 in
(42 x 42 x 10 cm)
Stoneware, wood

frontispiece
Magdalene ODUNDO, UK
Untitled, 27 x 13 in (69.5 x 33 cm)
Earthenware, burnished, in the African tradition

title page
Tjok DESSAUVAGE, Belgium
Pot Structure/Orbit, 12 x 13 in (30 x 33 cm)
Earthenware, glaze

opposite
Chris GUSTIN, USA
Stirrup Pot, 15 x 11 x 10 in (38 x 28 x 25 cm)
Stoneware

contents

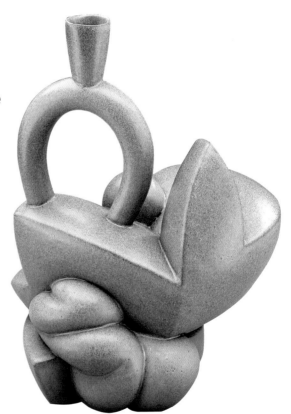

art is vision, past and present

FROM THE BEGINNING of the twentieth century ceramics changed its appearance and its tradition as it burst upon the art scene after millennia of being man's indispensable and functional workhorse. Individual attitudes towards clay suddenly emerged, developing out of several hundred years of decorative vessels, often highly embellished, from Renaissance majolica and seventeenth-century Delft ware to rococo work of the eighteenth century and elaborate factory-made furnishing accessories of the Victorian era. Different types of clays and glazes, along with a willingness to experiment, came to the fore in the second decade of the 1900s. Prior to this ceramics as an art flourished in imperial China and Japan, but otherwise was generally practised over thousands of years in the form of primitive bonfired, pit-fired, or kiln-fired functional ware: cook-pots, wall and floor tiles, burial urns, storage casks, water pipes and other components of daily life.

Ancient ceramic craft was a communal activity, engaged in by almost everyone in a village near a clay source, or by extended families in all societies who made ceramics a small business, seeking to solve particular problems of everyday living.

At least five thousand years ago the potter's wheel developed in Egypt, Mesopotamia and Asia as the quickest source of form, once the skill was learned. Thousands of years before that, and still today, hand techniques such as 'pinching', 'coiling', or fabricating from 'slabs' of clay were the usual prerequisites before firing the pot or tile to red heat to make it hard and more durable.

Archaeologists think that glass was discovered about the same time in history as the potter's wheel, probably by the Egyptians, who were surrounded by deserts of unlimited sand containing silica oxide, the single constituent necessary to ceramic science. The Egyptians also had plentiful supplies of salt – sodium chloride, one of the most useful minerals, which will cause silica oxide to fuse at a relatively low temperature, yielding a ceramic product from bonfire temperatures up.

Probably some ancient Egyptian one day noticed a glistening, transparent, hard substance in the ashes of a very hot fire – just the right amount of sodium chloride had combined with the siliceous sand and the heat to make glass. When man had discovered glass, glaze was close behind. Glass stands alone, while glaze needs to adhere to a surface – hence the addition of a necessary binder, usually alumina (aluminium oxide), a component of clay as well as a prospected single oxide. Simply stated, glaze is glass with clay added.

Various glazes were developed over centuries, using as colourants ground metallic oxide-bearing rocks such as cobalt for blue, copper for grass green, iron for amber and brown, rutile for orange, manganese for purple-brown and chrome for forest green. Early man found that these colours and glazes could be varied by the introduction of other substances such as calcium, barium, zinc, magnesium and other materials with high melting-points. Or ground metallic oxide pigments could be added to liquid clay and painted on to pots without glaze, for a matt finish characteristic of neolithic times. Colour enlivened the simple functional forms of long ago, and gradually took over, to the point where the coloration and the decoration were more important than the contour.

It is said that ceramics is the earliest technology. Imagine a village of potters who did almost nothing else from morning till night throughout their lives but make wares, over and over, year after year, handing down techniques and building centuries of experience. China is the only area of the world where this phenomenon has continued unchanged for the past ten thousand years, in the same vicinities, to this day. Potters learned to find local clays that could be hand-built or thrown and would stand up during drying and burning. The Chinese were the first to discover 'china stone' in their own land,

a natural earth composition of feldspathic clay which made the first semi-porcelain about 2500 years ago. As Chinese potters learned to contain heat at higher temperatures, they needed a more refractory clay body – one which would not slump at these temperatures. In the Sung dynasty, 960–1279 AD, the golden age of ceramics, the first deposits of pure kaolin – the most refractory clay – were discovered, mined and added to the lower-firing china stone.

These ancient Chinese ceramicists were extraordinary scientists who somehow developed the first kilns – after using bonfires for many millennia, then cave and pit enclosures, then brick beehive structures – about four thousand years ago. These first 'climbing' or 'dragon' kilns were built on an incline, so that heat from the wood-stoked firebox at the base would rise up through the long chamber to the top when the fuel and heat were increased. During the Sung dynasty, the Chinese learned to fire kilns that would retain great heat long enough to achieve translucent porcelain. Further, these incredible ceramicists learned that varying the atmosphere inside the kiln during the firing would yield unusual colours. In an atmosphere of reduced oxygen, copper oxide, normally green or turquoise, gave pinks, reds and 'ox-blood' purple-reds, while iron oxide, normally amber to brown in an oxygen-rich atmosphere, gave sea-green celadons under specific conditions.

All three end-products, earthenware, stoneware and porcelain, fired in various temperatures in a variety of kiln types, developed in Korea, but never achieved the sophistication of the elegant Sung and later dynasties in China. The ceramics of both countries would eventually influence Japan.

In Europe none of this was happening. The ability to make a translucent porcelain was not discovered until the eighteenth cen-tury, when first J. F. Boettger at Meissen, Germany, and later Josiah Spode, an English pottery manufacturer, independently of each other, put together china clay and bone ash from natural deposits in their own countries and fired to 2400° F (1300° C). The result was a completely dense white body, acid-resistant, and translucent when thin, which was the first European porcelain; when it was not translu-cent, and fired at lower temperature, it was stoneware.

Previously, though, the Middle East, especially Persia, was the seat of the discovery of tin oxide, a natural mineral opacifier, enabling potters to create a white glaze on which cobalt oxide could be painted in brush-strokes that resulted in vibrant blue after firing to low temperature. Marco Polo, that great explorer, travelled to Asia in the thirteenth century, bringing back to Europe the trademark ware of the Chinese Ming dynasty: cobalt blue on white decorated porcelains. Fascinated by these products, potters across Europe used cobalt over a low-temperature white glaze on earthenware in imitation of the Ming ware. The Dutch called their version Delft after the town in which it was made; the British called theirs Lambeth Delft. The Italians and later the Spaniards added other coloured pig-ments to the cobalt blue in an overglaze technique termed 'majolica'. Especially in Florence, beginning in the twelfth century and reaching a high point in the sixteenth with the Della Robbia family, potters used many colours in the overglaze technique for their moulded ceramic sculptures. At Valencia, Spain, the lustre-glaze reduction firing technique developed in the ninth century by the Persians was brought to a new elegance in Renaissance times.

Peasant pottery, for domestic use but often highly embellished with decoration, flourished in all parts of Europe from the tenth century. Stoneware, a more dense body than earthenware, fired to

The village of Jingdezhen in China, where ceramics have been produced for many thousands of years.

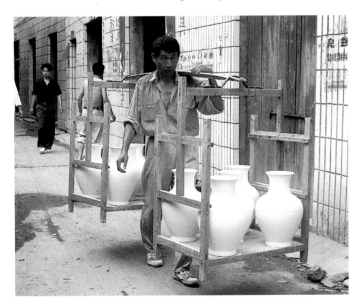
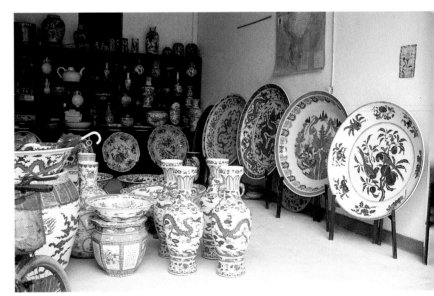

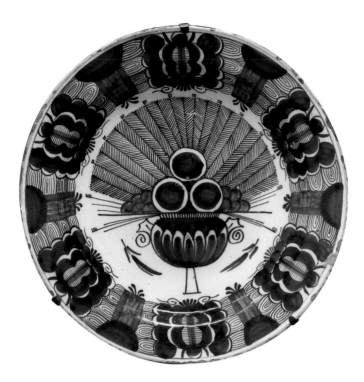

An earthenware plate decorated with cobalt blue over tin-opaque glaze, from the Dutch manufactory in Delft, early sixteenth century.

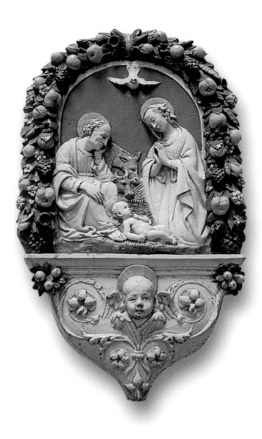

Carved white clay body plaque with majolica decoration by the Della Robbia workshop in Florence, Italy, late fifteenth to early sixteenth century.

An American ceramic spittoon, early eighteenth century.

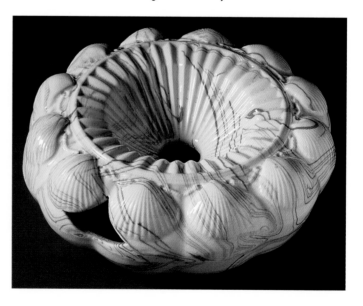

higher temperature than bricks, had been made in China for centuries, but was not discovered until the Middle Ages in the West. Salt-glazed stoneware, achieved by inserting rock salt into the kiln atmosphere at the maturing temperature of the unglazed clay, which yielded a peculiar orange-peel-textured, shiny glaze, was discovered in Germany about 1500 AD and taken up by British clayworkers soon after. Most European countries were making functional and decorative earthenware and stoneware with superb technical skills, and beginning to perfect porcelain fabrication in the eighteenth century.

To the new world of America came European potters who, knowing how to work in each of the three types of clay bodies, built potteries in the eastern colonies near good clay deposits. Eventually many of them moved into Ohio, where abundant clay was available.

During the 1600s, at about the same period as the colonization of America, Japan adopted the ceramic art. Following Emperor Hideyoshi's invasions, many Chinese and Korean potters were brought back, chained to the wheel and made to teach their art. The Japanese quickly became expert in stoneware and porcelain, while the several thousand years of clay tradition were culminating in the flamboyant Chinese Qing overglaze enamel decorations on perfect porcelains.

In Africa, India and, surprisingly, in Egypt and Persia where the earliest ceramic processes had evolved, claywork remained an

indigenous folk craft, handbuilt or thrown on makeshift wooden wheels revolving on stones or sticks in the ground; wares were decorated with natural clays containing metallic colouring oxides, and fired in open bonfires or in pits. Island peoples around the world used gourds or wooden vessels for eating and drinking and did not develop a clay culture unless it was imposed. Inuit and others in very cold climates learned ceramics recently or not at all.

American Indians in the north and south of the western hemisphere were and are exceptional clay artists. For at least two thousand years these peoples have created high art in their pottery, which is made from local clays, decorated with drawings or brush-strokes of other local clays, and fired in bonfires. Each tribe or area has its own marks, its own clay, its own style. In these cultures of no written language, functional pottery and sculptural effigies help us to understand the history of their civilization. Although Mayan, Aztec, Colima, Nyarit and many other important clay traditions have vanished, others still flourish today, notably among the Pueblo Indians of the southwestern United States. The habits and traditions of these self-contained communities are kept alive by ceremony and ritual, in which pottery has always played an important role.

By the twentieth century, the Industrial Revolution already past, the world was alive with innovative technology, mass-production techniques, automobiles, electricity and telephones. A new-found adherence to old values was apparent in movements such as William Morris's design company, established in the nineteenth century in England, and the Bauhaus school in Germany of the 1920s. Functional ceramics were an accomplished fact; dinnerware, floor and wall tiles, sanitary ware and purely decorative clayworks were manufactured on assembly lines. Ceramic engineering science and ceramic design were taught at the world's only college of ceramics, located at Alfred University, Alfred, New York, founded by the Englishman Charles Binns in 1899.

Two young men, one British, the other Japanese, met in Tokyo in 1920 and changed the course of so-called studio pottery from that time onward. Bernard Leach, brought up in China, learned raku and stoneware potting in Japan, and met Shoji Hamada, a younger Japanese potter who was trained in technical ceramics as well as in art. Leach wanted to return to England to establish a pottery and asked Hamada to accompany him on the journey, to seek clay. Together they built Leach's shop in St Ives, Cornwall, where they found significant fireclay deposits for stoneware.

In Japan Leach and Hamada had two collaborators: Soetsu Yanagi, the foremost exponent of Zen Buddhism, who, as a protégé of its main interpreter Daisetz Suzuki, articulated a Buddhist aesthetic and wrote and lectured on the subject internationally; and Kanjiro Kawai, a very fine potter in Kyoto and a great friend of Hamada. These four men revered the untutored art of anonymous craftspeople and wanted to emulate the unsophisticated, simple, spontaneous method of working as a way of life. They gave the name *mingei* to this philosophy and adhered to it all their lives.

The influence of Bernard Leach and Shoji Hamada was greater in Europe and Japan than in the United States until after the Second World War, when they made their first trips to America. Charles Harder, Dean of the School of Design, brought Leach to the New York State College of Ceramics at Alfred University to work with graduate students, including myself, for several months in the spring of 1949. In December 1952 I brought Leach and his colleagues Hamada and Yanagi to Chouinard Art Institute in Los Angeles, where I was teaching, for a three-week workshop.

Those of us in attendance at the workshop were too naive to understand the implications of Yanagi's daily lectures on folk art, accompanied by his coloured pictures of fabrics and pots, or Bernard Leach's talks on working from the 'tap root', which in the United States he and Hamada classified as American Indian. This same lack of understanding was apparent as the three men made their way across the country in one-night stands, lecturing and demonstrating; newspaper articles made fun of their views. Eventually Hamada specifically, Leach reluctantly, came to the conclusion that the United States was a melting pot of people from all nations of the world, and that its tap root was indeed as varied.

The influence of Leach, Hamada, Yanagi, Kawai, and to some extent their colleague, the Japanese National Treasure in porcelain, Tensuke Tomimoto, was profound during their lifetimes and is being re-examined today. Hamada and Leach each taught a work ethic, albeit not the same one, and a philosophy of devotion to the duty of oneself. They gave us a way of daily work, an old-fashioned sense of integrity, and the idea that art is life and life is art. They enabled us to gain access to the connections between East and West. Their charisma and their leadership will live on for generations in those of us who came under their spell and passed it on.

The decades before and between the two World Wars brought many innovations. Cubism, Fauvism, Futurism, Constructivism and other avant-garde movements in art emerged. Important European painters, Matisse, Picasso, Léger, Chagall, Gauguin, Miró and his potter Artigas, and the like were experimenting with clay, Picasso in depth as we know. From 1919 to 1932 the Bauhaus in Weimar and Dessau, Germany, was instrumental in promoting ideas of form and function, design and production; the ceramicist Marguerite Freilander Wildenhain worked in the Weimar studio before moving to America in 1938. The Paris Exposition of 1925 pivoted around a new theme of 'modern design', as stated in the invitation to participating nations, and provided the name of the game.

Art Nouveau, a predecessor in the 1890s to the style now known as Art Deco, was an exotic, sensual movement that influenced furniture design more than ceramics. Conversely Art Deco, called Art Moderne in its own time from 1910 to 1925, is more familiar to clayworkers now for its brilliantly coloured geometric designs; it was followed by the Dutch De Stijl movement and by the Russian painters who created some of the most exciting ceramic production designs

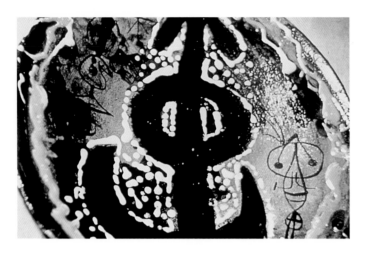

A platter by the Catalan artist Joan Miró (1893–1983).

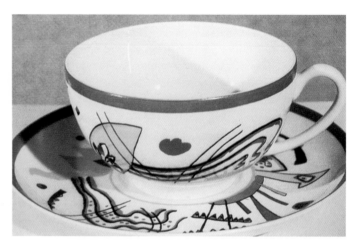

A cup and saucer by the Russian abstract artist Wassily Kandinsky (1866–1944), c.1922.

in our history: Kasimir Malevich, Wassily Kandinsky and Vladimir Tatlin. In the British strand of Art Deco, two women, Susie Cooper and Clarice Cliff, were vibrantly important in the 1930s. Leach and Hamada, aware of these avant-garde movements, were totally unsusceptible to the notions of 'design'.

Denmark, Sweden and Finland had their own brand of ceramic art during these years, primarily individually made pieces produced by such well-known names as Wilhelm Köge, Stig Lindberg and Berndt Friberg in the early 1930s, and later Nathalie Krebs, Christian Poulsen, Karin Bjorquist, Lisa Larson, Kaliki Salmenhara, Rut Byrk, Toini Muana and Kai Frank. These artists and others worked with and sometimes designed for the production facilities in the factories of Royal Copenhagen, Gustavsberg and Arabia, whose technical achievement in earthenware, stoneware and porcelain was impeccable. The individual wares produced by the artists who worked in factories achieved a perfection that was unusual in the industry at that time.

In the United States, a kind of kitsch ceramics – black panthers, Chinese pagodas, surreys with fringes, pink flamingoes – became very popular in southern California, and was produced in earthenware by as many as 400 small production potteries, designed by such names as Susie Singer, Kay Finch and Kay of Hollywood. These styles were a far cry from the European movements and came out of nowhere, except possibly the bright sunshine and free existence in the 'golden West'. Catalina Pottery, a short-lived studio on the island of Santa Catalina near Los Angeles, was a forerunner of the brilliantly coloured orange, blue, green, buff, yellow and red dinnerware that East Coast companies made later.

A number of so-called art potteries were founded in the Midwest, producing innumerable lines of brightly coloured low-fire glazed earthenware. Perhaps the best known was the Fiesta pattern of Homer Laughlin, but other single-coloured or painted tablewares came from

such names as Roseville and Greuby. In Europe the output of similar potteries is exemplified by the Mrazek Peasant Art line in Czechoslovakia in the 1920s, and the bright majolica ware of Italy and Spain. These earthenwares were produced at the same time as the porcelains of Spode, Wedgwood, Royal Doulton, Meissen, Sèvres and the Scandinavian and Russian factories, among others.

In the eastern United States the well-known designer Russell Wright created a tableware called American Modern, manufactured by Steubenville Pottery in Ohio in 1938, which answered the growing need for simple, curving, undecorated forms in lovely, subtle colours, and is sought by collectors today. Eva Zeisel, whom I first met in 1958 in California, and saw again in 1998 when each of us was awarded the Binns Medal by Alfred University's New York State College of Ceramics and the American Ceramic Society, had been designing in Eastern Europe and Russia from the 1920s; she fled to the United States at the rise of Nazism. Fortuitously, she was commissioned by Castleton China, Pennsylvania, and designed for them the beautiful white porcelain dinner service called 'Museum', inaugurated at the Museum of Modern Art, New York City, in 1946. This design, and others she did for Red Wing and for Hall China, are some of the most superbly elegant forms ever executed in tableware.

Today Gustavsberg and Arabia, the outstanding factories in Sweden and Finland, are gone, except for minor pilot production. In the United States, Gladding-McBean, once the largest and most diversified group of ceramic plants in the world, is gone, and so are most of the tile and sanitary-ware producers. Much of the dinnerware on American tables, most of the floor and wall tiles, now come from Italy, Spain, Mexico and Japan. The small potteries of southern California have almost ceased to exist. Of course, some of the world's famous porcelain factories are still working, but the pendu-

lum is swinging in other directions. In Japan, Korea, Taiwan and above all in China, traditional potteries still exist, in villages consisting of hundreds of potters.

Ceramic history after the Second World War has been virtually a phenomenon of the United States. There was no war on American soil, no political disruption. Into the vital, interesting, innovative potpourri of ceramic design in the aftermath of the war stepped a clique of young upstarts in southern California who pioneered improvements in equipment and fresh ideas in clay. Peter Voulkos, a painter who made pottery, came to the renamed Los Angeles County Art Institute (formerly and now the Otis Art Institute) in 1954 from a residency at Archie Bray Foundation, Montana, to begin a ceramics programme. I had already developed a new ceramics department nearby at the Chouinard Art Institute, and John Mason was my student and first assistant.

Voulkos began with equipment similar to that which I had designed and installed at Chouinard, which included updraft gas kilns of enormous capacity and electric gear-reduction-drive potter's wheels powerful enough to take several hundred pounds of clay. Nothing like this equipment existed anywhere else in the United States at that time for studio potters. In a few years I moved to a professorship at the University of Southern California and did the same thing again.

Voulkos and his first students, Paul Soldner, Henry Takemoto, Michael Frimkess, Jerry Rothman, Malcolm MacLain, and I and my students, John Mason, Ken Price and a few others, moved in and out of each other's spheres, with the charismatic Voulkos at the fore. Each of us worked independently and experimented with new options of all sorts – cutting and slashing clay into uncommon forms, often in enormous scale made possible by our big kilns, for instance – and a vital camaraderie and excitement permeated the group.

The Voulkos approach was different from my technically trained Alfred approach. I remember walking into his new studio at the Art Institute, when he was hand-mixing clay – this was before he bought a big commercial bread-dough mixer; he was also making up a few basic glazes. He had five or six large garbage cans in a row on the floor; one held a mixture of two clays, fire and ball, plasticized with water stirred together by hand or stick, for the working clay body. Other cans had random mixtures of two or three base ingredients for glazes, such as colemanite, barium/silica and feldspar/clay combinations, mixed with water. Pete didn't care about testing before using. Buckets of engobes (sometimes called slips) were at hand, the two-member clay body mixed with unmeasured handfuls of ceramic oxide pigments such as cobalt or copper. This was the painter's approach to another medium, much akin to the way Picasso is said to have begun to work in clay.

Around us in the city were the 400 small potteries making the kitsch California-style ceramics of that time, and many of the colourful, cheerfully vulgar buildings of Los Angeles flaunted their products, such as the hat of Brown Derby, the large orange for Orange Julius, the hot-dog for Oscar Weiner. The blue sky, white clouds, blue-green ocean, beaches and sunshine all contributed to an atmosphere of freedom and experimentation.

Plaster mould and teapot, Hallcraft I, Tomorrow's Classic, designed by Eva Zeisel for the Hall China Co., early 1950s.

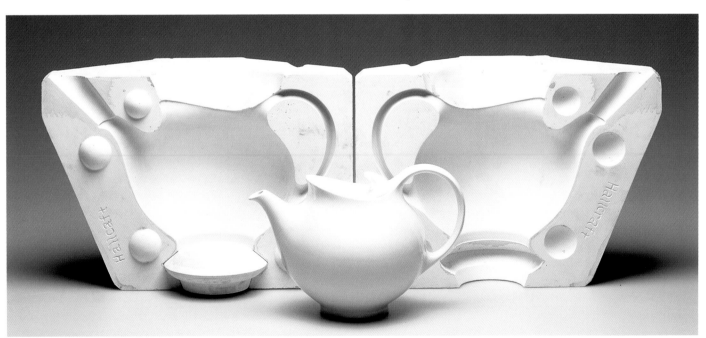

Here also were the functional potters of the 1930s and 40s, who continued to be functional: Glen Lukens, Gertrude and Otto Natzler, Laura Andresen, Harrison McIntosh, Myrton Purkis, and in the north F. Carlton Ball, Marguerite Wildenhain, Edith and Brian Heath. These artists were pure California, too, with their blistered finishes, glazes made from ground desert rocks, cadmium reds and oranges, and rich copper blues. Beatrice Wood was a renegade who cannot be categorized, keeping to herself, rising like an oracle, creating her low-fire reduction lustres on dishes that should not be eaten from and exhibiting her sometimes risqué sculpture.

Ceramic artists in Europe heard about Voulkos and the California excitement, and began to visit; venerable Japanese ceramicists also came. We were in the midst of the 1950s ceramic explosion, accelerated by the synergy of each of us. Voulkos had an amazing exhibition at the Pasadena Museum in 1956, John Mason at the Los Angeles County Museum of Art in 1966, Ken Price at the same museum in 1977. The annual California Design exhibitions at the Pasadena Museum, featuring ceramics and other crafts, directed by Eudorah Moore, were put on at about this time, with major photographic catalogues.

The annual Los Angeles County Fair's invitation exhibitions of ceramic art, curated by Richard Petterson and Millard Sheets of Scripps College, were widely covered by journalists, with articles and pictures of the newest works. Newspaper art critics were more inclined then than they are now to review exhibitions of ceramics. What was happening in southern California ceramics in the 50s did not occur anywhere else until its influence had had several years to percolate.

In 1958 Voulkos moved to Berkeley to begin a ceramics department at the University of California, and the new group that formed around him there included Jim Melchert, Ron Nagle, Richard Shaw, Viola Frey and Marilyn Levine. Ron Nagle said, in an interview with Michael McTwigan for the catalogue of Nagle's own retrospective exhibition in 1993, that when he first saw slides of the work of various Voulkos colleagues: 'That was it, nothing else mattered... I had never seen anything like it in my life.... And seeing all that goofy stuff that was so inventive... it just took my breath away.'

The gifted Robert Arneson, who graduated from Tony Prieto's programme at Mills College, went to teach at the University of California at Davis, and another group of his followers became leaders. Jun Kaneko, who arrived in Los Angeles from Japan in 1963, became the focus of another group. Kaneko eventually went to teach at several eastern USA colleges and influenced many hidebound clayworkers there. The energy, compatibility, vitality and empathy of this large collective of ground-breaking artists in California in the 50s and 60s has not occurred again anywhere. It was this irrepressible vanguard that carried ceramic art in the next decades into adulthood, and on to acquisition by national museums and galleries as well as being sought by collectors.

At this time in the United States, several important annual juried exhibitions were set up and began to contribute to the education of the consuming public about handmade craft. In Kansas, Maude Schollenberger held the influential yearly competitive Decorative Arts and Ceramic Exhibition for all crafts at the Wichita Art Association from 1945 to 1972; the yearly Syracuse exhibition at the Everson Museum was open to ceramic artists from 1938 to 1972. In Detroit a memorable exhibition was put on by the Museum in 1949.

In the Midwest and the eastern States the western ceramic movement was approached with awe and a bit of misgiving, and took hold only gradually. Maija Grotell, from Finland, who began a ceramic department at Cranbrook Art Institute in 1938, pioneered ways and means of glazing, and gave some of the well-known clay artists of today their start. Sheldon Carey taught at Kansas, Harding Black in Texas, Charles Lakofsky and Victor Schreckengost in Ohio, and in 1948 Dan Rhodes came back to his *alma mater*, Alfred. But, as the art critic Lucy Lippard has said, the ceramics on the West Coast became known as art while the ceramics of the East Coast were still craft.

The legendary Aileen Vanderbilt Osborne Webb, founder of the American Craft Council in New York City in 1945, became the prime mover in espousing the validity of handcrafts in a technological society. Mrs Webb also founded the School of American Craftsmen, now at Rochester Institute of Technology; America House, a sales outlet; the Museum of Contemporary Craft (now the Museum of American Craft); and the World Craft Council, a division of UNESCO chartered in 1964. Regional and country organizations for crafts still exist around the world, as well as a residue of the WCC with headquarters in Denmark. Mrs Webb's most profound idea, of uniting the world's craftspeople in the cause of peace by means of communal energies, made a valiant start but has not had the same impetus since her death in 1978.

Scholarship and criticism developed in the 1950s in the USA as galleries and museums began to exhibit ceramics as a matter of course, and critics began to write about them. The magazine *Craft Horizons* (an arm of the American Craft Council) was edited from 1955 to 1978 by the indomitable Rose Slivka, who wrote seminal articles on the emerging innovations in claywork; that magazine is gone, but Rose was then and still is a force in international art criticism. Ake Huldt and Arthur Hald in Sweden, Edward Lucie-Smith and Philip Rawson in England, emulated John Ruskin and William Morris, who initially revitalized crafts through their words.

In Europe the pottery brigade was still being led by Bernard Leach and his followers in the British Isles and the Commonwealths of Canada and Australia. Lucie Rie from Austria and Hans Coper from Germany emigrated to England in the 1930s and became two of the most renowned clay artists in the world. Other developments were outgrowths of the 30s Scandinavian design movement that we have already examined. Miró and Artigas went on their own course,

while Picasso continued to wave his particular flag. Africa felt the influence of Michael Cardew's thirty-year residence there, and Japan was still under the spell of Hamada, the self-styled 'folk potter', offset by his eccentric friend Rosanjin, a restaurateur turned clay artist, and Kawai, who emulated the folk potter but was a step ahead.

When I began the ceramics department at Chouinard in 1952 in Los Angeles there were three colleges teaching ceramics in the vicinity and one in northern California. A few scattered institutions in the Midwest and the eastern States included ceramic courses in their art departments; the exceptions were New York State College of Ceramics at Alfred, and Ohio State University, where large departments of ceramic art and engineering existed side by side. Today almost every one of the thousands of institutions of higher education in the United States teaches ceramics.

In Europe a parallel situation developed from the 1950s, with a proliferation of art schools and colleges offering studies in ceramics. Particularly in Asia, ceramics continued to be learned in the studio on an apprenticeship basis, and in some third-world societies clay working continues to follow the tradition of centuries.

The popularity of china-painting, practised as a fine art in the 1920s and 30s all over the world and now revived, hobby classes, videotapes of how to do it, along with specific training, have contributed to the ceramic culture upheld today by collectors, museums, galleries and artists.

Eastern European potters survived fifty years or more of oppression, made clayworks between wars, and are doing so again. China has a new generation of young potters benefiting from the tutelage of the previous generation, which grew up during the Cultural Revolution; both are adding new ideas to their age-old heritage. Ceramic organizations proliferate, such as the International Academy of Ceramics, which began in 1950 in Geneva, the International Museum of Ceramics in Faenza with its great 50s collection including Fontana, and the government-sponsored craft councils in many countries. In the United States the National Endowment for the Arts and the arts councils of each state promote ceramic art and artists. Universities, art schools and colleges everywhere have ceramic departments that engage artists to teach. All this has helped energize ceramics as an art form in the second half of the twentieth century.

A growing market of collectors; the shrinking world; selling on the Internet; mass media; instant communication; gallery dealers and buyers travelling the world: all this is producing a democratic art, belonging 'to the people', unprecedented in any time. It is a far cry from the pedlars hauling carts of pots around villages such as Hamada's Mashiko, in Japan, which is how some of his pots were sold in the 1920s. Ceramics is such an old art that it is hard to find the new, but the 50s ceramic explosion in California was new and it revitalized other art media too.

As we move ahead into the twenty-first century it seems less likely that we will see another forward leap in ceramic innovation.

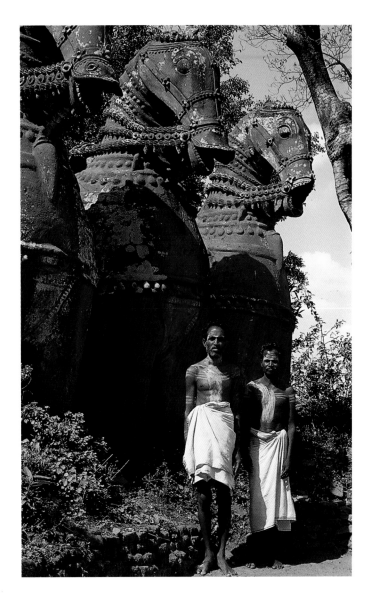

Gigantic horses at Ayyanaur, southern India, part of a temple site in the forest.

Unlike their predecessors at the mid-century, who were fired with passion and produced a 'style', today's clayworkers immerse themselves in all the directions that have gone before, and are as technically competent as it is possible to be. Clay artists in countries that were deprived of development due to political revolutions or wars are catching up, but seem not yet to be ploughing new ground.

Mass communication allows everyone to participate in the process and results of creativity. The pressure is on to stand in front and show the way forward. As always, only a few will do so.

materials speak

THE NATURAL MATERIALS of clay and glaze are the basic elements of which ceramics are fabricated. For centuries these materials of the earth and the results of combining them into fired earthenware, stoneware and porcelain objects have yielded a wide variety of satisfactory results for most clayworkers.

Earthenware, a lightweight, low-fired porous clay body made of the common clay components that cover the planet, is attractive in its natural, robust red to buff colours, and is often decorated with other coloured clays or a myriad bright-hued oxides, with or without a glaze. **Stoneware**, a composition of higher-temperature fire and ball clays, has a gutsy, coarse appearance when fired, is more durable and substantial, and carries a more subtle palette of colour.

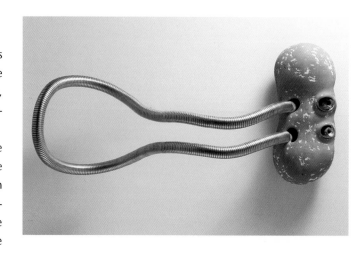

Porcelain, the ware of kings, is slick-hard after firing at very high temperatures to vitrification, strong and tough when thick and beautifully translucent when thin.

Clays for decoration, called **engobes** (or slips by some artists and in some countries), can be coloured with earth oxides such as copper, cobalt, iron, manganese, vanadium, titanium and chrome, or with manufactured stains that are compounds of those oxides plus additions of ingredients to obtain a rainbow palette. Coloured clays by themselves have been used for generations in folk art societies with or without a covering glaze. Today engobes are used alone by many artists for the strong, bold, clay-like texture they impart.

On a different note, recent innovations in sculptural ceramic forms have given rise to the use of combinations of claywork with metals, fibre, glass and numerous alternative materials. Nylon fibres, nutshells, coffee grounds and various other organic substances burn out, leaving their imprint or residue. Bits of fired clays (called chamotte or grog), stones, metals that melt, and the like, can be added to raw clay to yield textures in the final work. Today much clay art is composed of a multitude of man-made or natural materials glued on, wrapped around or otherwise attached to enhance the artist's intention.

New ways of incorporating complex materials with the raw clay before firing, and the hundreds of possibilities for attaching materials to clay objects after firing, may be the most exciting arena for ceramics today.

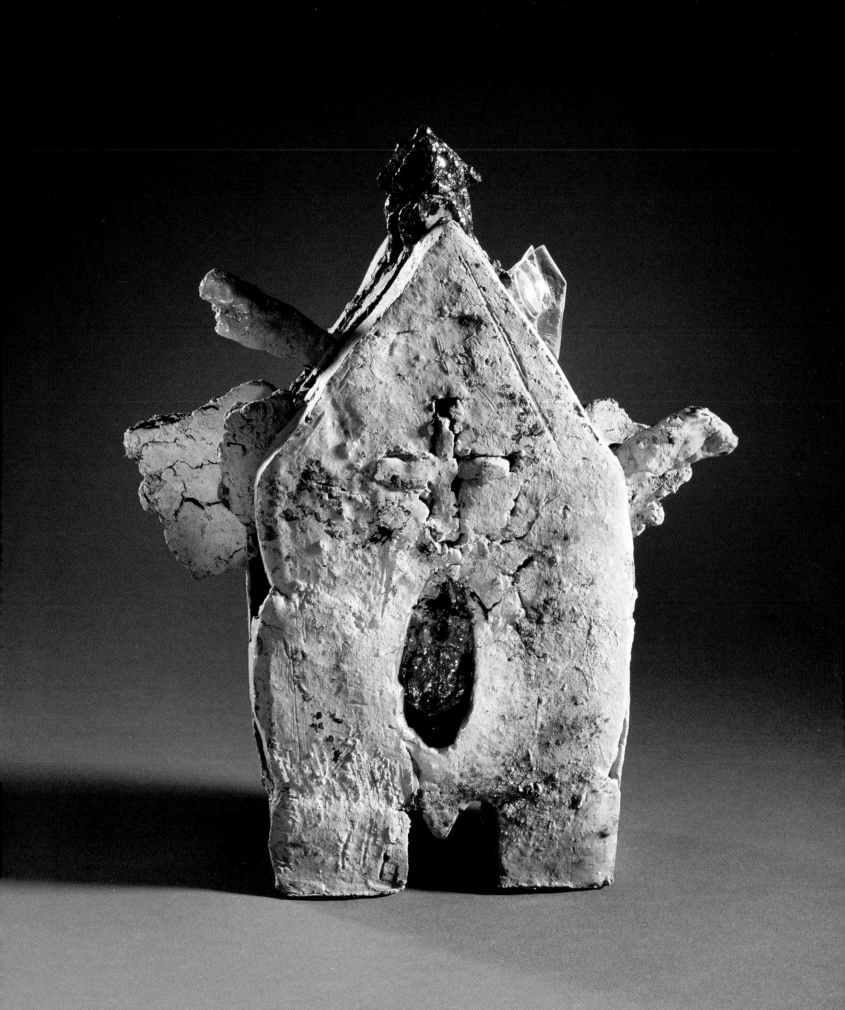

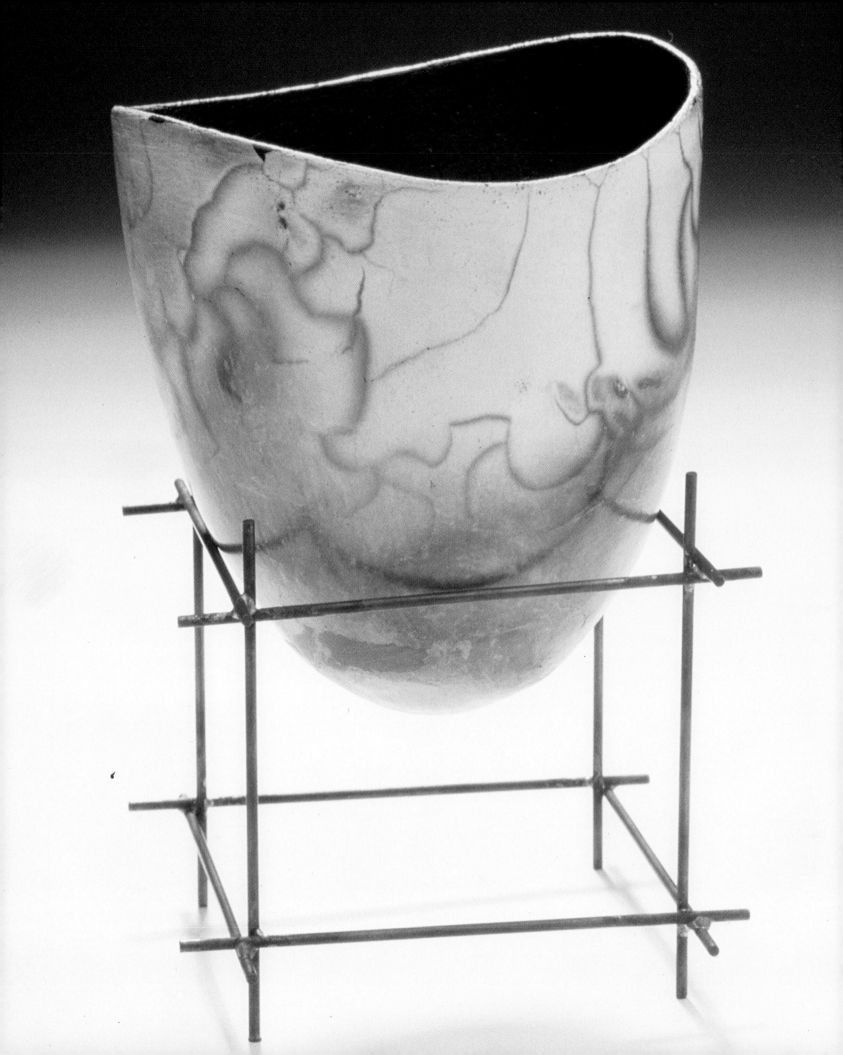

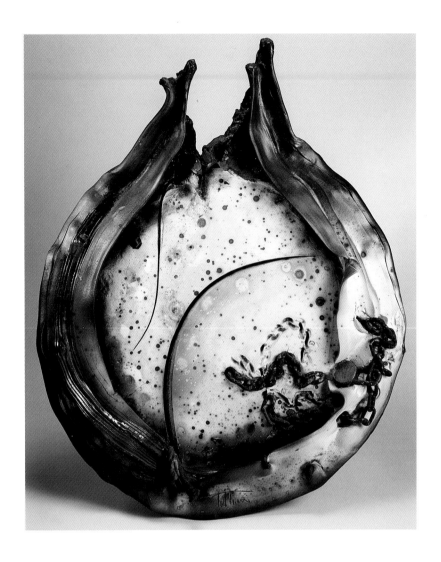

opposite
Jimmy CLARK, USA
Tall Pot with Stand, 10 x 5 x 5 in (25 x 12.5 x 12.5 cm)
Pinched earthenware, terra sigillata, pit-fired; metal

left
Neil TETKOWSKI, USA
Horseshoe with Lock and Chain, 47 x 36 x 6¼ in
(120 x 92 x 16 cm)
Stoneware, iron

below
Fritz ROSSMANN, Germany
Peg Top Form, 6 x 11½ in (15 x 29 cm)
Stoneware, engobes

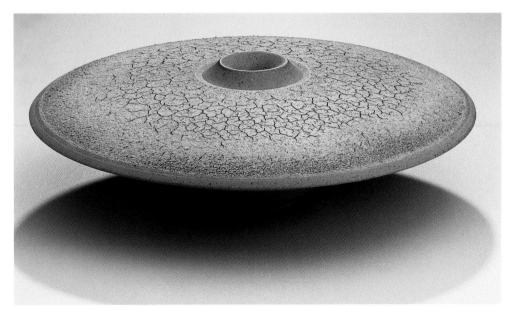

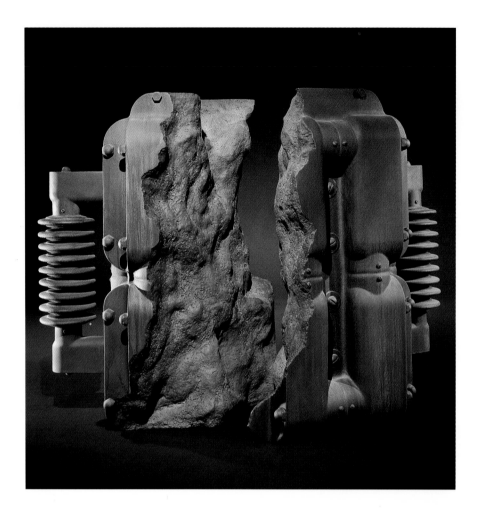

Steven MONTGOMERY, USA
Disjunction No.2, **26 x 39 x 23 in (66 x 99 x 58 cm)**
Stoneware, paint

below left
Ewen HENDERSON, UK
Knotted I, **14 x 27 x 21 in (36 x 69 x 53 cm)**
Paperclay and oxides

below
John CHALKE, Canada
Oval Plate, **9 x 8 in (23 x 20 cm)**
Multi-fired layers of glaze

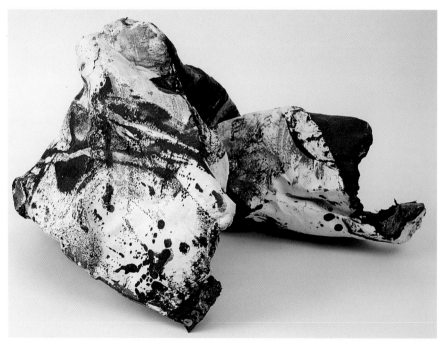

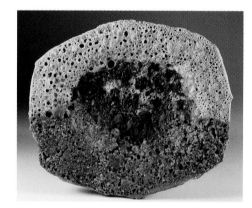

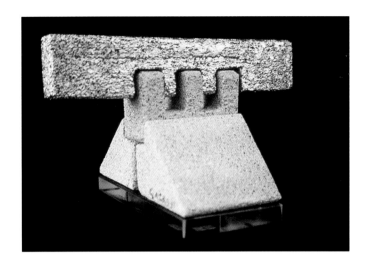

Emidio GALASSI, Italy
Ara, Trave Oro (Altar with Golden Beam), 16 x 12 x 14 in (40 x 30 x 35 cm)
Refractory brick clay and glaze

right
Joseph ROSCHAR, Canada
Deconstructed Warrior, 39 x 21 x 14 in (99 x 53 x 35.5 cm)
Raku, oxidized metal and stoneware

below
Phyllis GREEN, USA
Symbiota, 7 x 11 x 9 in (18 x 28 x 23 cm)
Earthenware, glazes, flocking, fabric

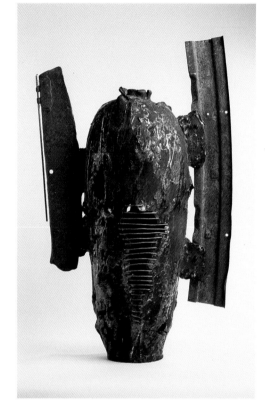

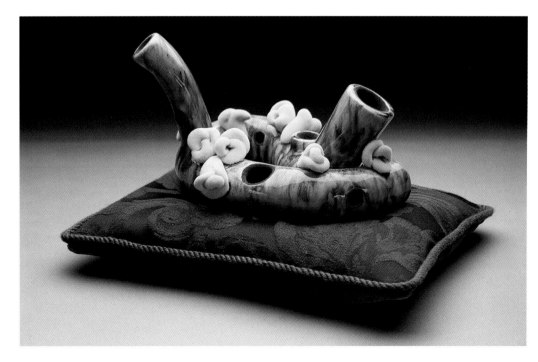

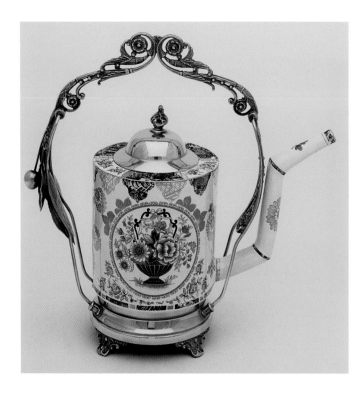

Léopold L. FOULEM, Canada
Encre de Chine Teapot, **12 x 12 x 5 in** (31 x 31 x 13 cm)
Porcelain and found object

Adrian SAXE, USA
Untitled Ewer (Boz), **12 x 7³/₄ x 4¹/₄ in** (30 x 20 x 11 cm)
Porcelain, mixed media

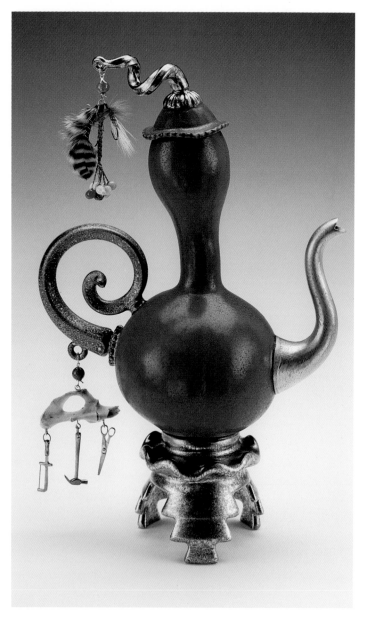

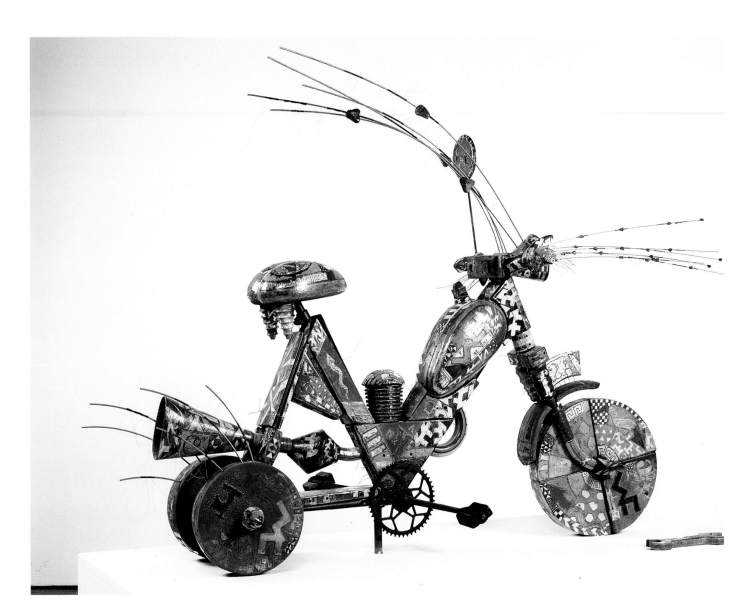

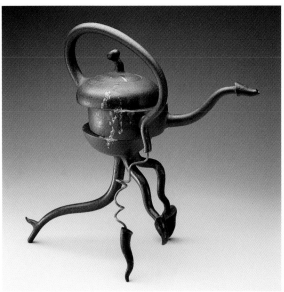

above
Judith PÜSCHEL, Germany
Herzschrittmacher (Pacemaker), **71 x 31½ in (180 x 80 cm)**
Raku, metal, mixed media

left
HWANG Jeng-Daw, Taiwan
Teapot: Walking Alien Insect, **19 x 18½ x 9 in (49 x 47 x 23 cm)**
Yi-Xing type clay, copper wire

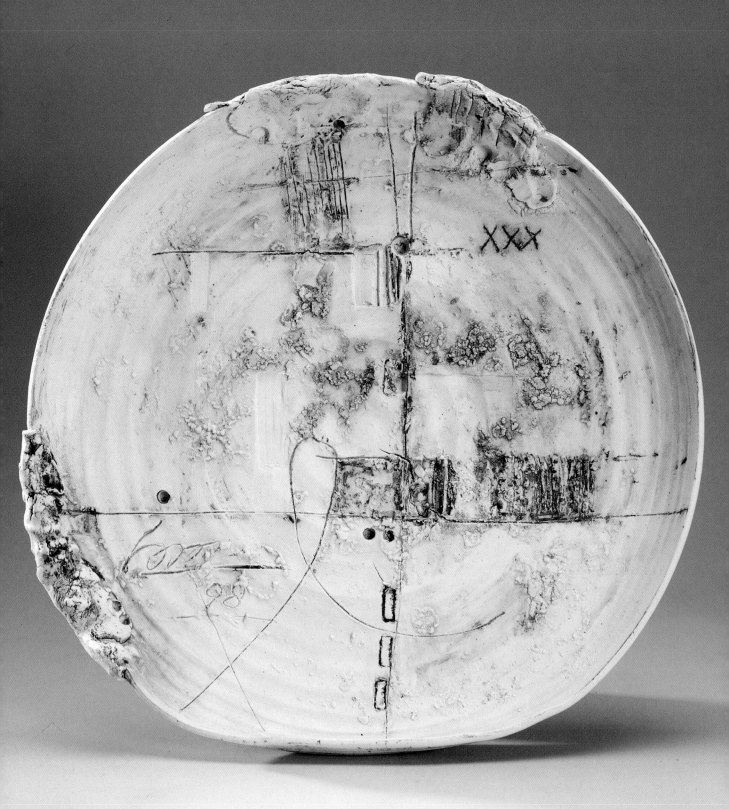

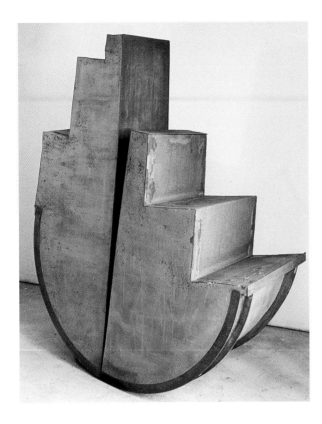

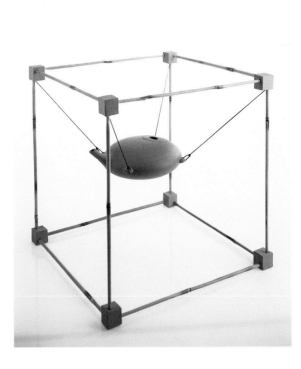

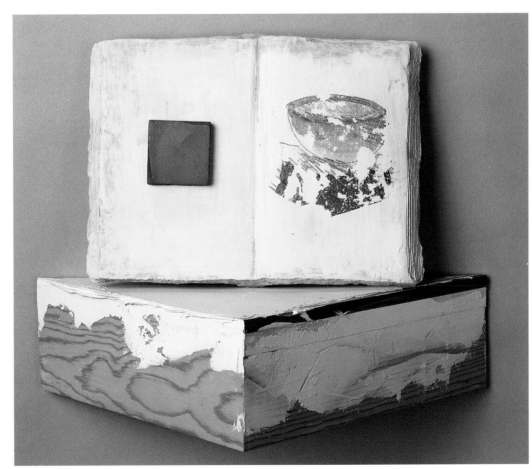

above
Joyce KOHL, USA
Major Split, 5 x 4 x 4 ft
(152 x 122 x 122 cm)
Adobe, steel from fragments of
farm and industrial implements

above right
Dominique MORIN, France
Untitled, 12 x 12 x 12 in
(30 x 30 x 30 cm)
Stoneware, metal

right
Nancy SELVIN, USA
Still Life, 16 x 16 x 8 in
(40.6 x 40.6 x 20 cm)
Xerox transfer process,
mixed media

opposite
BAI Ming, China
Plate, 24 x 24 in (61 x 61 cm)
Stoneware with oxide drawing

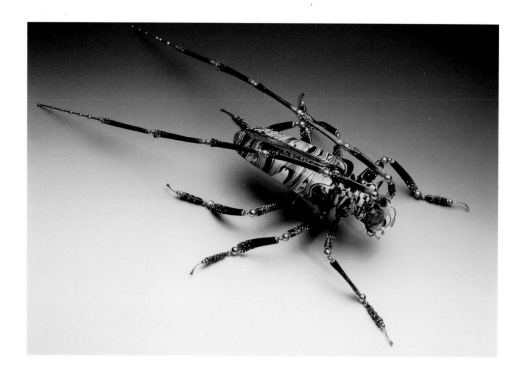

Cynthia CHUANG and Erh-Ping TSAI, USA
Beetle, 11 x 7 x 2.5 in (28 x 18 x 6 cm)
Porcelain, metal, glaze and mixed media

right
Netty VAN DEN HEUVEL, The Netherlands
Three-Dimensional Drawing, 14 x 30 x 46 in (35.5 x 76 x 117 cm)
Porcelain and wood

below
Ron FONDAW, USA
Hand of Time, 4 x 4 x 4 ft (122 x 122 x 122 cm)
Adobe and steel

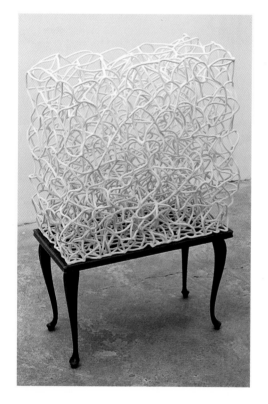

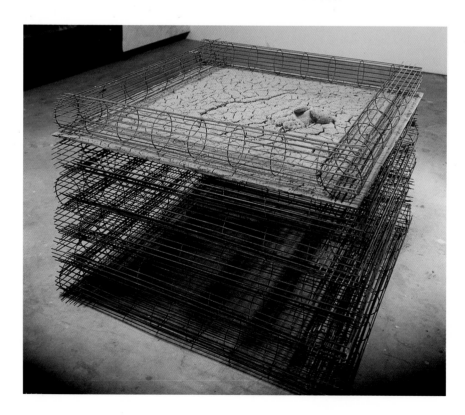

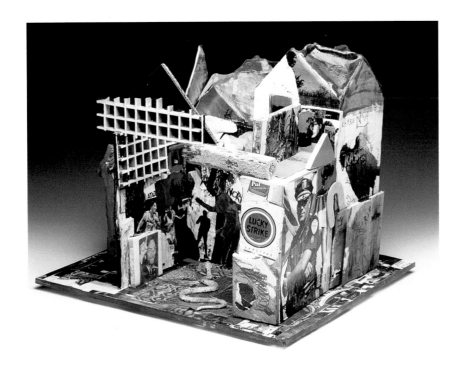

Leroy JOHNSON, USA
Black and Blue Eden, 13 x 10 x 12 in (33 x 25 x 30 cm)
Earthenware, glazes, mixed media

Ruth CHAMBERS, Canada
Another Science Experiment, installation
Video projections, computer graphics, earthenware

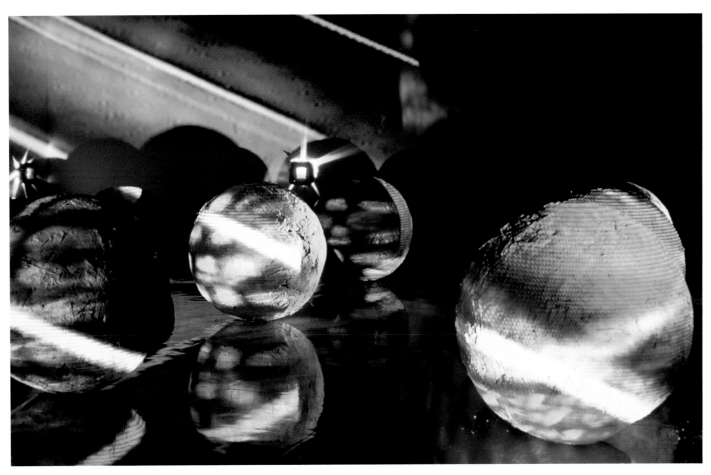

expression through fire

THE CATALAN PAINTER Joan Miró, who from 1944 to his death made large ceramic sculptures, walls and tiles with the potter Lorenzo Artigas, said in a Paris interview with Yvon Taillandier, 1959: 'The brightness of ceramics appeals to me: it seems to produce sparks. And then there is the struggle with the elements – clay and fire. As I have said, I am a fighter. You have to know how to control fire when you do ceramics. And it's unpredictable! That too is very seductive. Even when you use the same formula, the same kiln temperature, you do not get the same result. Unpredictability causes a shock, and that appeals to me now.'

Firing is the last mysterious end to the whole ceramic process. Claywork is the only art medium that never reveals its final look during its making and decorating. Raw clay has a different appearance at all stages, wet to dry to fired, and glaze mixtures are generally whitish or dark brown no matter what the eventual colour. The potter does not see the end from the beginning.

Heat of bonfire temperature, 1300° F (700° C), is necessary to complete the silicate chemistry of clay and glaze, but porcelain translucence usually requires 2300–2400° F (1260–1315° C). Today space components, computer chips and other new products developed in materials science require much higher temperatures, perhaps 10,000° F (5500° C).

Primitive peoples hardened their pots quickly in open fires for 30 or 40 minutes. Early kiln enclosures enabled temperatures up to 2000° F (1100° C), and eventually Chinese potters learned to reach 2400° F (1315° C) for porcelain vitrification. Higher heats demanded longer firing, sometimes for days or weeks, and equally lengthy cooling to prevent thermal shock.

Different temperatures create different looks, from low-fired earthenware, with the possibility of the brightest glaze colours of all temperatures, to denser, heavier stoneware, with its more muted glaze range, to porcelain, which is totally dense and usually white; when very thin it becomes translucent.

Kiln atmosphere also creates visual differences: plenty of oxygen produces the regular colour of a metallic oxide, while reducing the oxygen during firing produces alternative colours, for

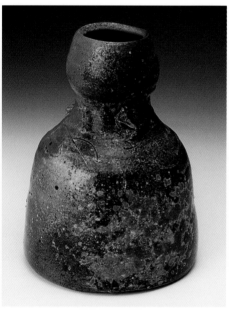

Janet MANSFIELD, Australia
Untitled, **ht 15 in (38 cm)**
Stoneware, woodfired

Jun KANEKO, USA
Expansion, 6'1" x 4'8" x 21"
(185 x 142 x 53 cm)
White earthenwave, low-fire glazes, oxidation

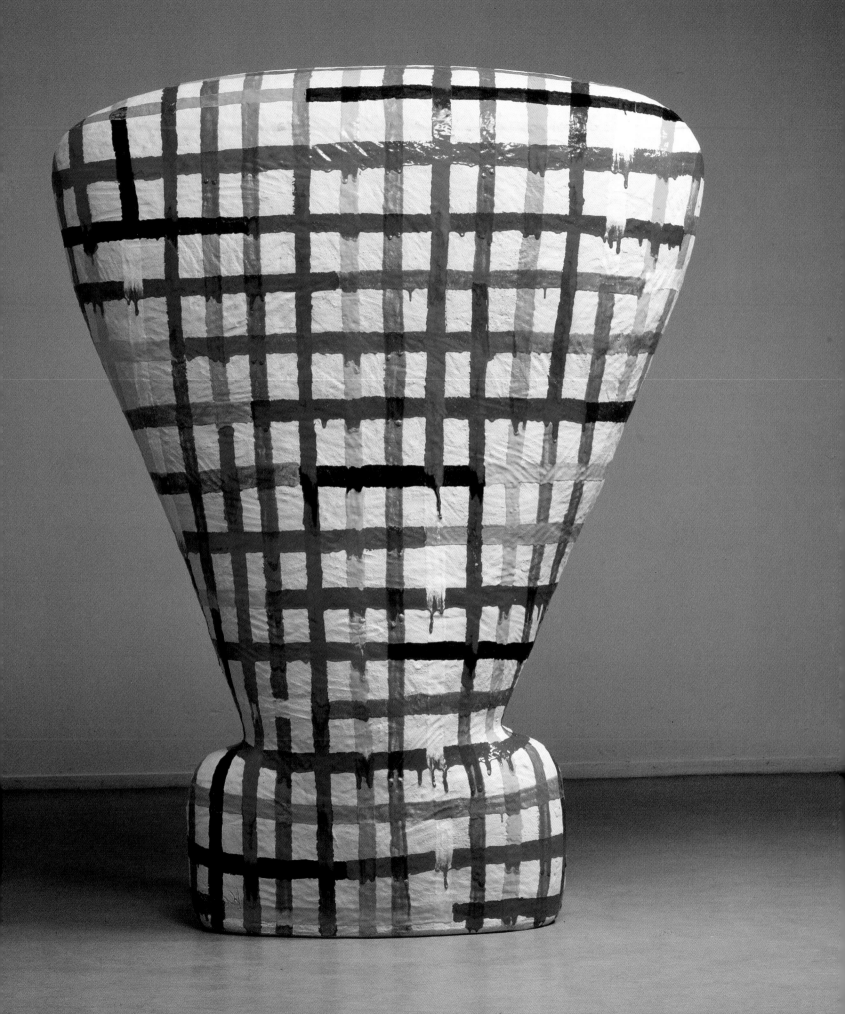

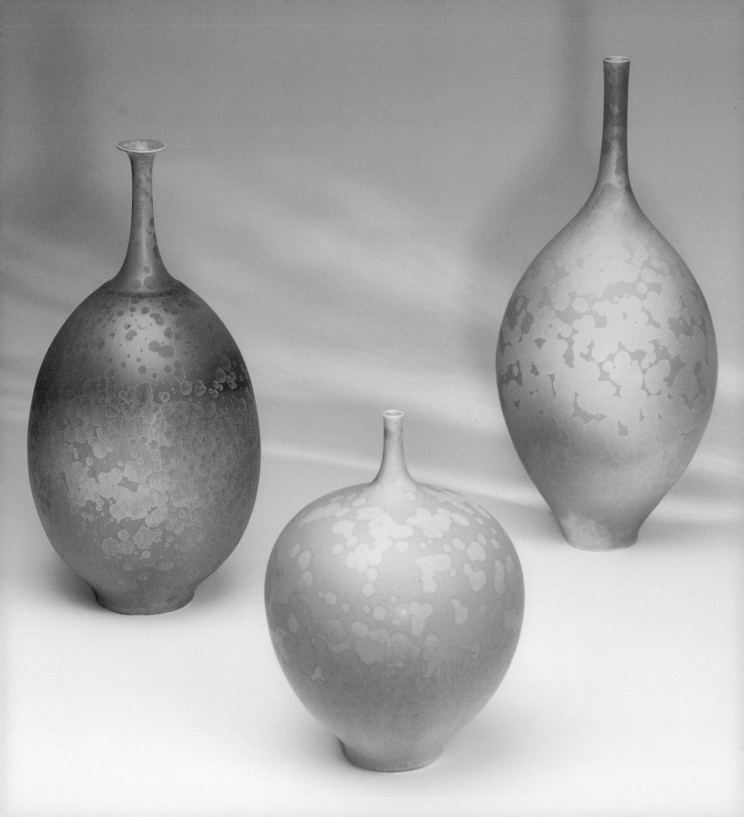

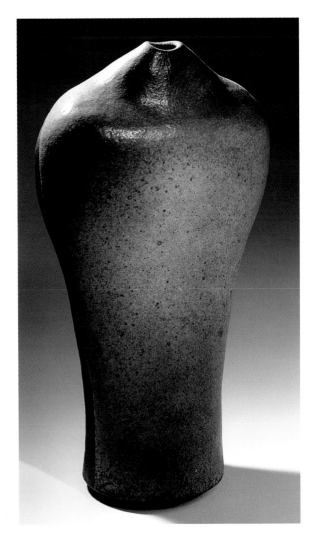

instance red from copper and celadon green from iron; heavy oxygen **reduction** or smoke produces grey to black.

Fuels create differences too: wood or animal dung used in bonfires yields uneven coloration; natural gas and propane vary; oil and kerosene have impurities; woods and other organic materials cause tremendous variables according to where they were grown and when they were harvested; electricity produces a neutral atmosphere, which is sometimes deleterious to colour and is difficult to control.

The ceramic vocabulary is almost endless. Potters learn through long experience to lead the clay, the fabrication and especially the firing towards the conceptual end.

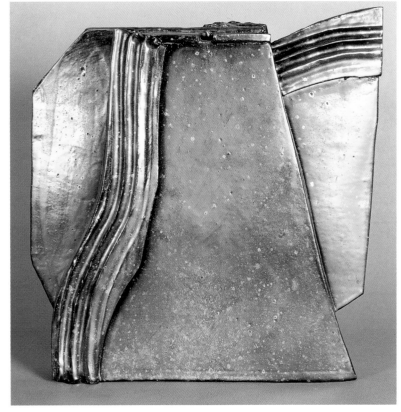

above
Karen KARNES, USA
Untitled, **ht 15 in (38 cm)**
Stoneware and engobes, woodfired

right
Jane Ford AEBERSOLD, USA
Winter Suite No.8, 16¼ x 17¼ x 3¼ in (41 x 44 x 8 cm)
Earthenware, metallic salts, raku, lustres

opposite
Hein SEVERIJNS, The Netherlands
Group of Pots, ht 6–15¾ in (15–40 cm)
Porcelain, matt crystalline glaze, cobalt, nickel, titanium, zinc

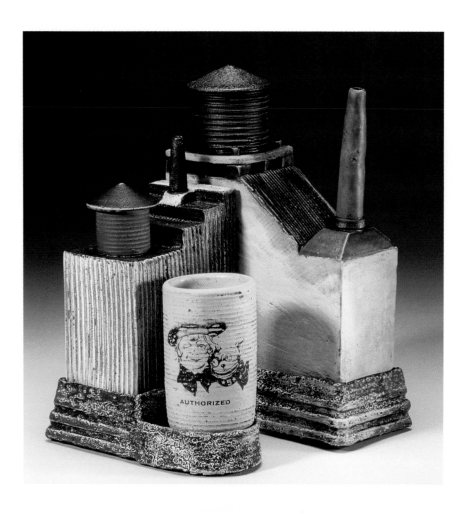

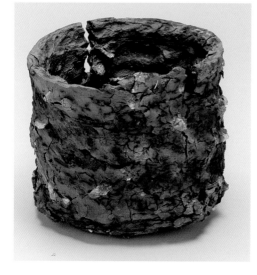

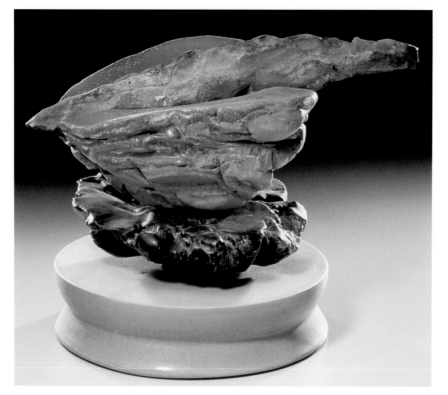

above left
Dan ANDERSON, USA
Chicago Water Tower Teaset, **12 x 12 x 10 in**
(30 x 30 x 25 cm)
Soda-fired stoneware with decal

above
Claudi CASANOVAS, Spain
Teabowl, dia. 5 in (13 cm)
Stoneware with grog, woodfired

left
Richard HIRSCH, USA
Altar Bowl with Weapon Artifacts No.5,
12 x 16 x 11¹/₂ in (30 x 41 x 29 cm)
Raku, low-fire glaze, sandblasted

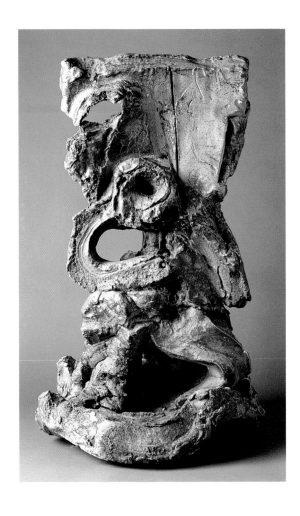

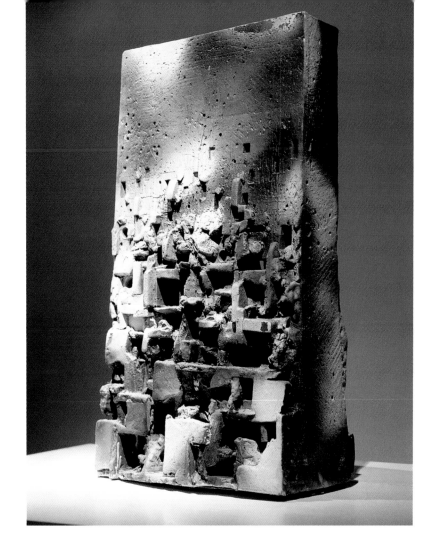

above
Peter CALLAS, USA
Zao, 28 x 20 x 17 in (71 x 51 x 43 cm)
Stoneware, woodfired

above right
LU Pin Chang, China
Grotto Series No. 18, 30 x 10 x 17 in (75 x 26 x 45 cm)
Stoneware, woodfired

right
Jay LaCOUTURE, USA
Covered Jar, 13$^1/_2$ x 10$^1/_4$ x 8$^1/_2$ in (34 x 26 x 22 cm)
Porcelain, soda-vapour glazed

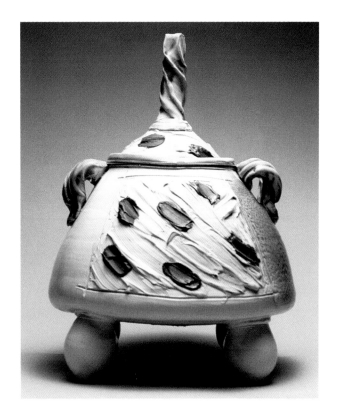

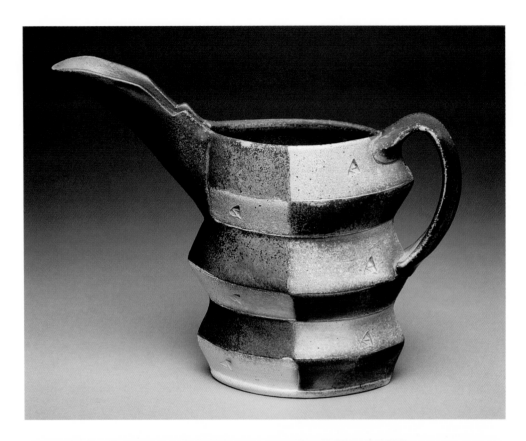

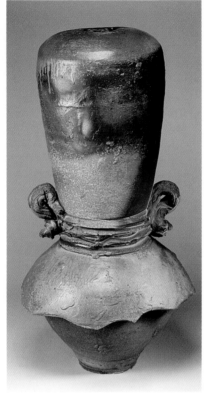

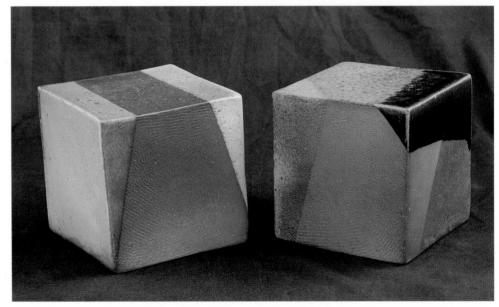

above left
Jeff OESTREICH, USA
Untitled, 11 x 12 x 4 in (28 x 30 x 10 cm)
Stoneware, soda-fired

above
Don REITZ, USA
Untitled, 40 x 19 in (102 x 48 cm)
Stoneware, woodfired

left
Harriet BRISSON, USA
Two Woodfired Cubes, 6 x 6 x 6 in
(15 x 15 x 15 cm)
Stoneware, woodfired, with lustre

opposite
Jane PERRYMAN, UK
Coiled Vase, ht 12 in (30 cm)
Earthenware, smoked in sawdust

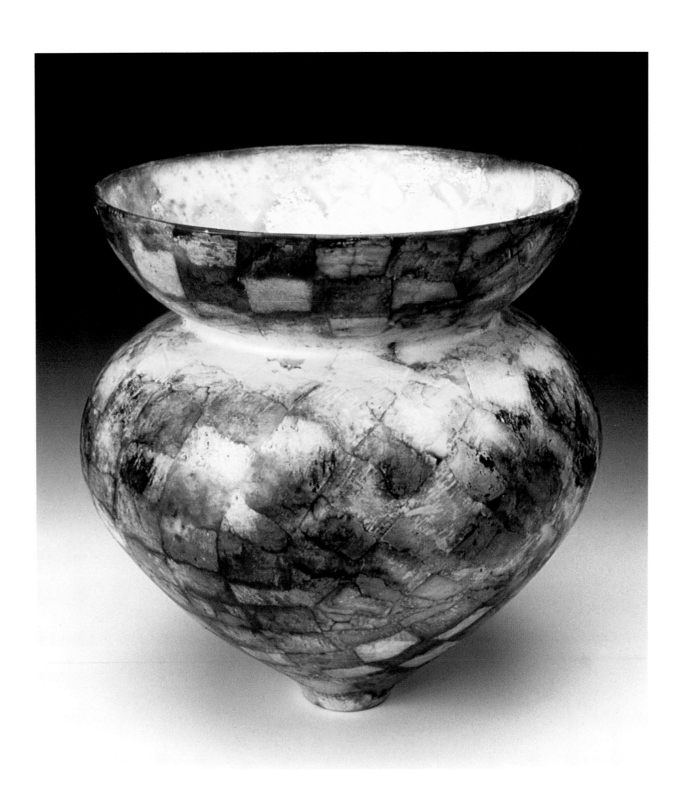

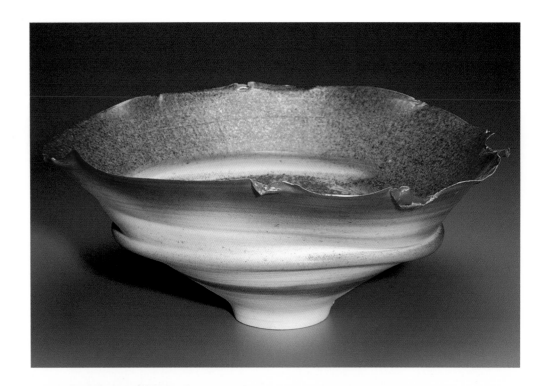

Mary ROEHM, USA
Bowl, dia. 15 in (38 cm)
Porcelain, woodfired

Susan PETERSON, USA
Bowl, 8 x 20 in (20 x 51 cm)
Stoneware, copper reduction

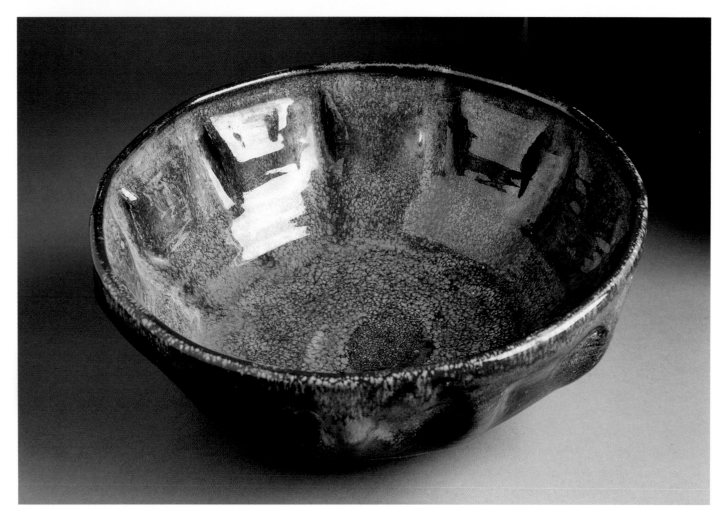

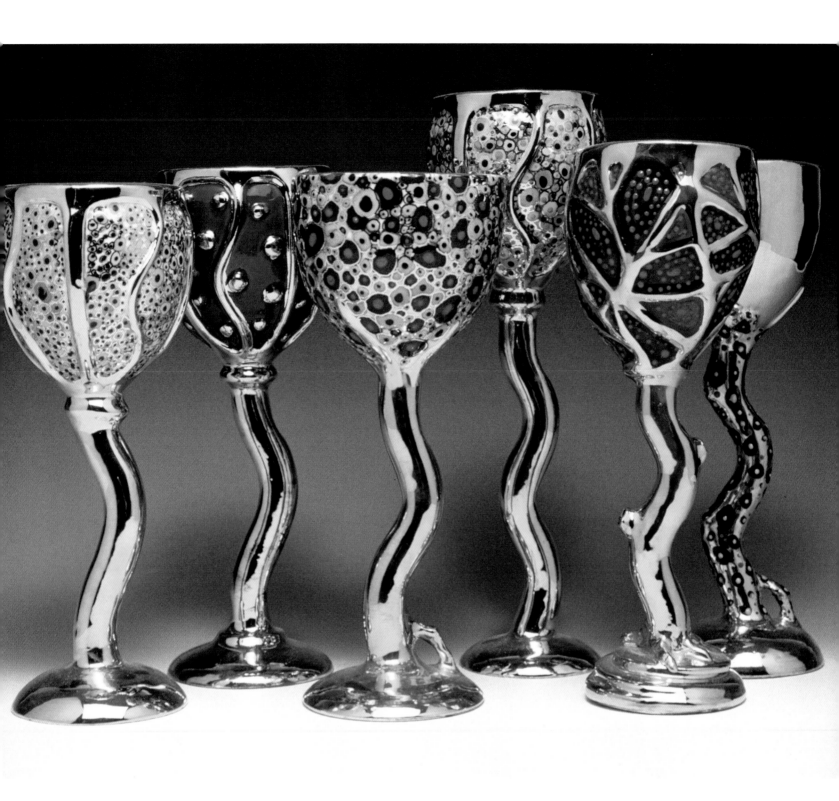

Joan TAKAYAMA-OGAWA, USA
Set of Goblets, 10 x 4 x 4 in (25 x 10 x 10 cm)
Earthenware, engobe, china paint,
lustres, multi-firings

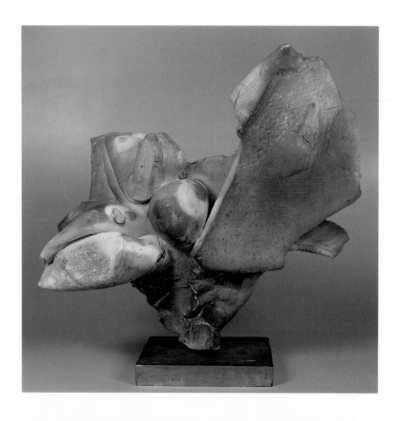

left
Paul SOLDNER, USA
Untitled, 28 x 32 x 16 in (71 x 81 x 41 cm)
Raku, engobes, low-fire salt

below left
Byron TEMPLE, USA
Bamboo Jar, 6 x 6¼ in (15 x 16 cm)
Stoneware, salt glaze

opposite
Peter VOULKOS, USA
Chic Blundie – Stack, 43 x 25 in (109 x 63.5 cm)
Stoneware, woodfired

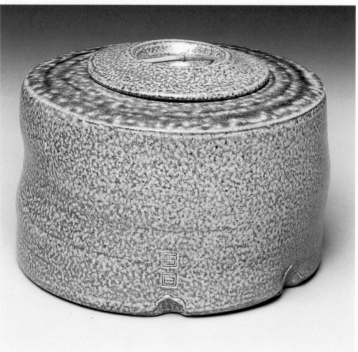

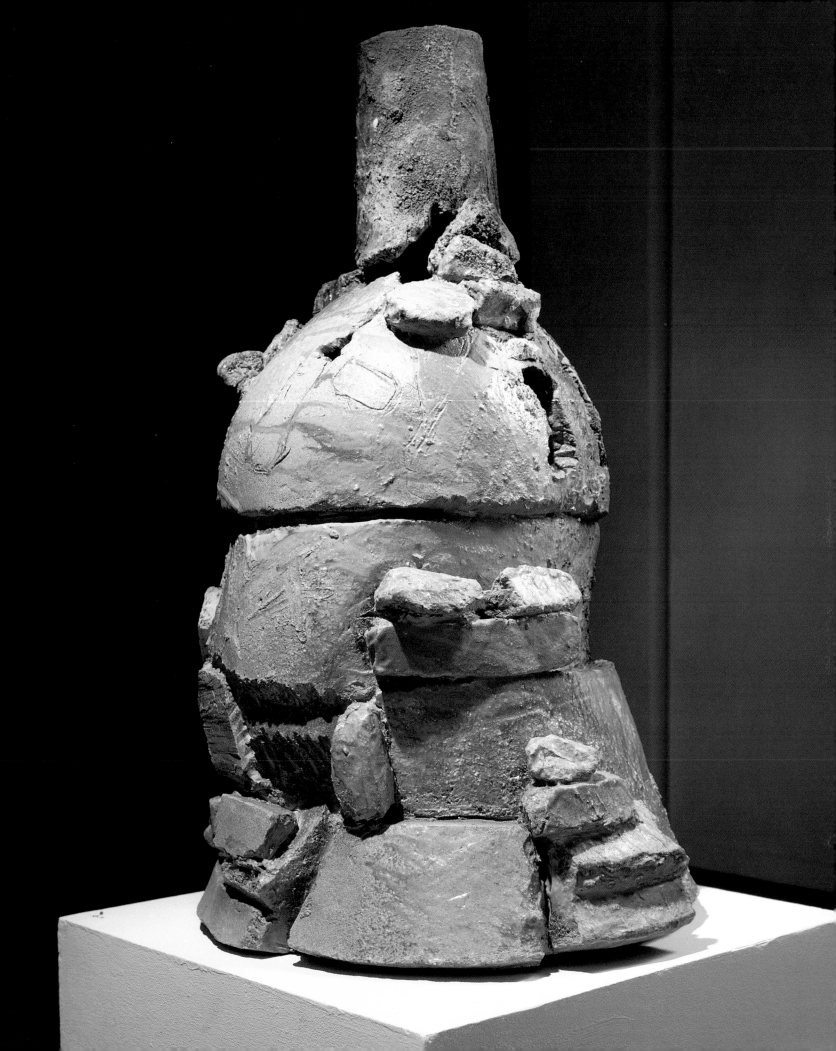

colour versus monochrome

ANCIENT CERAMICS were coloured with natural pigments ground from rocks containing oxides of iron, manganese, copper, chrome, cobalt, nickel, uranium and the like, which were added to liquid clay or mixed in suspension with plant juices and organic gums for painting. Moist claywork could be burnished for a shine and then decorated or left plain; some cultures used hot pine sap or soured milk to seal the porous pot after firing.

When glass and glaze were discovered about 3000 BC, a clear, shiny, more or less impervious surface became possible. Later ceramicists learned to control the glaze chemistry to make opaque and matt glazes. As metallic oxides, firing temperatures and atmospheric control were refined, more colour ranges ensued. The modern ceramic industry strives for quality-control in providing consistency of colour over many years to dinnerware customers, even though raw materials are constantly changing and new discoveries are being made.

Today bright orange, fire-engine red and clear yellows are still best made with cadmium-selenium combinations fired in an oxygen-rich atmosphere (called **oxidation**) in the temperature range 1300–1900° F (700–1040° C). Patented, stabilized cadmium colours are available that will allow the firing range to be increased to 2400° F (1315° C), but without achieving the same brilliance. Claywork can be fired high to vitrify the body and subsequently glazed at progressively lower temperatures to maintain specific colours at specific heats. Colour is seductive, in the hands of a master appearing at times almost unreal or fantastic, and it can even disguise form.

At first glance, monochrome may seem to provide a weaker statement than colour but, as the examples in this section will illustrate, an absence of colour, or light or dark values of neutral shades, can be used to enhance form just as excitingly.

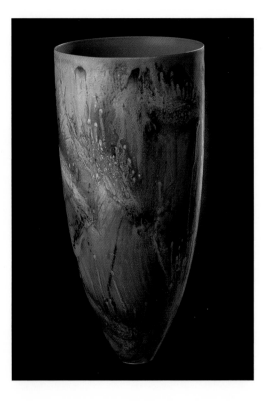

Pippin DRYSDALE, Australia
North Series I: Concealed
Ritual, **26 in (66 cm)**
Porcelain, stains, glaze

Kuriki TATSUSUKE, Japan
Gin'In Saimon Henko (painted
bottle), **10³/₄ x 8 in (27 x 20 cm)**
Stoneware, pigments

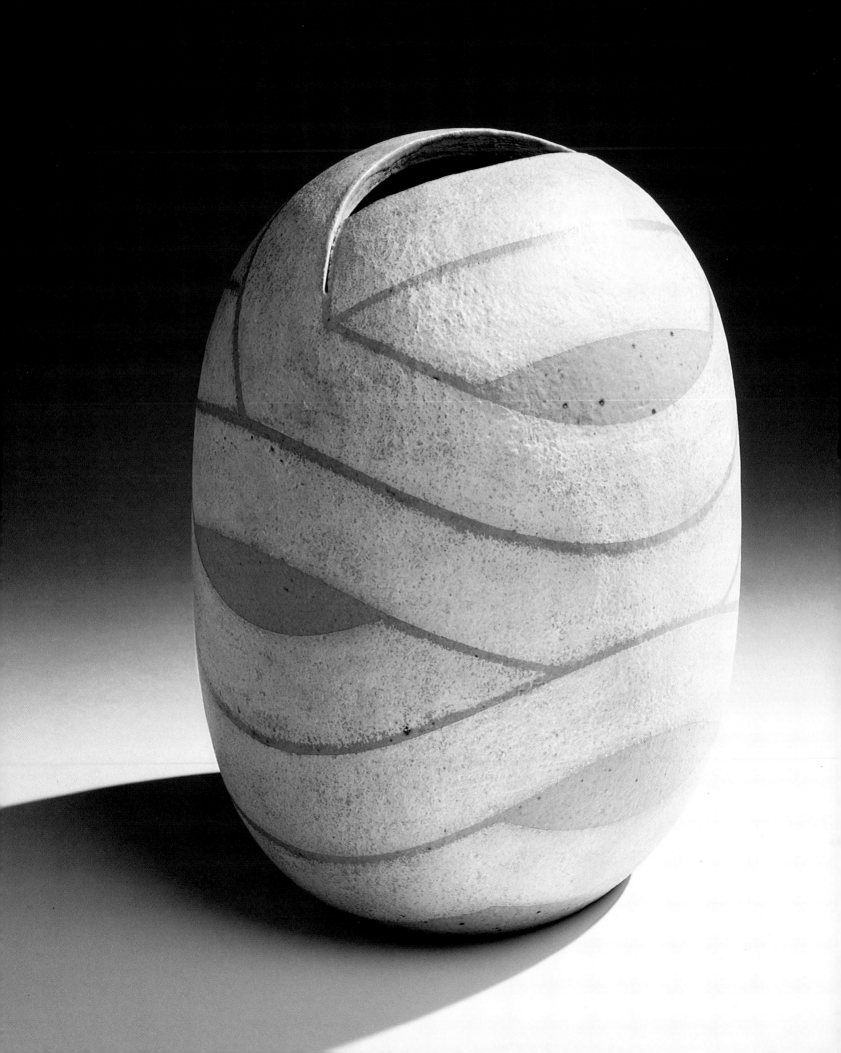

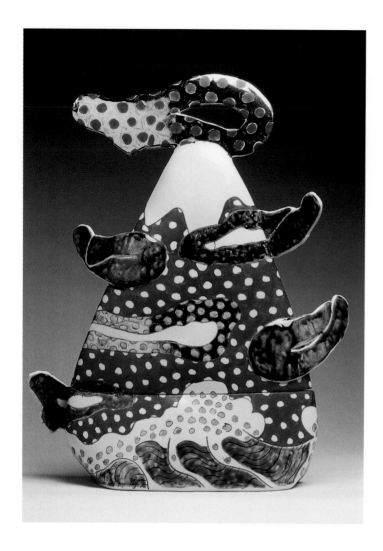

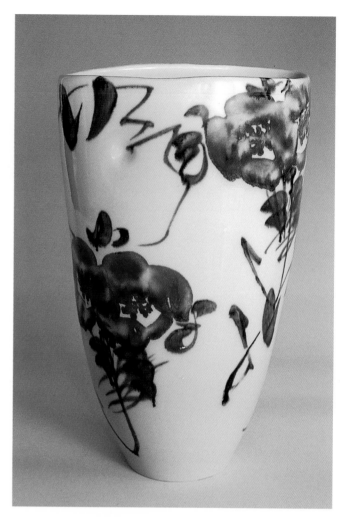

above
Yuriko MATSUDA, Japan
Mount Fuji with Clouds, **16 x 6 x 20 in**
(40 x 16 x 52 cm)
Press-moulded porcelain, overglaze, enamel,
reduction fired

above right
QIN Xi Lin, China
Spring in Air, **ht 14 in** (35.5 cm)
Porcelain, copper and cobalt engobe, clear glaze,
reduction fired

right
Ingegerd RÅMAN, Sweden
Cups and bowls, **3–6 in** (7.5–15 cm)
Earthenware, black glaze

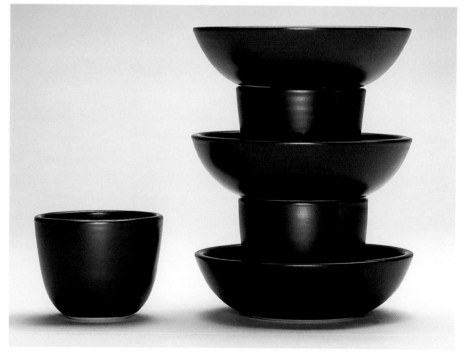

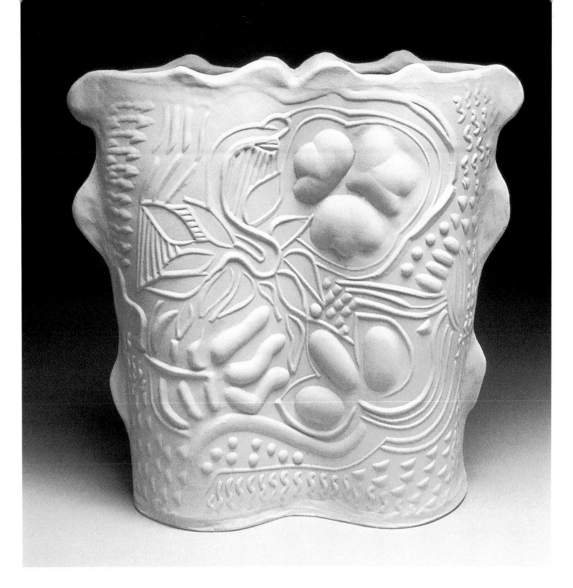

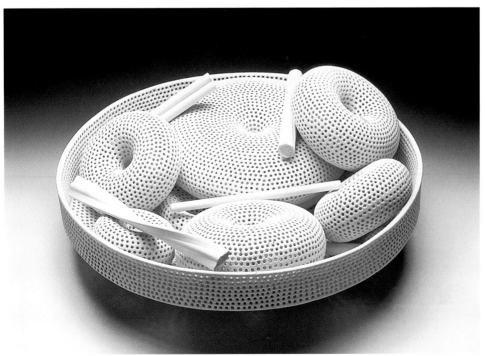

Dora DeLARIOS, USA
Pot, 12 x 13 in (30 x 33 cm)
Porcelain, slab-built, carved

Tony MARSH, USA
Perforated Vessel, 7 x 20½ in (18 x 52 cm)
Earthenware

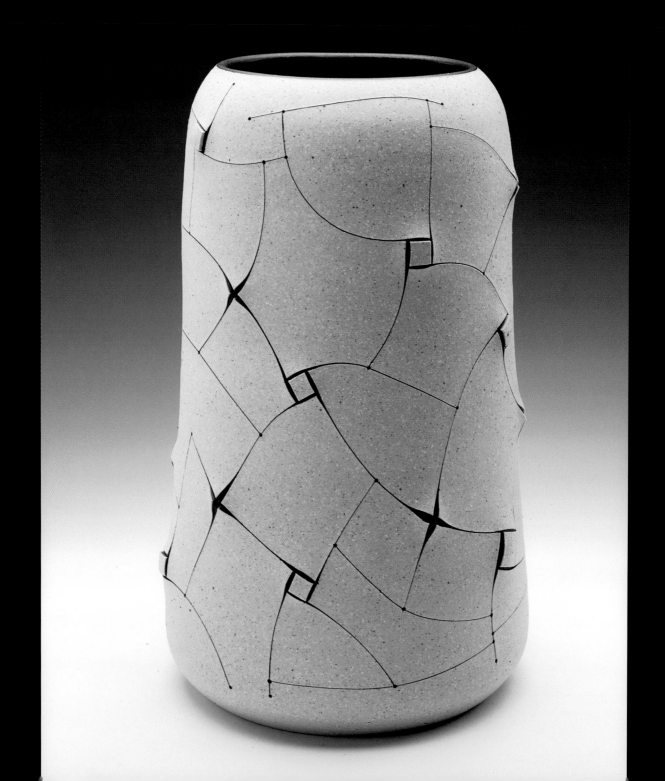

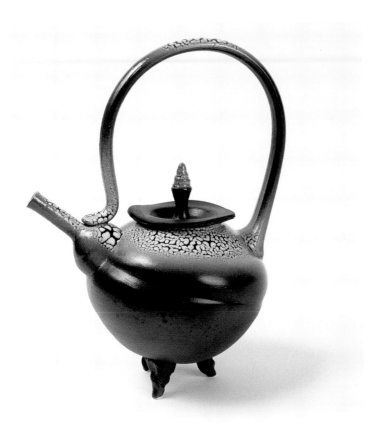

above
Don DAVIS, USA
Teapot, 12 x 8 x 5½ in (30 x 20 x 14 cm)
Porcelain, crawled engobe over glaze

right
Tom COLEMAN, USA
Anxietea, 21 x 13 x 5 in (53 x 33 x 13 cm)
Porcelain, stains

opposite
Gustavo PEREZ, Mexico
Untitled Vase, 11¼ x 7¼ in (28.5 x 18 cm)
Stoneware, incised engobe

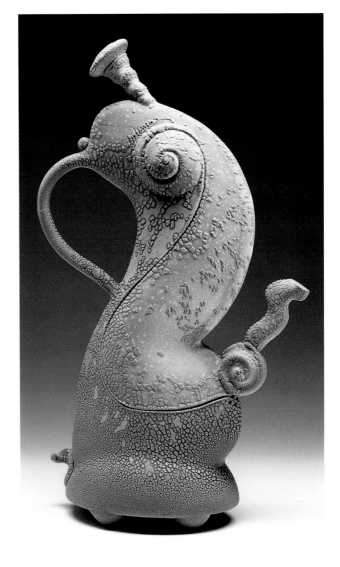

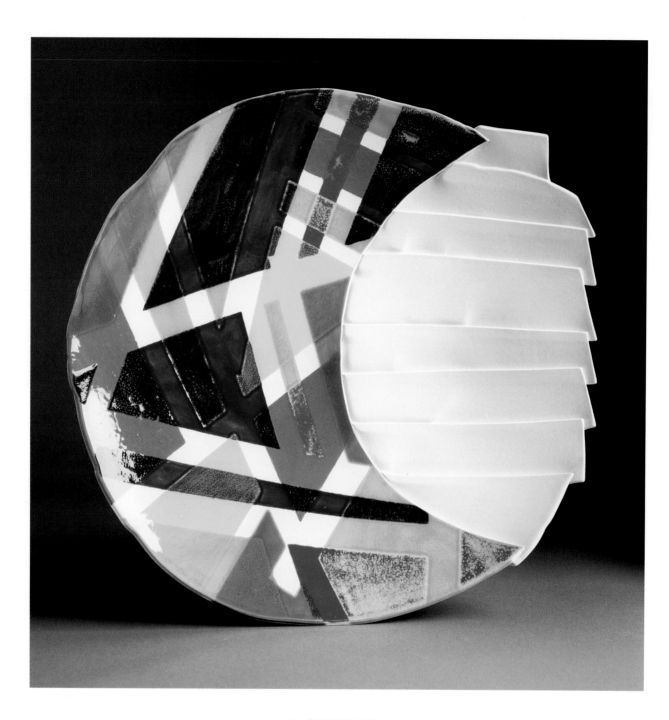

Jan PETERSON, USA
City Streets, 18 x 18 x 3 in (46 x 46 x 7.5 cm)
Porcelain bisque, low-fire glazes

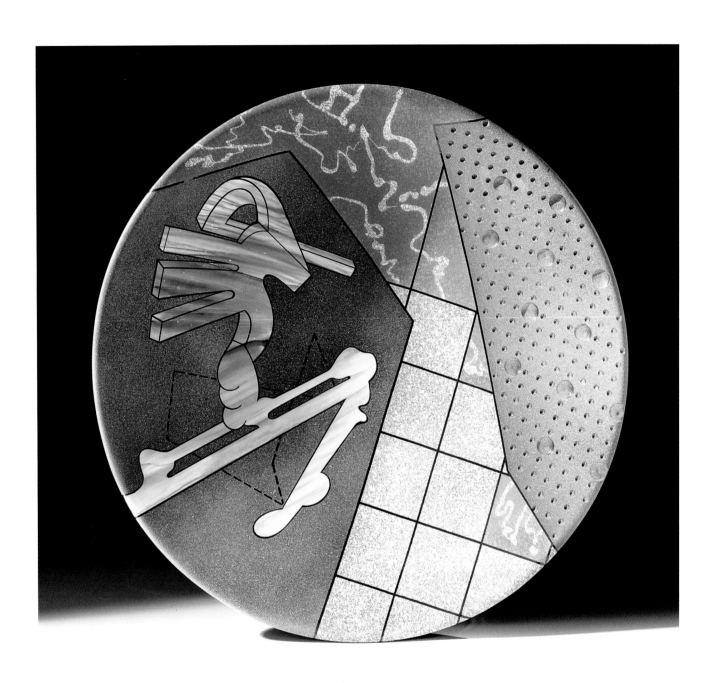

John W. HOPKINS, USA
Plate, dia. 23 in (58 cm)
Earthenware, underglaze, glaze, china paint, sandblasted

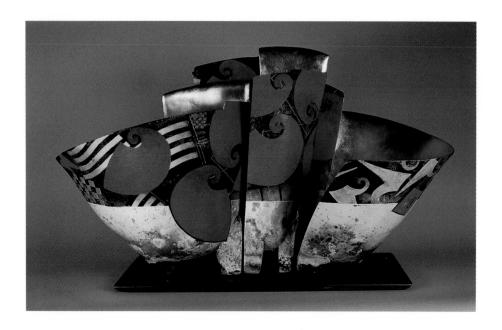

Bennett BEAN, USA
Triptych, **18 x 31 x 18 in (46 x 79 x 46 cm)**
Earthenware, pit-fired, acrylic paint, gold leaf

Ron NAGLE, USA
Fade to Tracy, **4¹/₂ x 6¹/₄ x 3¹/₂ in**
(11 x 16 x 9 cm)
Earthenware, overglaze colours

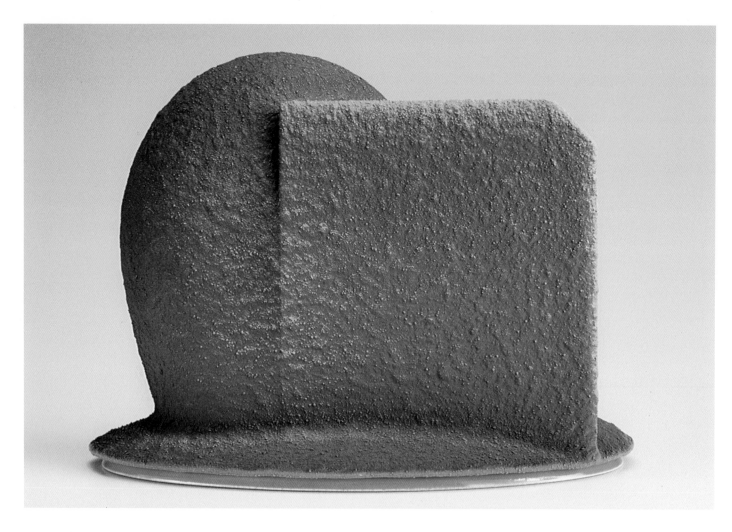

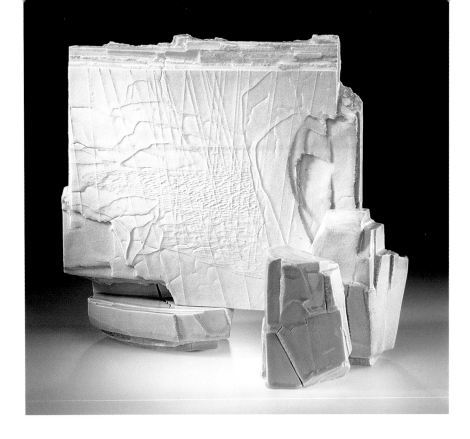

Wayne HIGBY, USA
Lake Powell Memory – Rain, **17³/₄ x 19¹/₂ x 12¹/₄ in**
(45 x 49.5 x 31 cm)
Porcelain, glazed, reduction fired

Elisabeth von KROGH, Norway
Vessels, **21 x 25 x 10 in (53 x 63.5 x 25 cm)**
Earthenware, engobes

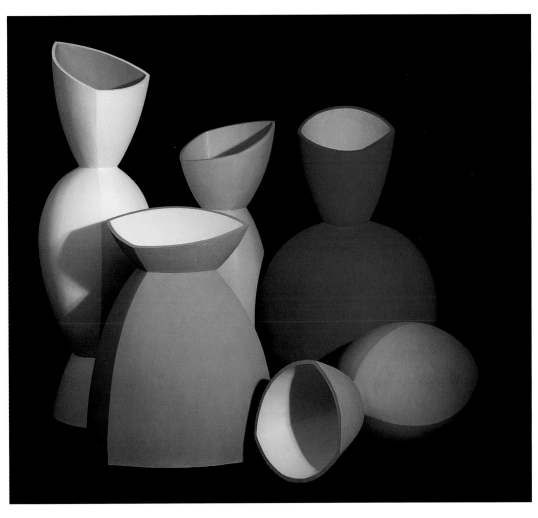

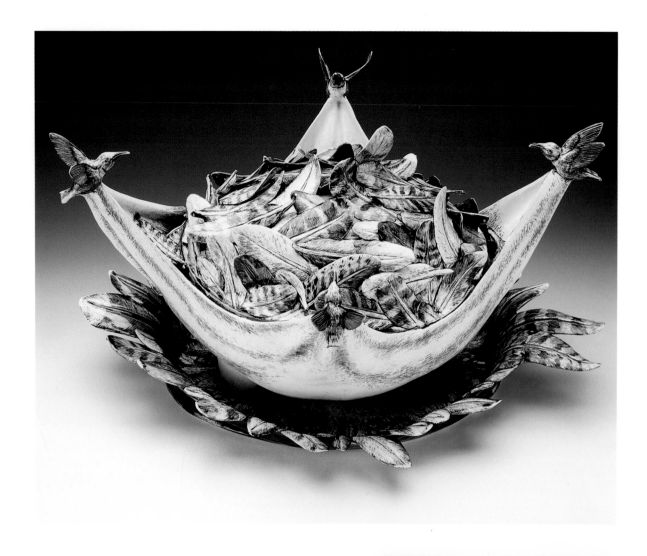

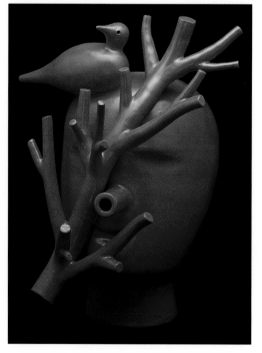

David REGAN, USA
Untitled, 12 x 22 in (30 x 56 cm)
Porcelain, oxide drawing

Stan WELSH, USA
Red Head, 32 x 16 x 15 in (81 x 41 x 38 cm)
Earthenware, satin matt glaze

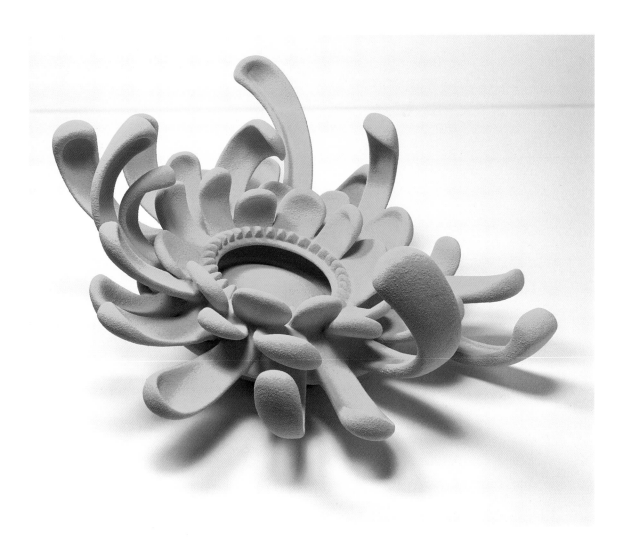

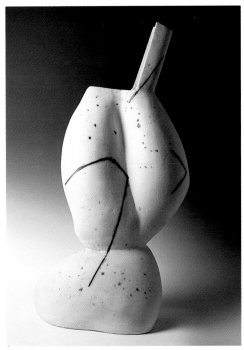

Barbara NANNING, The Netherlands
Flower, 31½ x 29½ x 16 in (80 x 75 x 40 cm)
Earthenware, glaze

Gordon BALDWIN, UK
Untitled Pot, ht 10 in (25 cm)
Stoneware, engobes

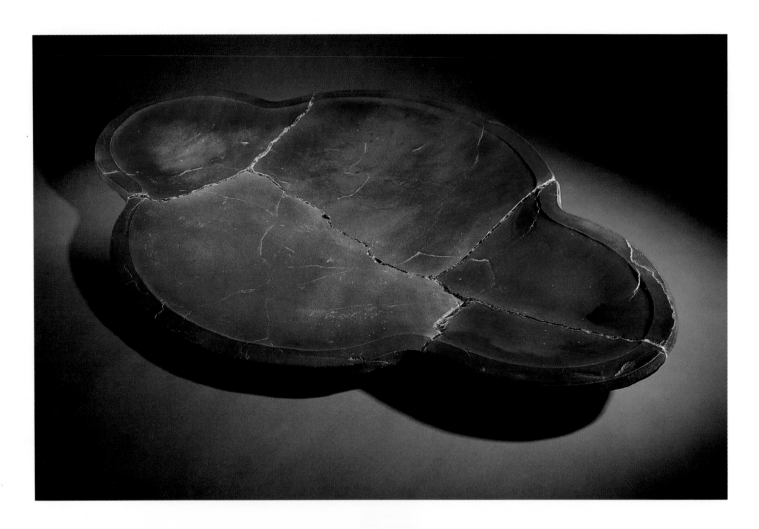

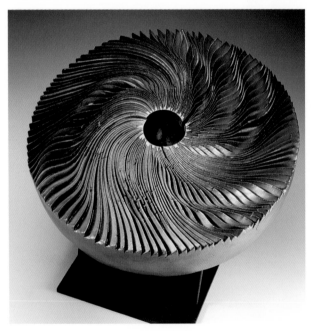

Nazare FELICIANO, USA
Sanctuary, 78 x 54 in (198 x 137 cm)
Earthenware, gold leaf over lapiz-blue glaze

Marc LEUTHOLD, USA
Hemisphere, dia. 12 in (30 cm)
Carved stoneware, reduction fired

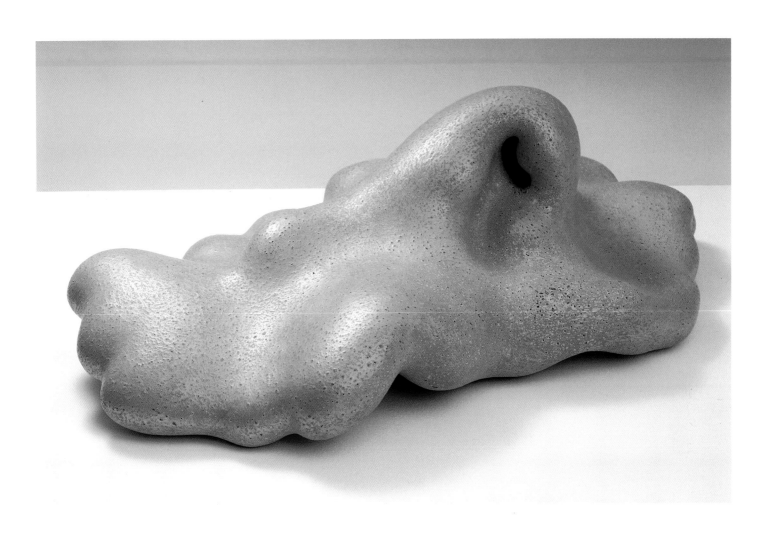

Ken PRICE, USA
Prone, 9¹/₂ x 28¹/₂ x 18¹/₂ in (24 x 72 x 47 cm)
Acrylic on fired clay

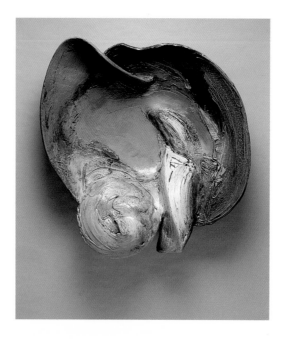

Susanne G. STEPHENSON, USA
Dusk VI, 8¹/₂ x 27¹/₂ x 26 in (21.5 x 70 x 66 cm)
Earthenware, engobes

Alexander ZADORIN, Russia
White Nude, 17 x 38 x 9 in (43 x 96 x 23 cm)
Stoneware

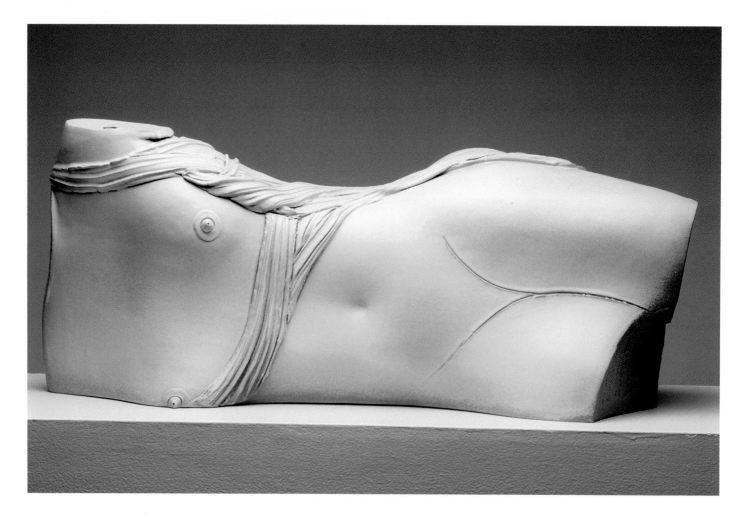

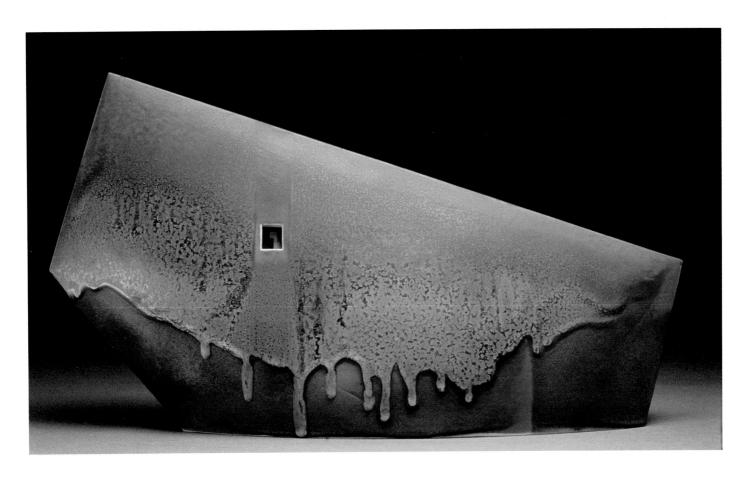

Yih-wen KUO, USA
Eternal Home, 14 x 25 x 5 in (35.5 x 63.5 x 13 cm)
Earthenware, glaze

AH-Leon, Taiwan
Tree Trunk Teapot, 14 x 23 in (35 x 58 cm)
Carved stoneware, reduction fired

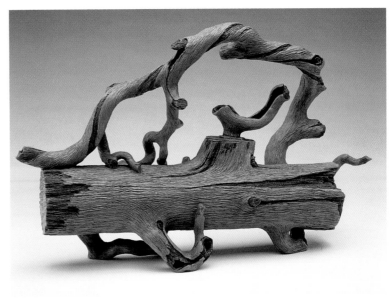

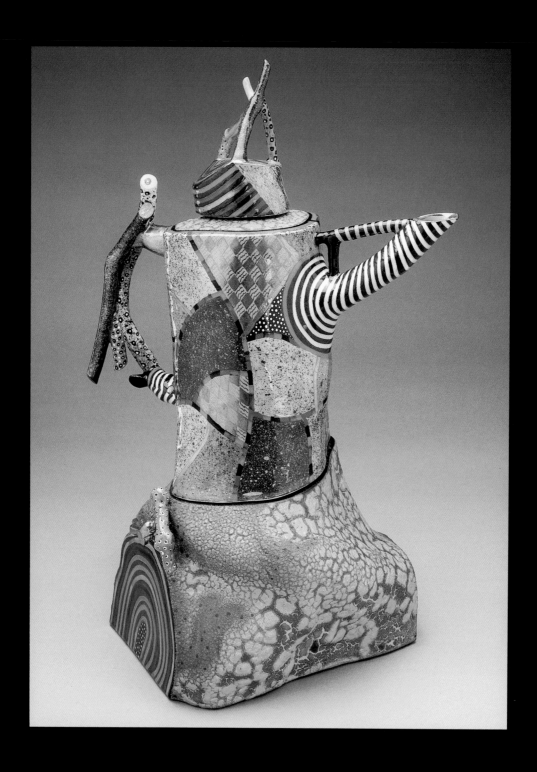

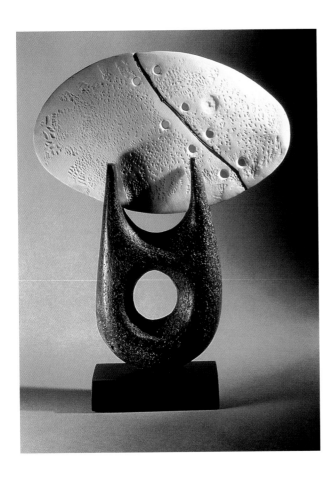

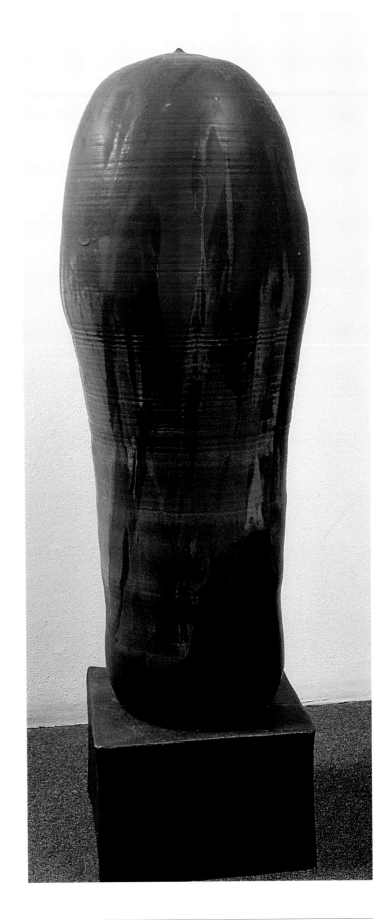

above
Peter HAYES, UK
Mounted Form, ht 12 in (30 cm)
Bone china (porcelain)

right
Toshiko TAKAEZU, USA
Untitled (Makaha Blue),
47¹/₂ x 17¹/₂ in (121 x 44 cm), base 11 x 16¹/₄ x 16 in
(28 x 41 x 41 cm)
Porcelain, reduction fired

opposite
Ralph BACERRA, USA
Teapot, ht 16¹/₂ in (42 cm)
Cast earthenware, engobes, overglaze, lustres

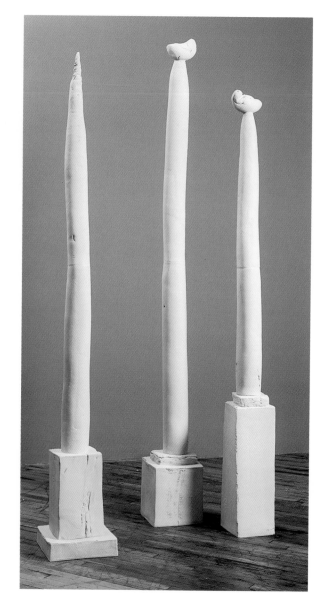

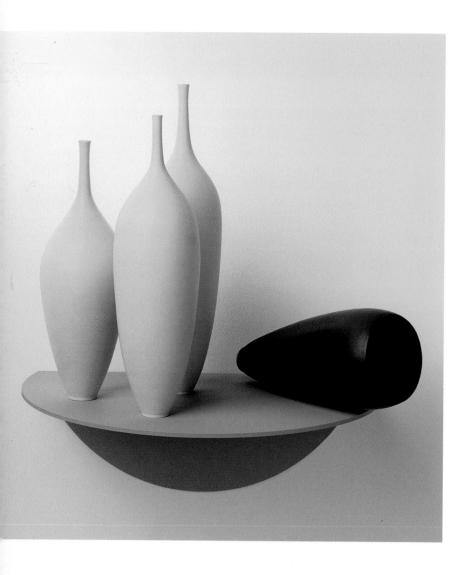

above
Paula WINOKUR, USA
Markers, **each 8 x 10 x 12 in (20 x 25 x 30 cm)**
Porcelain

left
Elsa RADY, USA
Still Life No.55, **21 x 24 x 16 in (53 x 61 x 41 cm)**
Porcelain, oxidation fired, painted aluminium shelf

Ruth DUCKWORTH, USA
Untitled, 20 x 9^1/$_2$ x 4^1/$_2$ in (51 x 24 x 11 cm)
Porcelain, burnished

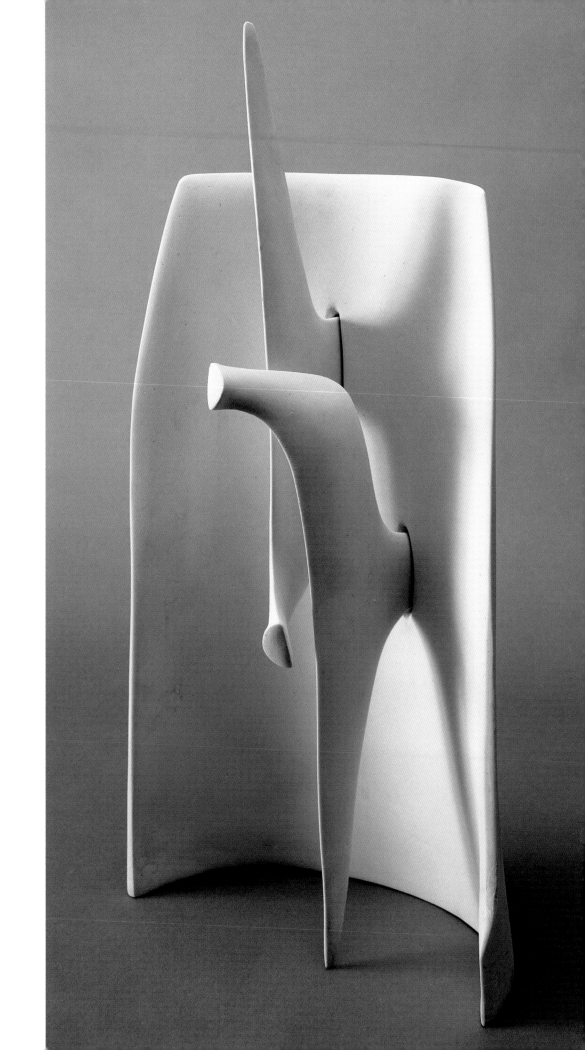

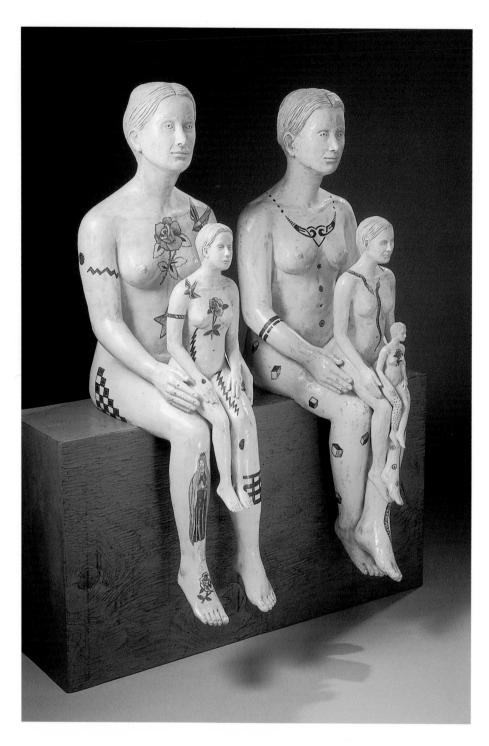

Marilyn LYSOHIR, USA
Tattooed Ladies, ht 30 in (76 cm)
Stoneware, oxides

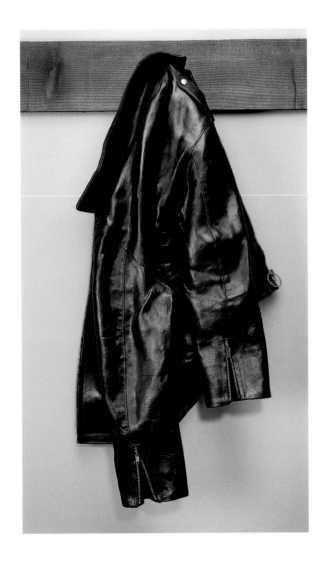

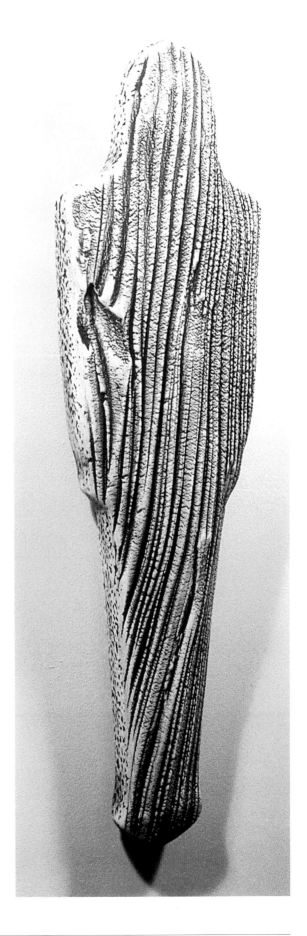

Marilyn LEVINE, USA
Elmer's Jacket, 35 x 19 x 7 in (89 x 48 x 18 cm)
Stoneware, zippers, pigments

Jeffrey MONGRAIN, USA
Mont Majour Figure, 44 x 12 x 6 in (112 x 30 x 15 cm)
Stoneware, engobes

architecture and installation

FROM MAN'S EARLIEST BEGINNINGS, red or buff common surface clay, found everywhere, was used to make the vessels, water pipes, dwellings, burial urns and watchtowers utilized in daily existence. Architecturally, clay was always a good choice. Properly compounded with other materials and properly fired to a correct temperature, clay products have high structural strength, are not affected by weather, will not disintegrate in water, fire or space, and will withstand the ravages of centuries. As societies progressed, decorative floor and wall tiles and other housing embellishments resulted from better firing techniques and the development of glazed surfaces.

In Africa, India and elsewhere, whole houses were constructed like coil-built or slab-built pots from a sticky adobe-type clay that could bake to hardness in the sun, and would dissolve only after a series of heavy rains. Many of these dwellings were therefore built in areas with little rainfall. Usually the huts were decorated with rice paste, or a calcium slurry, or natural clays; in the Nebele area of Africa the exceptionally beautiful decorations were concocted from ground gemstones, boiled plants and coloured clays.

This ancient heritage gave rise to a magnificent decorative tradition. During the Renaissance period, the Della Robbia family's ceramic workshops made medallions and wall plaques that adorned many of the buildings in Italy. In Persia and other Islamic regions the splendid brick structures of mosques were covered with earthenware glazed tiles brushed with cobalt and copper blues. The Alhambra in Granada, the Blue Mosque in Istanbul, the Friday Mosque in Isfahan are famous for their ceramic decorative schemes.

Stone sculptures from pre-history were used to enhance parks and building façades, line the way to cemeteries, or denote a town's headquarters. In many cases stone was replaced by ceramic, notably in China, where ceramic sculptures decorated temples, houses and the gates to the cities. For a modern example of this, visit Barcelona to see the houses and apartment blocks covered by the fantastic mosaics and tiles of Antoni Gaudí.

In the United States between 1930 and 1960 Gladding-McBean, a company founded in the nineteenth century in California but no longer extant, dry-pressed the largest clay tiles in the world, 36 inches square, for use on building façades. Today huge tiles are fabricated from a non-

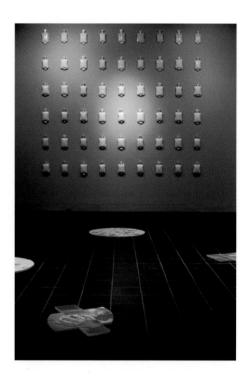

Katherine L. ROSS, USA
Prophylaxis/Hygiene, **each tile**
8 x 8 x 1 in (20 x 20 x 2.5 cm)
Porcelain

Nancy JURS, USA
Rochester International Airport,
18 x 16 ft (5.5 x 5 m)
Stoneware with oxide patina

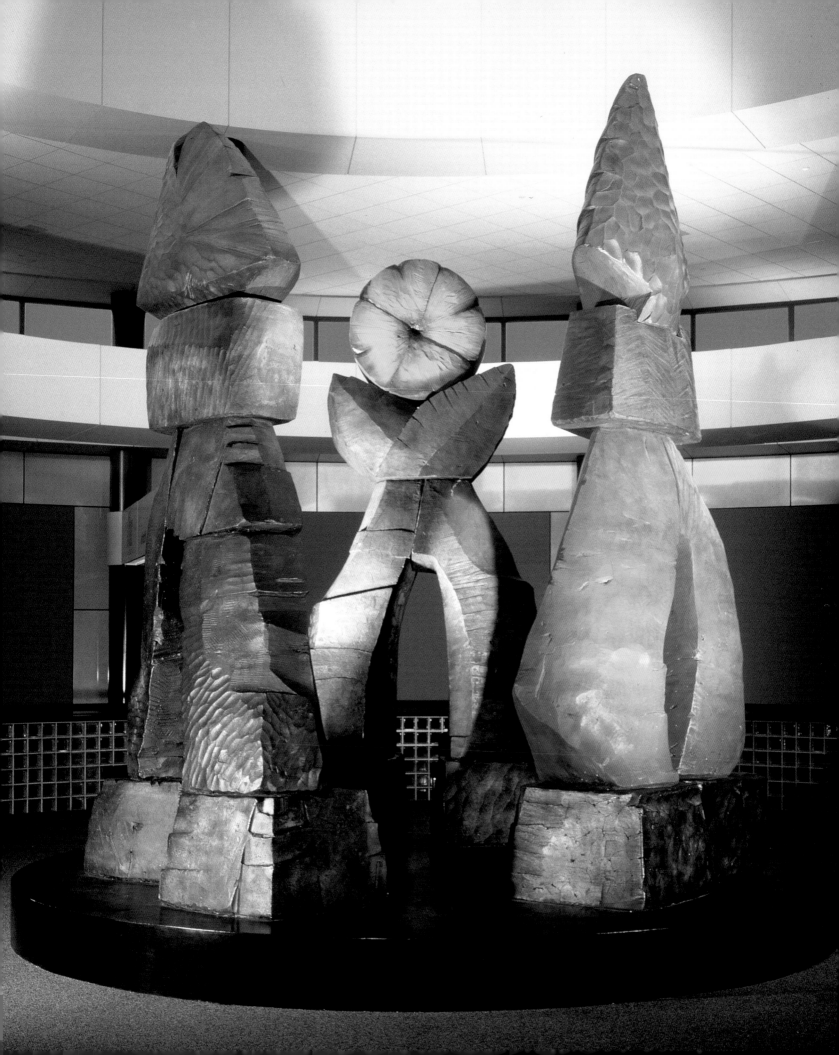

shrink clay body, glazed and fired at the Otsuka Factory, Shigaraki, Japan. No other factory in the world has managed to make such enormous ceramic tiles. Otsuka has an artist-in-residence programme.

After the Second World War, the newfound ability to create large works and to fire them in huge gas or electric kilns enabled ceramic artists to begin again to decorate the insides and outsides of commercial buildings. Fired clay is one of the strongest building materials, especially when reinforced with steel, but ceramics are not used for structures in today's industrialized societies. Although clay buildings could be fired and glaze-decorated in one operation, and never need painting or repair, this is not an architectural norm. It remains for the ceramic artist to imply architectural ideas in sculpture, or add them on to buildings.

Installation is a rather new term, and is in my view an outgrowth of architectural scale and advanced techniques made possible with the innovative equipment of the 1950s. Clayworkers are combining complex forms, sometimes with non-clay materials, for permanent installations – usually site-specific, or for short-duration exhibitions.

In clay, what has not been tried recently, even if it was practised hundreds of years ago, will be attempted anew today. The decorated porcelain walls and ceilings of the Palace of Versailles were installations in their own right, in their own time. New concepts are always added to old ideas.

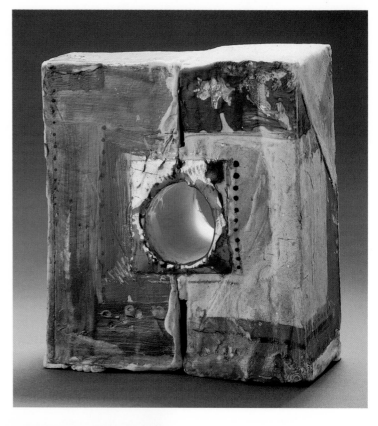

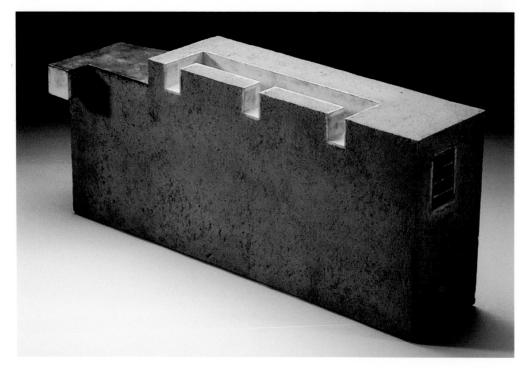

Jim DANISH, USA
Opening, 5 x 5 x 2½ in (13 x 13 x 6 cm)
Porcelain, engobes, gold lustre

Enrique MESTRE, Spain
Grey Rectangle with Three Notches,
31 x 14 x 10 in (79 x 36 x 26 cm)
Stoneware, oxides

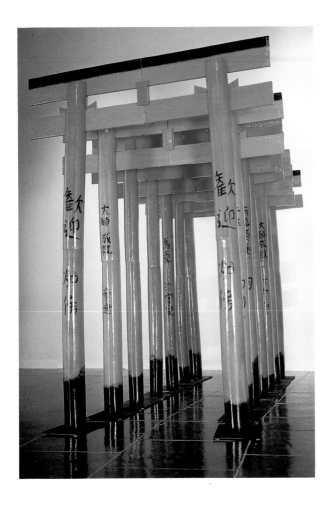

Roberta GRIFFITH, USA
Nezu Reflections, **7 x 5 x 11 ft**
(2 x 1.5 x 3.3 m)
Earthenware, glaze

Hans HEDBERG, France and Sweden
Cherries, **ht 60 in (152 cm)**
Earthenware, glazes

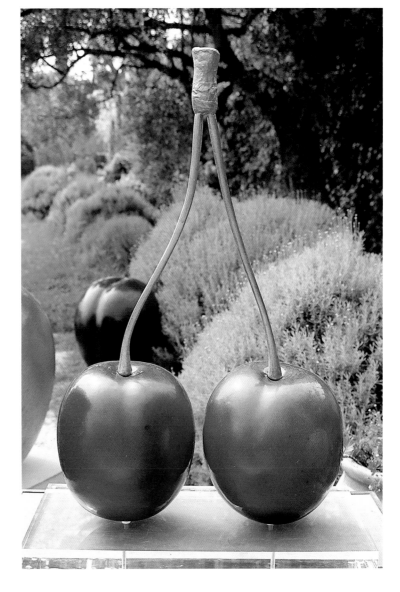

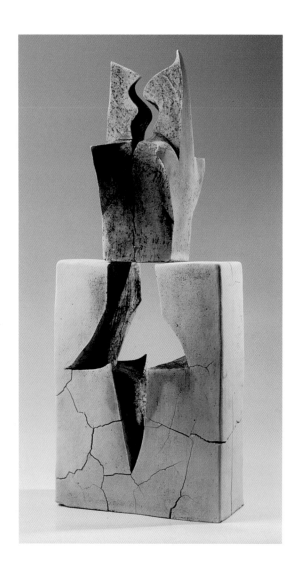

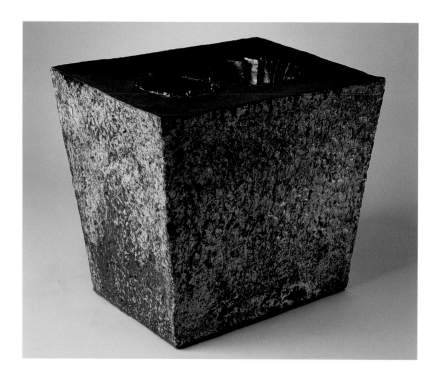

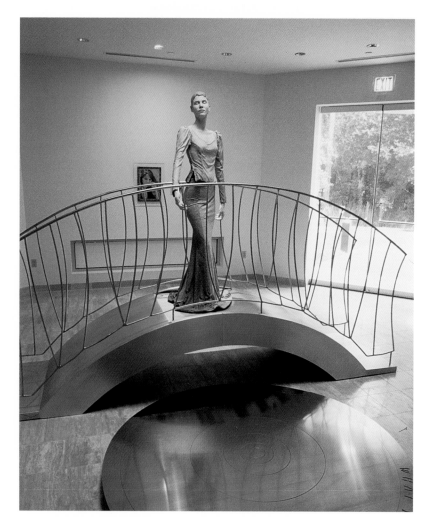

above
Dong Hee SUH, Korea
Talk with Moses and Elijah 2, **15 x 49 in** (38 x 124.5 cm)
Stoneware, glazes

above right
Paul CHALEFF, USA
Crucible with Two Negatives, **24 x 19 x 26 in**
(61 x 48 x 66 cm)
Glazed stoneware

right
Nan SMITH, USA
Guardian, **7 ft 8 in x 11 ft 6 in x 7 ft 8 in** (2.3 x 3.5 x 2.3 m)
Stoneware, steel, aluminium, wood

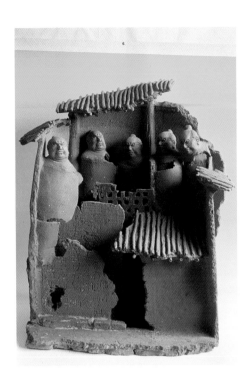

WANG Jian-Zhong, China
Eternity No. 2, 62 x 33 x 19 in (158 x 85 x 48 cm)
Stoneware, woodfired

Bruce DEHNERT, USA
Red Room, 19¹/₂ x 13 x 8 ft (6 x 4 x 2.5 m)
Earthenware, porcelain, stoneware, glazes

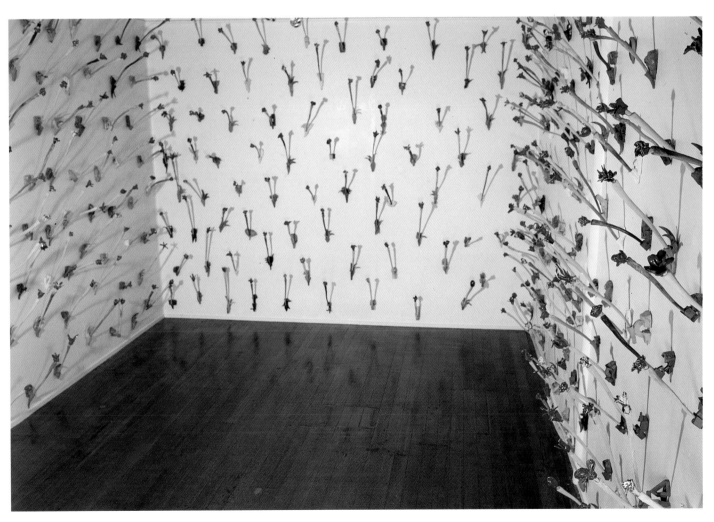

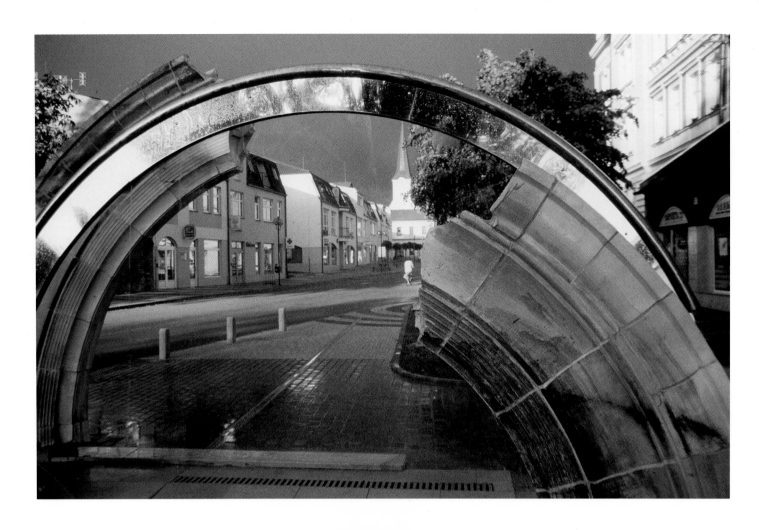

above
Vaslav ŠERÁK, Czech Republic
Rainbow Arch, 10¹/₂ x 21 ft (3.2 x 6.5 m)
Stoneware, glazed, stainless steel

left
Diane MANN, USA
Merom Arch, 36 x 36 in (91 x 91 cm)
Stoneware

opposite
Elisabeth LANGSCH, Switzerland
Hotel Widder Zürich: Fayence Relief, 23 x 5 ft (7 x 1.8 m)
Earthenware, glazes

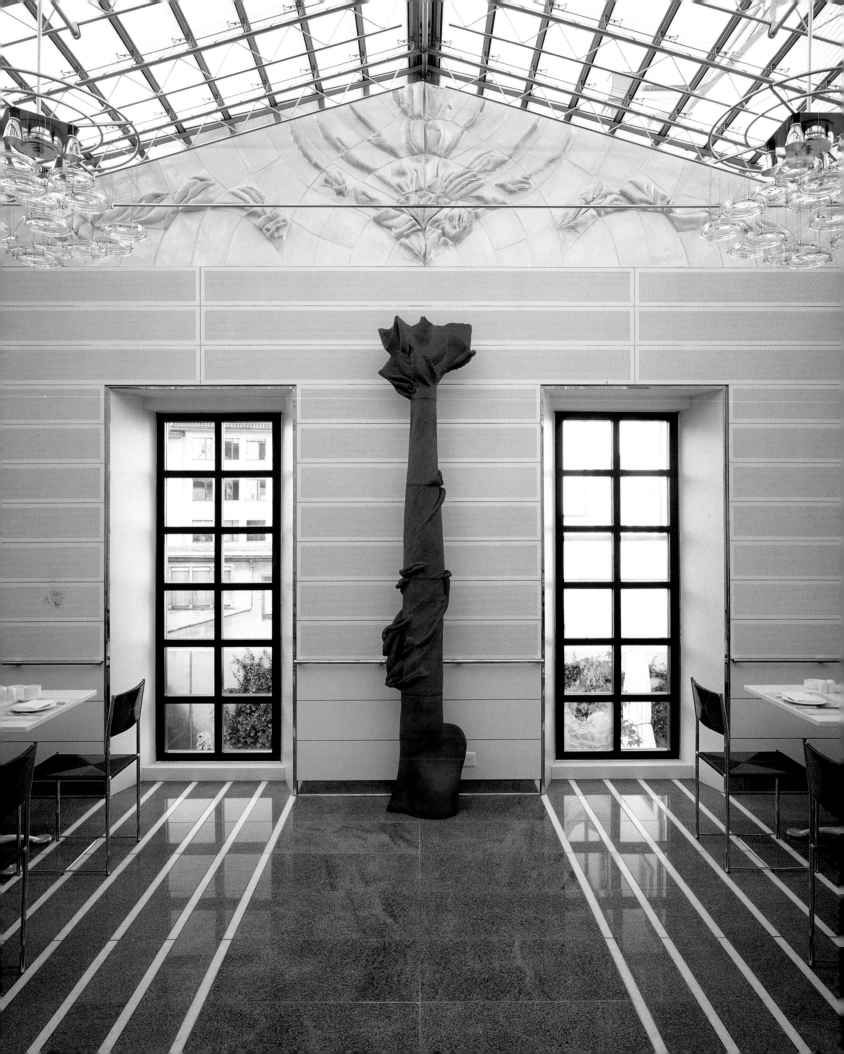

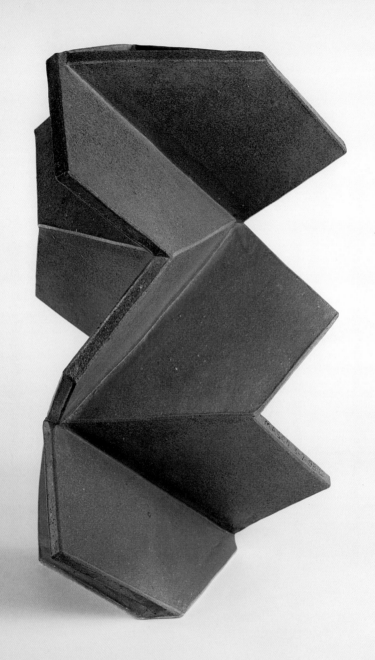

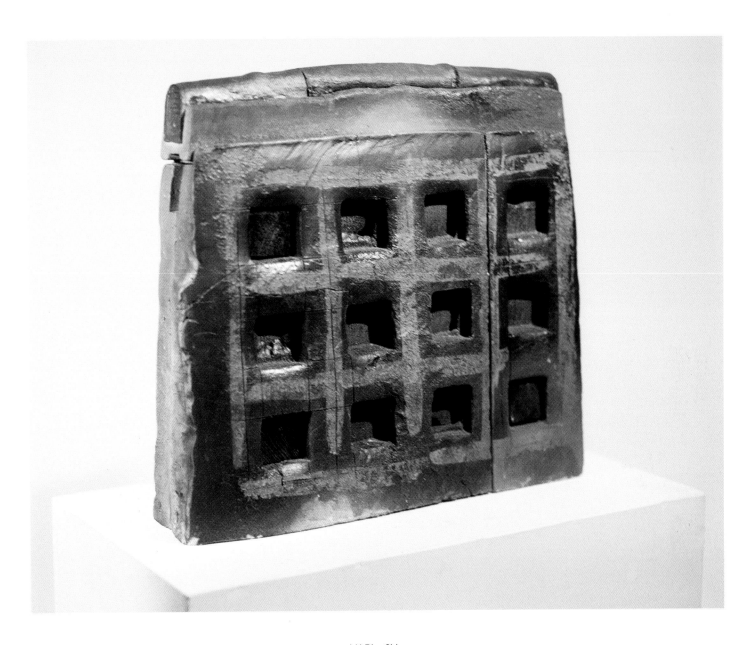

LU Bin, China
Brick Statement I, 21 x 20 x 6 in (55 x 52 x 16 cm)
Stoneware, woodfired

opposite
John MASON, USA
Triangular Torque, Blue/Green, 36 x 15 x 15 in (91 x 38 x 38 cm)
Stoneware, glazed, reduction fired

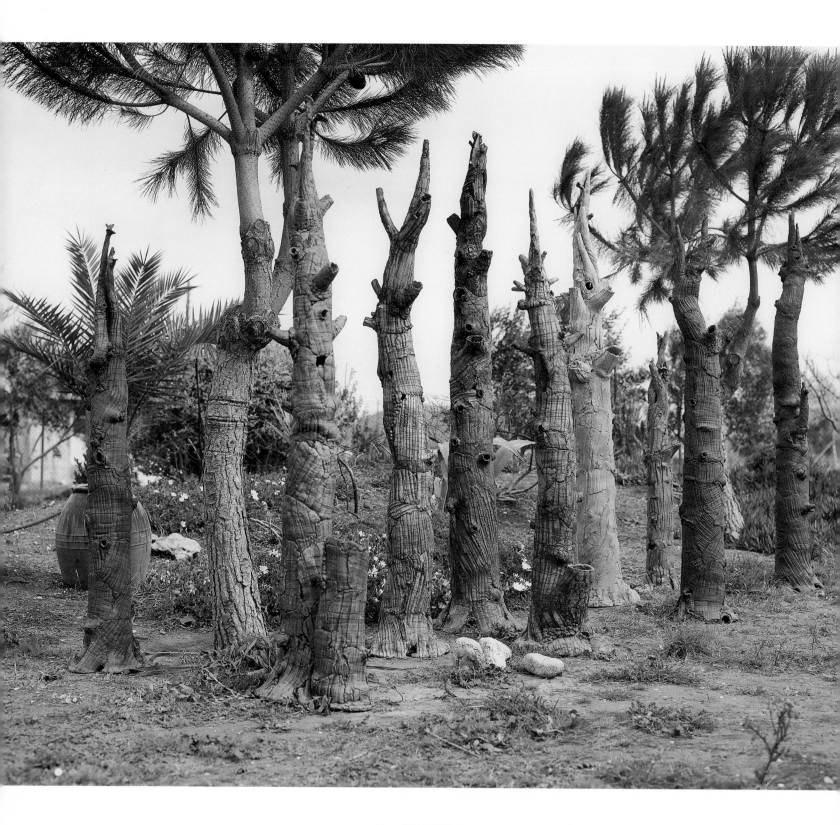

Maro KERASSIOTI, Greece
Inaro Kerassioti in the Forest, **15 trees**, ht 98 in (250 cm)
Stoneware and oxides

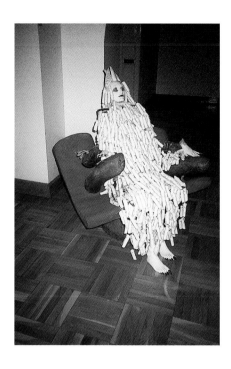

left
Anna MALICKA-ZAMORSKA, Poland
Seated Figure, **59 x 31½ x 26 in**
(150 x 80 x 67 cm)
Cast porcelain, gold, platinum

right
Grace WAPNER, USA
Fireplace without Mantel, **7 ft x 7 ft 8 in x 12 in**
(2.13 x 2.3 m x 30 cm)
Porcelain, plaster

below
Deborah HORRELL, USA
Passages: In Between, **9 x 6 ft x 1½ in**
(2.74 x 1.8 m x 4 cm)
Glazed stoneware

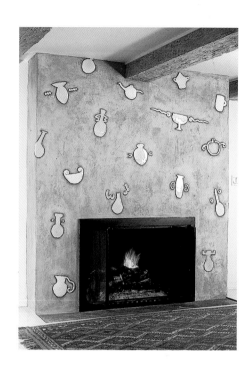

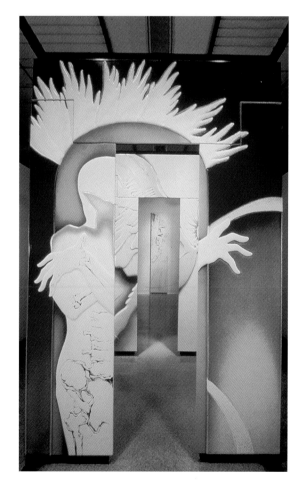

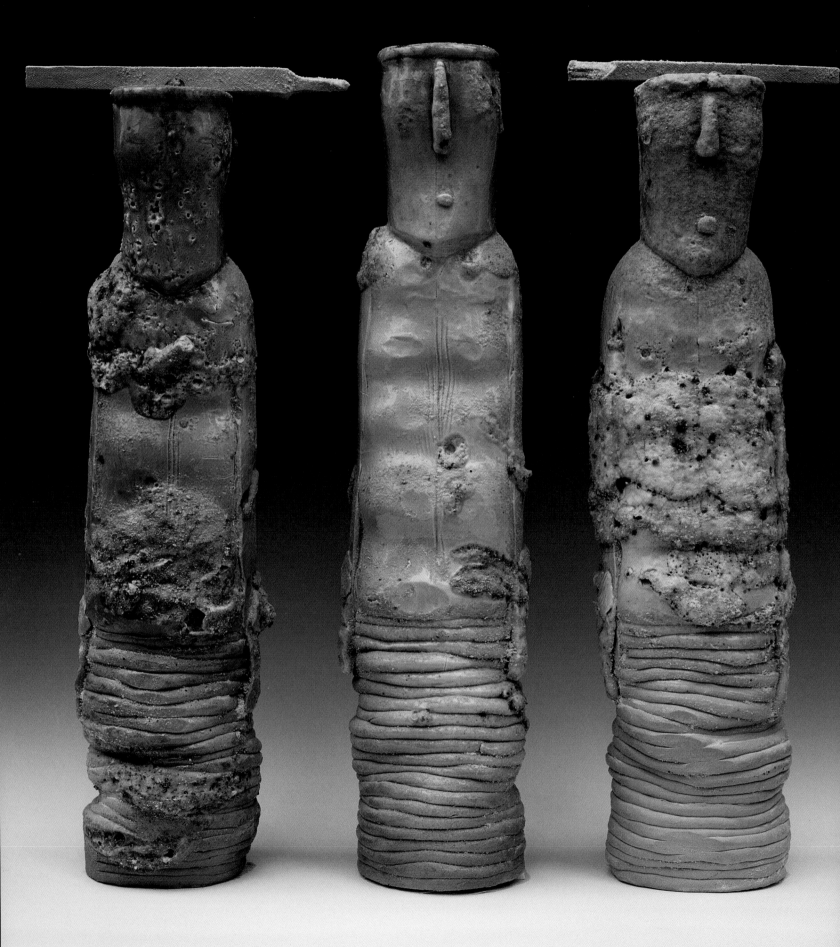

opposite
YAO Yong Kang
Group of Figures, **ht 30 in (76 cm)**
Porcelain, stoneware, woodfired

right
David SHANER, USA
Plateau, **20 x 8 x 3 in (51 x 20 x 8 cm)**
Stoneware

below
Lilo SCHRAMMEL, Austria
White Spiral, **36 x 10^1/$_2$ in (92 x 27 cm)**
Stoneware, porcelain, engobe

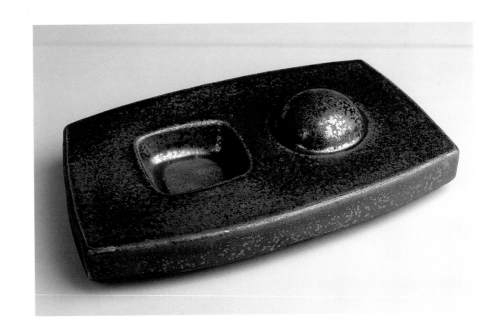

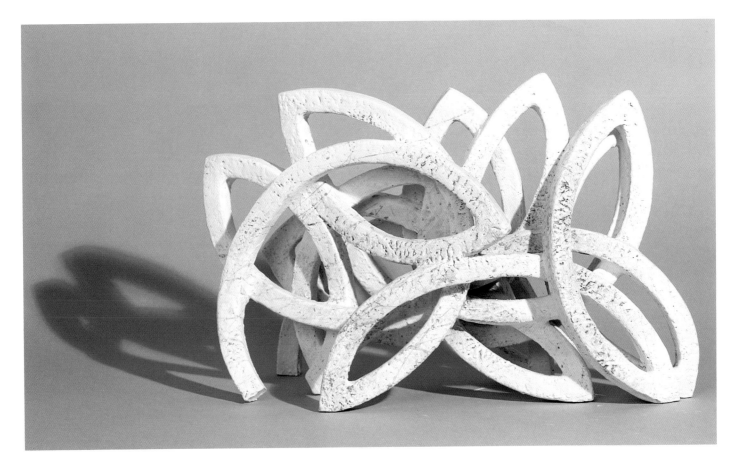

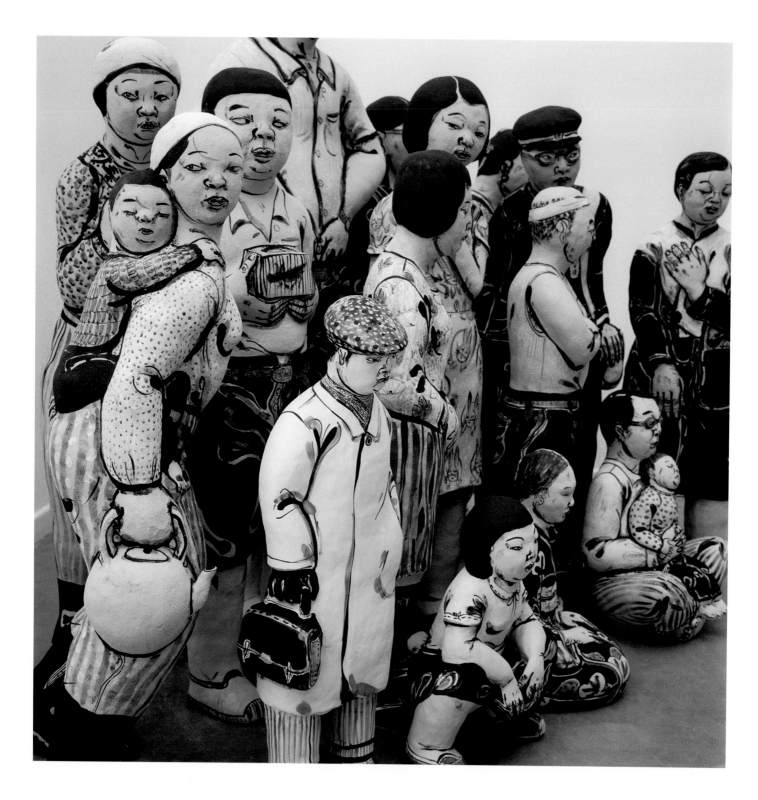

Akio TAKAMORI, USA
Clay Figures, ht 14–33 in (35.5–83 cm)
Porcelain, underglaze drawing

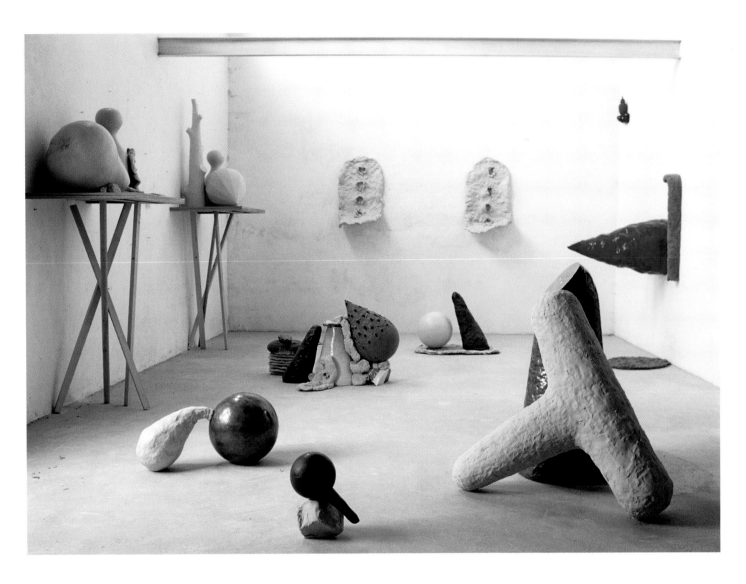

Anton REIJNDERS, The Netherlands
Status1, 2 and 3, ht 8 ft (2.4 m)
Stoneware, wood

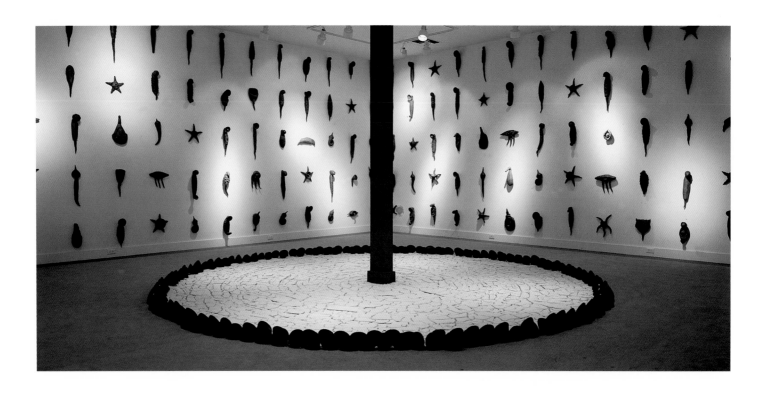

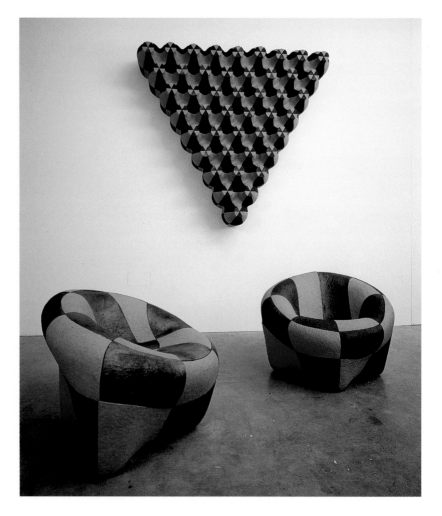

Sadashi INUZUKA, USA
Exotic Species, installation at Davis Art Center, Davis,
California, area 1000 sq. ft (93 sq. m)
Fired and unfired earthenware

Angel GARRAZA, Spain
Emblems, 52 x 57 x 13 in, 21 x 25 x 27 in
(132 x 145 x 34 cm, 54 x 64 x 68 cm)
Earthenware, oxides, reduction/oxidation fired

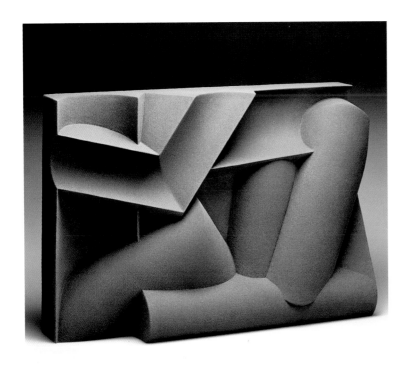

Anne CURRIER, USA
No. 2 Panel Series: Caress, **20 x 30 x 7 in**
(51 x 76 x 18 cm)
Glazed stoneware

John BALISTRERI, USA
Installation of Monoliths
Woodfired stoneware

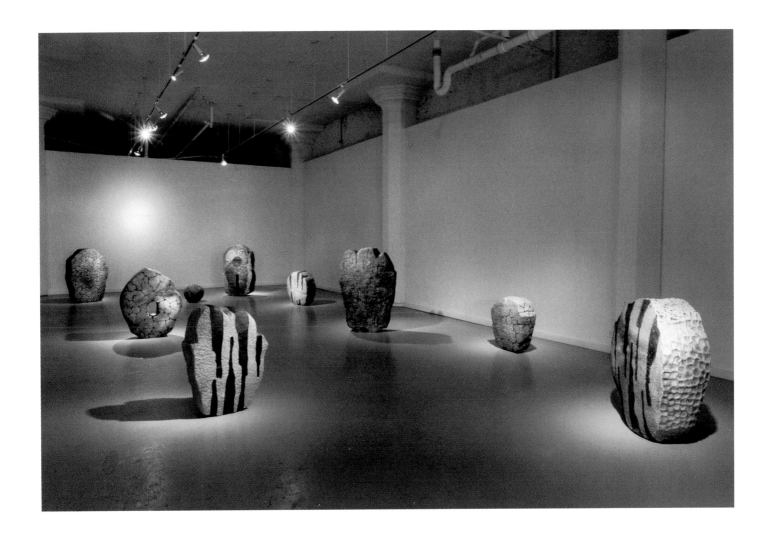

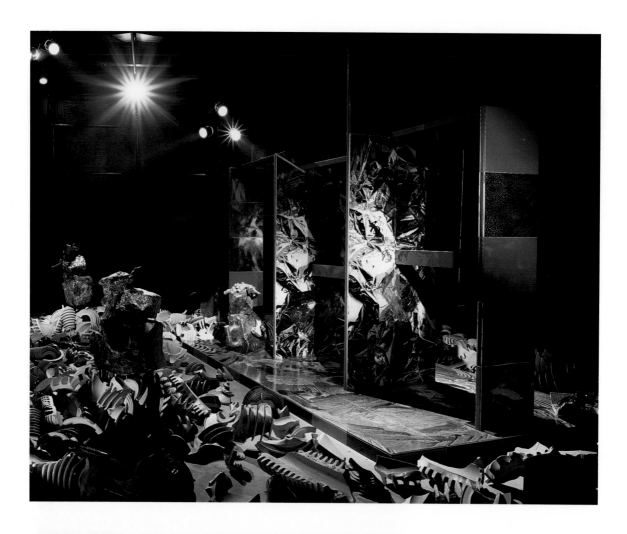

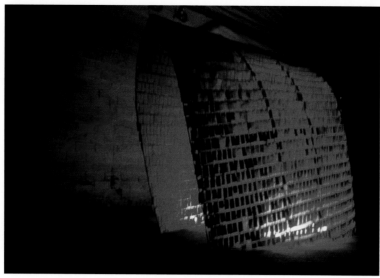

above
Kimpei NAKAMURA, Japan
Kitschy Recollection of
Momayama Aesthetics,
21 x 6 ft (6.4 x 1.8 m)
Stoneware, porcelain,
mixed media

left
Berry MATTHEWS, USA
Crucible, 7 x 5 x 8 ft
(2.13 x 1.5 x 2.43 m)
Clay, metal, neon

opposite
Mikhail KOPYLKOV, Russia
VitaNova, ht 62 in (158 cm)
Stoneware, grog, glazes

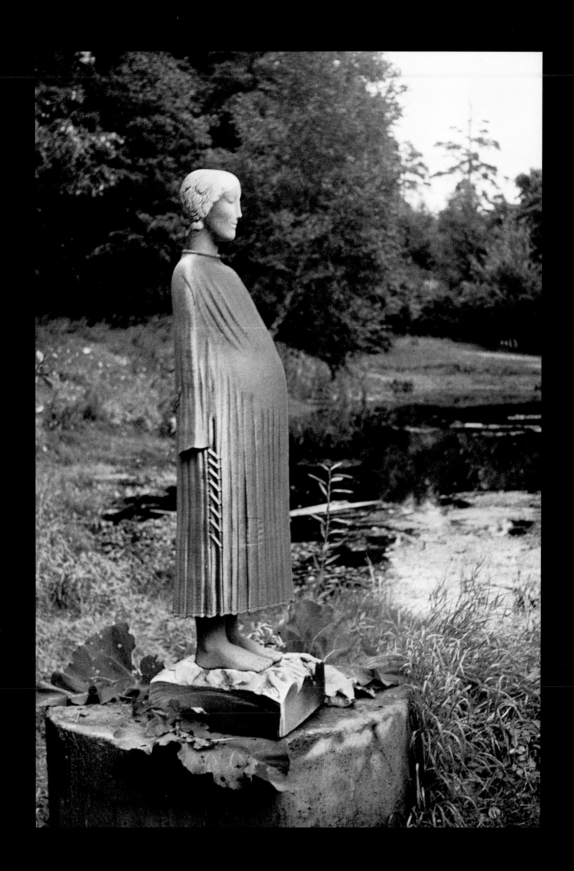

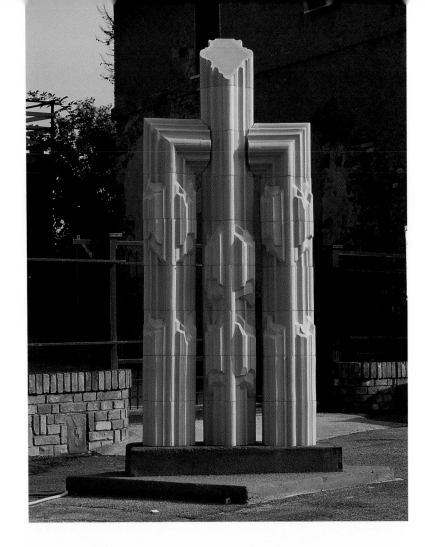

Nino CARUSO, Italy
Mediterranean Memory,
110 x 47 x 19¹/₂ in (280 x 120 x 50 cm)
Stoneware

VAEA, USA
Immédiats à l'état brut
(The Immediacy of the Raw State),
room-size
Raw clay, plaster, fibre, plastic,
sand, paint

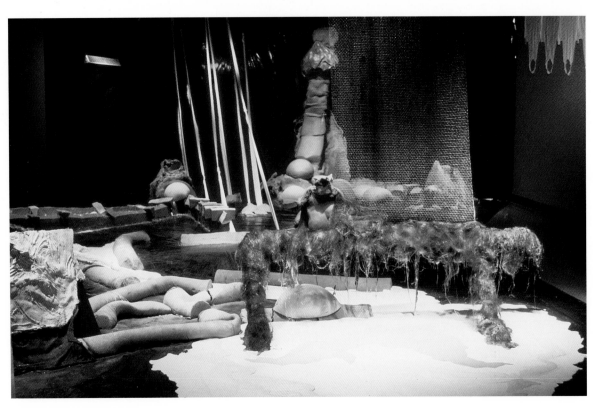

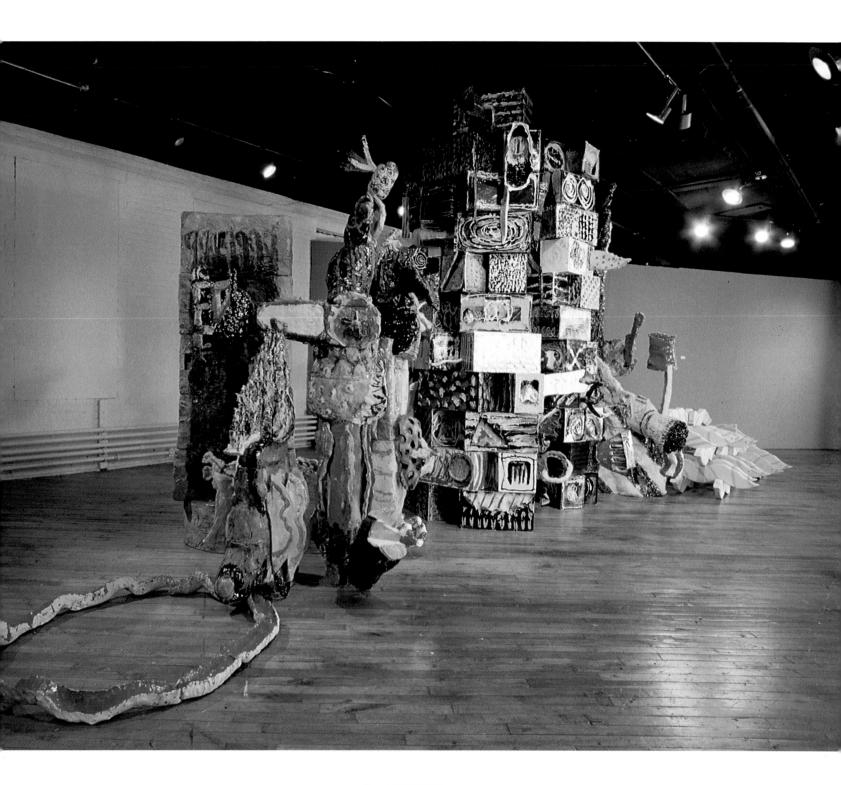

Albert PFARR, USA
Three Born, 39 x 12 x 12 ft (11.8 x 3.65 x 3.65 m)
Earthenware, stoneware, porcelain, mixed media

objects and non-objects

A GOOD POT, plain and simple, is hard to find when we are confronted with the wealth of experimentation in ceramic sculpture today. The vessel has been an integral part of functional and ceremonial use since the beginning of time. Some of the most beautiful wares were created thousands of years ago, and many are still being made in indigenous societies and in the traditional ceramic-making villages of China and Japan.

Throwing on the potter's wheel developed many centuries ago in Egypt and Mesopotamia, and eventually spread to most of the world, with the exception of North and South American Indian potters, who coil-build and have never used the wheel. In all societies very large vessels were put together with the throw-and-coil method, by coil and paddle, by joining previously thrown sections, or were made monolithically by coil or slab hand-building. These methods can still be seen in many parts of the world.

Making pottery or clay sculpture by hand is hard work, one of the most arduous – if not the most arduous – of all art media. The potter must find the clay and compose a clay body mixture that will do the job according to a preconceived idea, then fabricate the work, which often crumbles or cracks from its own weight or imbalance or from being dried too fast; then he or she must go on to decorate it with glaze, colour or other techniques; later come the lengthy vigils at the kiln during the firing and cooling cycles. In the end all may be lost through an accident in the kiln, caused by some erroneous procedure during construction or by improper firing.

The ancients had their own problems; they had to deal with prospected natural materials, which are never the same twice from mother earth, and an open fire or a primitive enclosure for the necessary heat. Today's clayworkers with access to ceramic suppliers and refined materials have similar difficulties determining which materials, which kilns, which firing schedules are the most appropriate.

In Europe functional pottery has a glorious history, from Greek and Roman ware to the brightly coloured peasant wares of medieval times, the engobe-decorated earthenwares of Spain and Italy and the porcelains of eighteenth-century Germany, France and England. Vestiges of tradition can be seen today in the Mexican and South American earthenwares on sale in street markets, the storage and cooking vessels made all over India and Africa, and the folk pottery still produced in Asia. In America, hand-

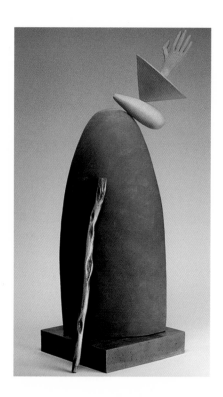

Curtis HOARD, USA
Figure with Stick,
68 x 26 x 22 in
(173 x 66 x 56 cm)
Earthenware, engobes, glazes

John MALTBY, UK
Sloping Oval Pot with Handle,
ht 6 in (15 cm)
Stoneware, low-fire colour

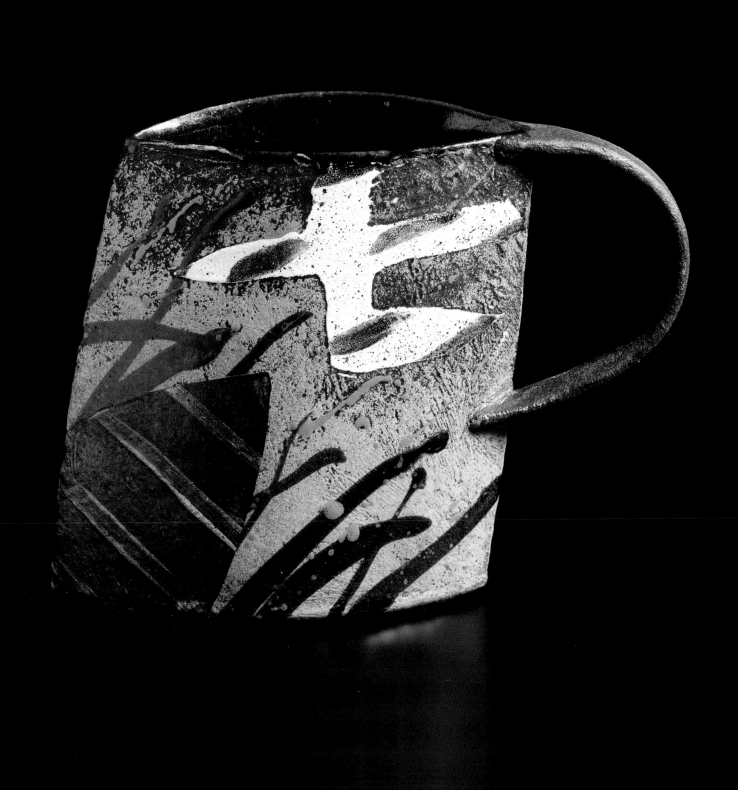

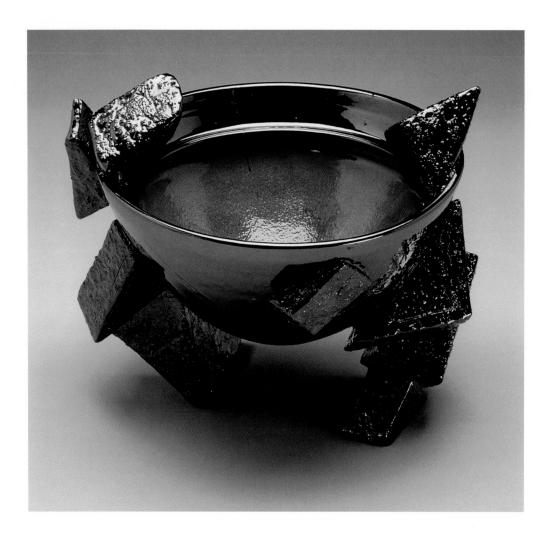

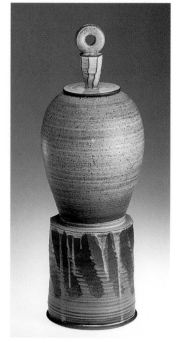

potteries were founded on the East Coast following the colonization by Europeans in 1620. Some of these early American traditions still persist, especially the face-jugs and pots fired in the 'ground-hog' kilns of North and South Carolina, Georgia and Tennessee.

Historical traditions contrast with 'studio pottery', a term given in this century to the making of individual, one-of-a-kind works by a so-called artist or craftsperson in his or her studio. In the 1920s, impetus was added to this notion by the work of Bernard Leach in England and Shoji Hamada in Japan, but studio potters existed in other countries as well. Potters from many nations went to study or observe the masters. After the Second World War potters everywhere were teaching students of all origins.

Artists who are today committed to vessel-making for functional or decorative use continue to labour side by side with clayworkers who cut, slice, expand and dislocate the vessel, making it a non-functional object that can be called sculpture, referential and conceptual. Sometimes, surprisingly, such objects and non-objects find their way into art galleries and museums and may command large prices. The world art market has developed sophistication.

The struggle now seems to be to find a difference, any difference, from what has gone before. Following the ceramic explosion of the 1950s, embellishment on the themes established by Voulkos, Price, Mason, Soldner and their circle has been expanded by the following generations up to the 1990s. No more breakthroughs are discernible, and it may not be possible to top what has been done in claywork in the second half of the twentieth century.

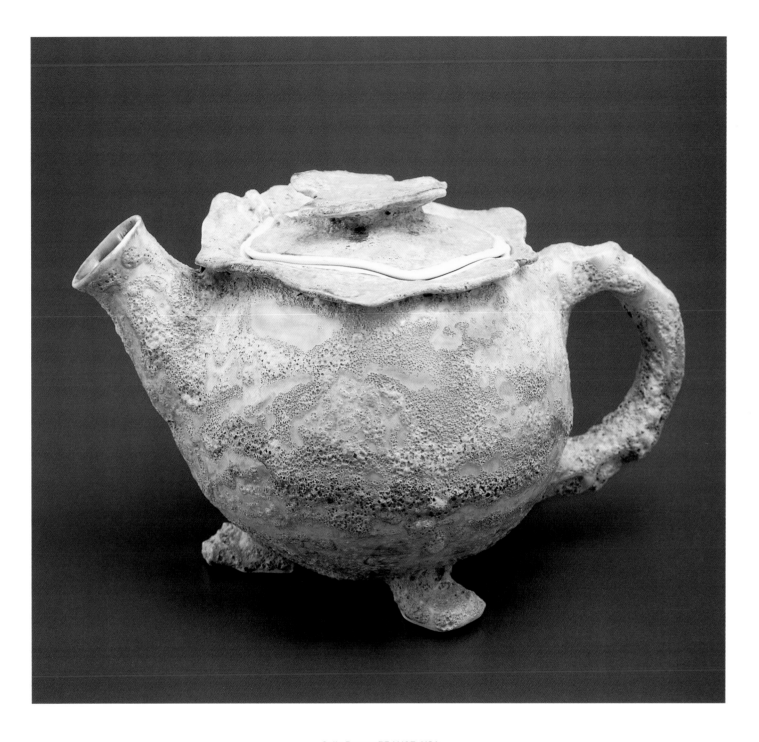

Sally Bowen PRANGE, USA
Barnacle Teapot, 6 x 11 x 6½ in (15 x 28 x 16 cm)
Stoneware, silicon carbide

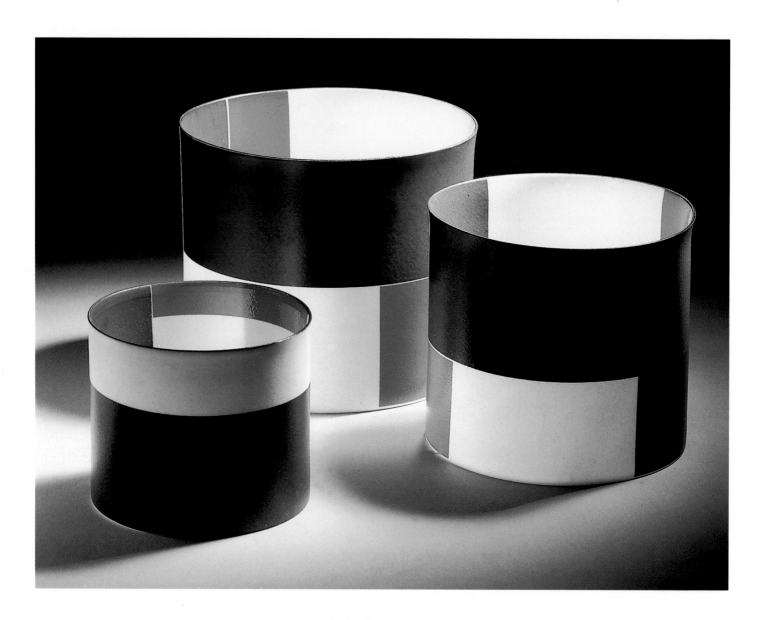

Bodil MANZ, Denmark
Three Vessels, ht 3¹/₂–5¹/₂ in (9–14 cm)
Porcelain, pigments

opposite
Elizabeth FRITSCH, UK
Flattened Vase, ht 11¹/₂ in (29 cm)
Stoneware, pigments

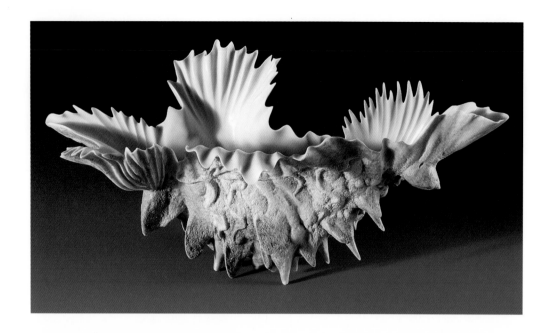

Elena KARINA, USA
Urn, 12 x 6 x 4 in (30 x 15 x 10 cm)
Porcelain, glazes

Karin BJÖRQUIST, Sweden
Bowls, 2³/₄ x 8¹/₄ in (7 x 21 cm)
Bone china, glaze, gold

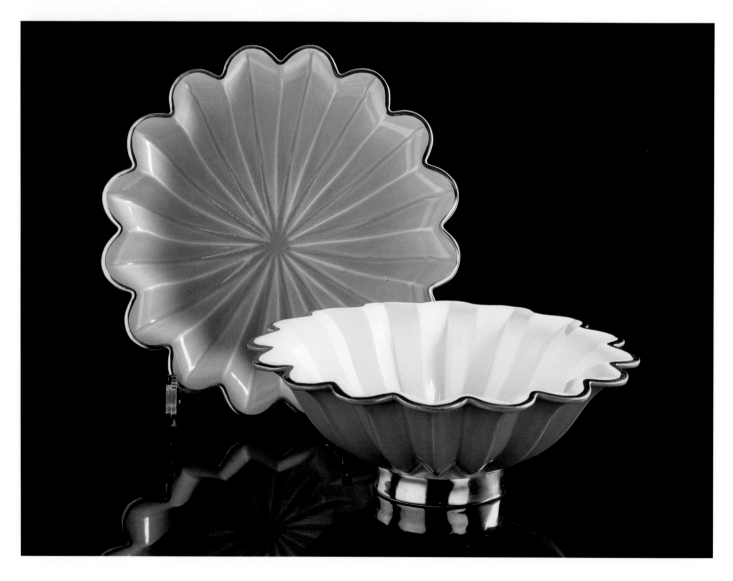

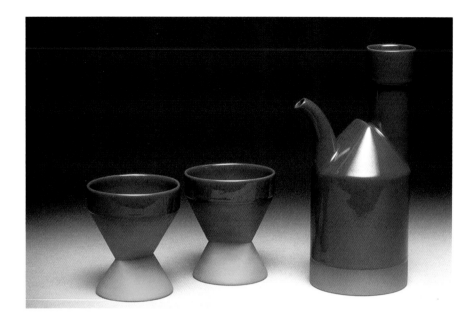

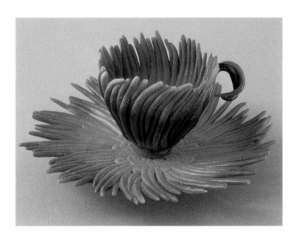

above
Paul ESHELMAN, USA
Ewer and Goblets, 9¹/₂ x 4¹/₂ in (24 x 11 cm)
Stoneware

left
Ann MORTIMER, Canada
Spring Welcome, 5 x 2¹/₄ in (13 x 6 cm)
Earthenware

below
Josh DeWEESE, USA
Liquor Set, 8 x 13 x 8 in (20 x 33 x 20 cm)
Stoneware, woodfired, soda glazed

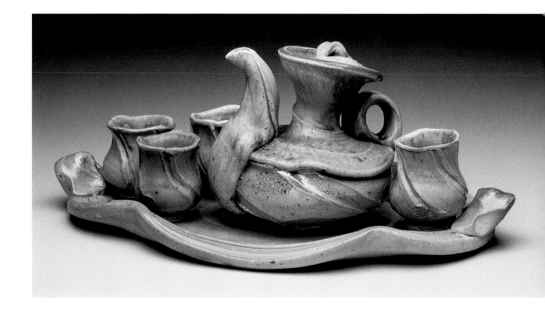

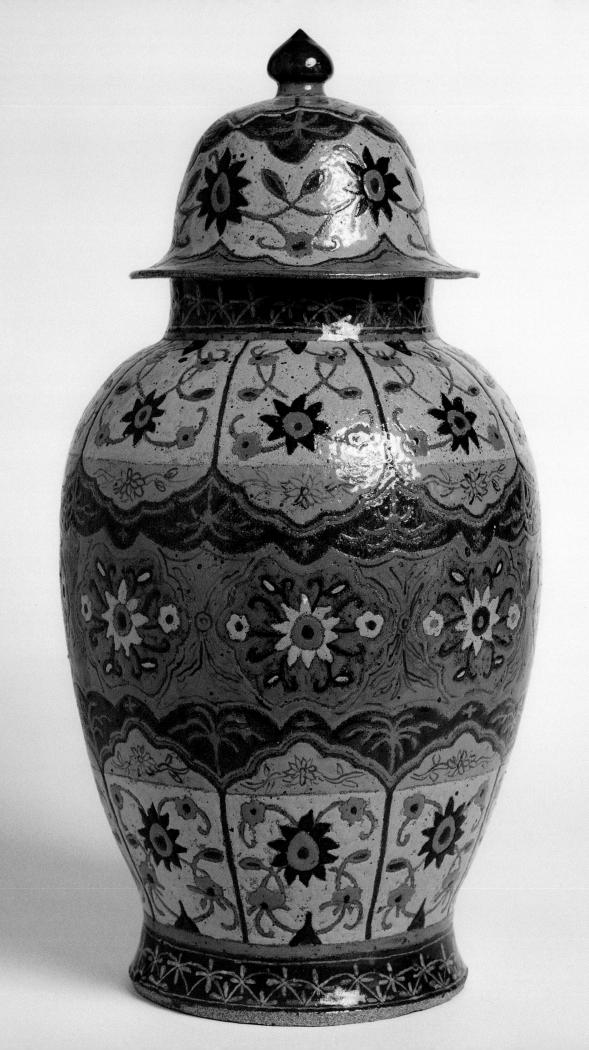

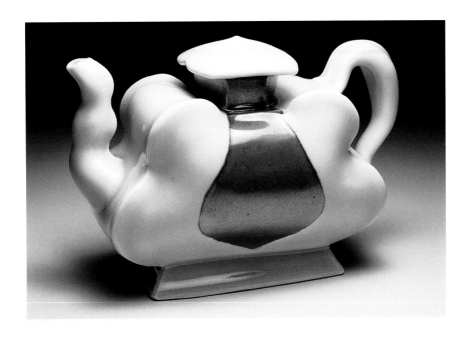

above
Sam CHUNG, USA
Teapot, 5 x 8 x 3 in (13 x 20 x 7.5 cm)
Porcelain

opposite
Michael and Magda FRIMKESS, USA
Ginger Jar, 16 x 8 in (41 x 20 cm)
Stoneware, reduction fired

below
Jeroen BECHTOLD, The Netherlands
Yi-Xing Teapot, 7 x 3¹/₂ x 4 in (18 x 9 x 10 cm)
Yi-Xing clay

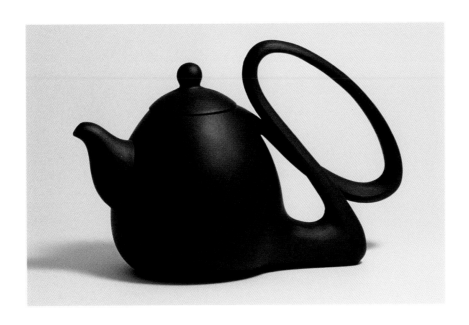

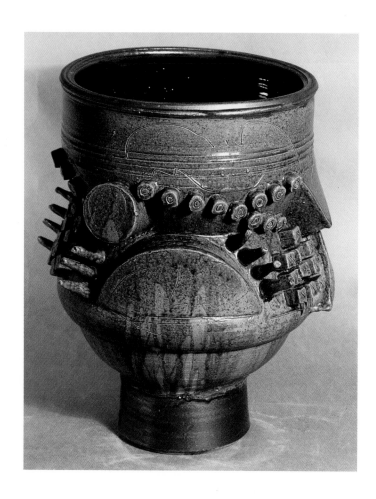

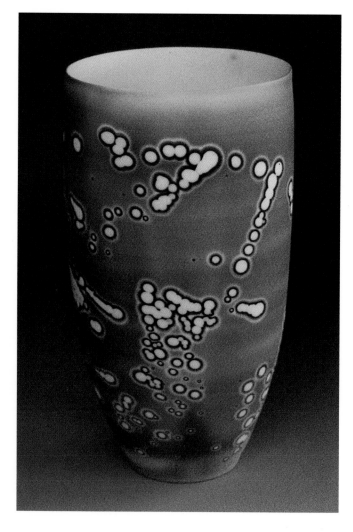

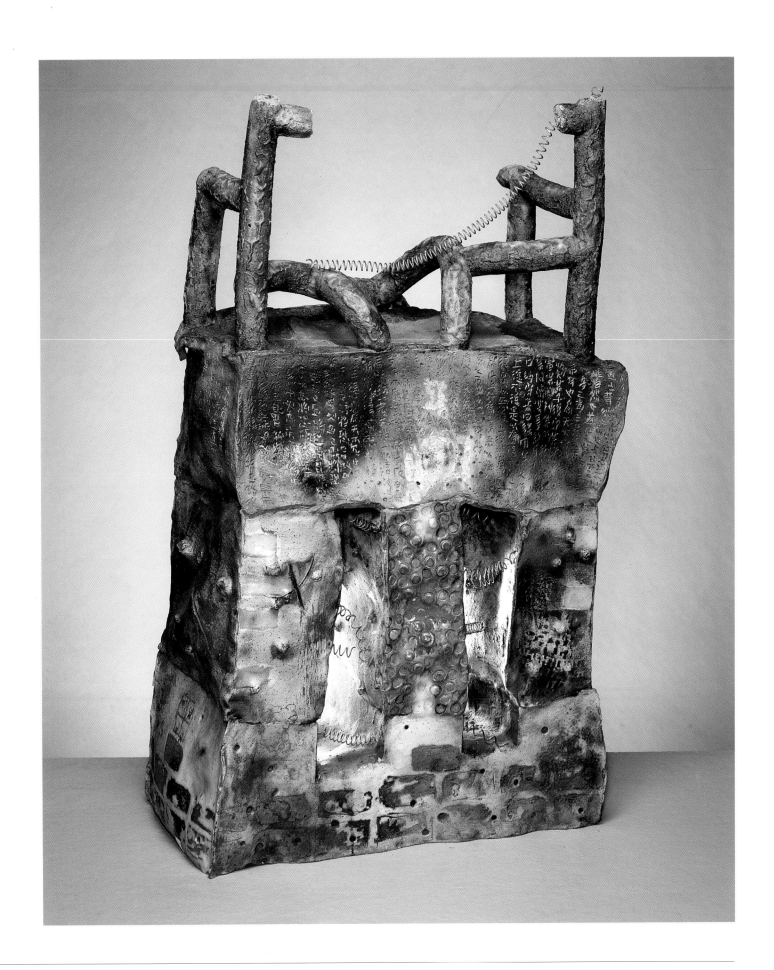

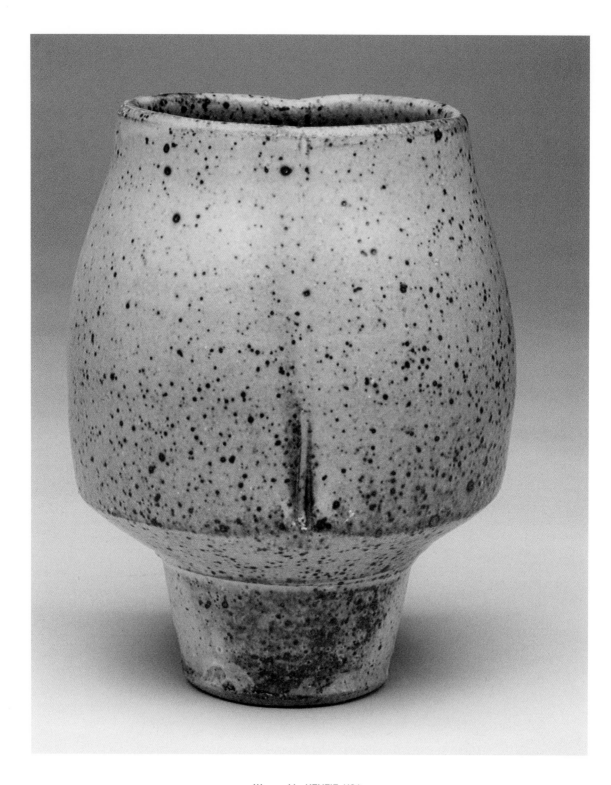

Warren MacKENZIE, USA
Teacup, ht 5 in (13 cm)
Stoneware

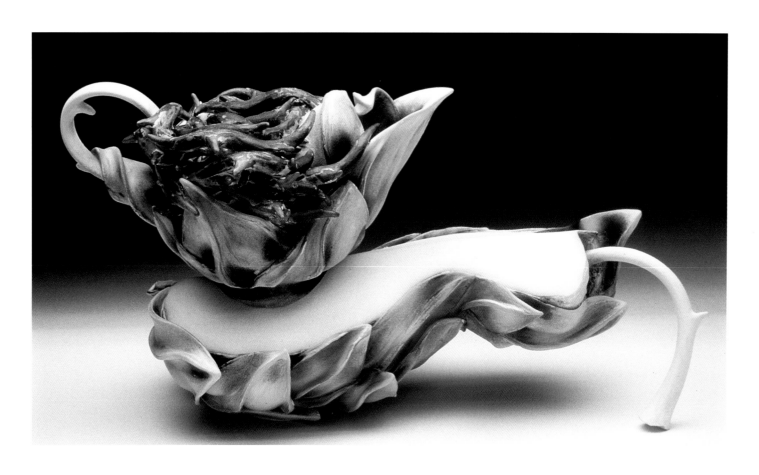

Kathleen ROYSTER, USA
Be Still, 6 x 10 x 6 in (15 x 25 x 15 cm)
Porcelain

Sandy SIMON, USA
Snake Teapot, 6 x 5 x 8 in (15 x 13 x 20 cm)
Porcelain, nichrome wire

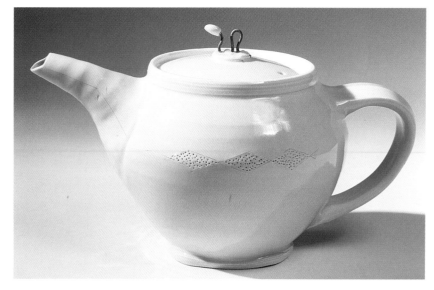

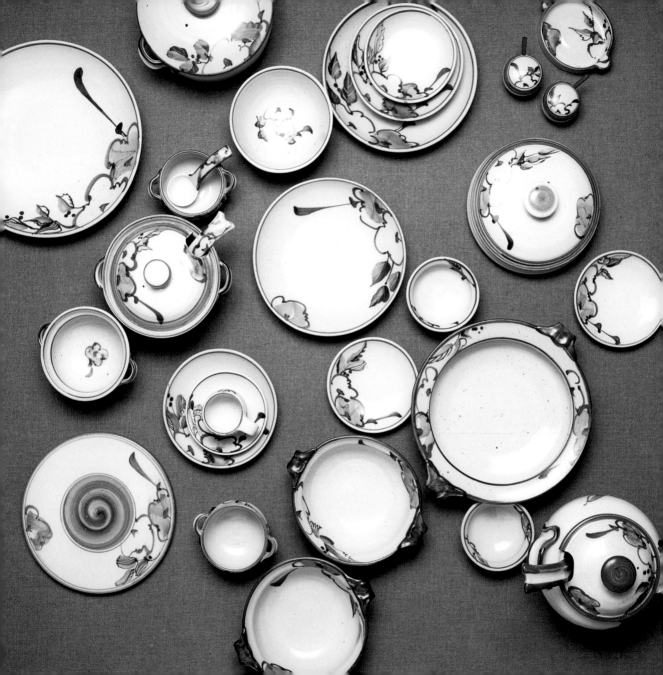

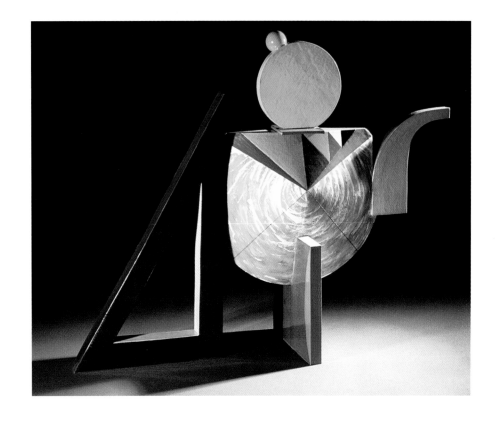

opposite
Deborah SMITH, India
Blue Flower, dinnerware
Porcelain, cobalt brushwork

right
Peter SHIRE, USA
Sengai Teapot, 20$^{1}/_{2}$ x 26 x 7$^{1}/_{2}$ in
(52 x 66 x 19 cm)
Porcelain, low-fire glazes

below
Peter POWNING, Canada
Step Series, 9$^{1}/_{2}$ x 50 x 4$^{1}/_{2}$ in
(24 x 127 x 11.5 cm)
Cast, raku

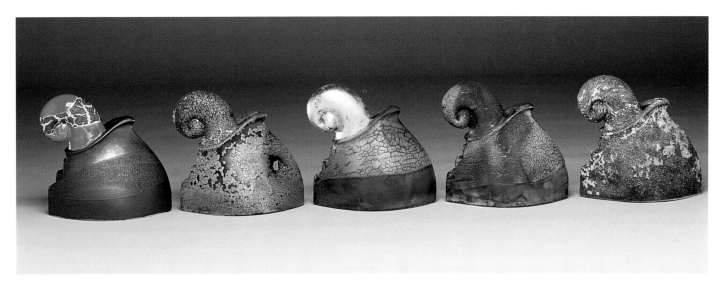

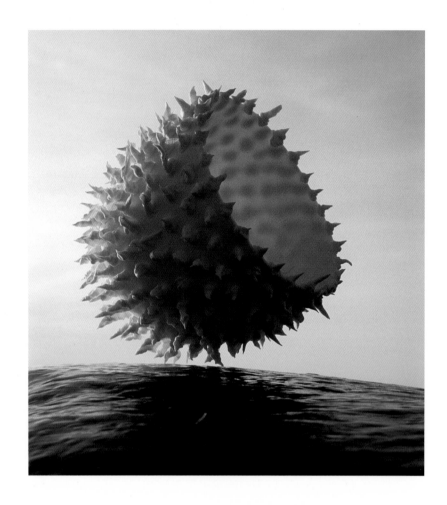

Anne TÜRN, Estonia
Light Chaser, **12 x 12 x 10 in (30 x 30 x 25 cm)**
Porcelain

opposite
Harrison McINTOSH, USA
Lidded Jar, **12³/₄ x 9¹/₄ in (32.5 x 23 cm)**
Stoneware, engobe, glaze

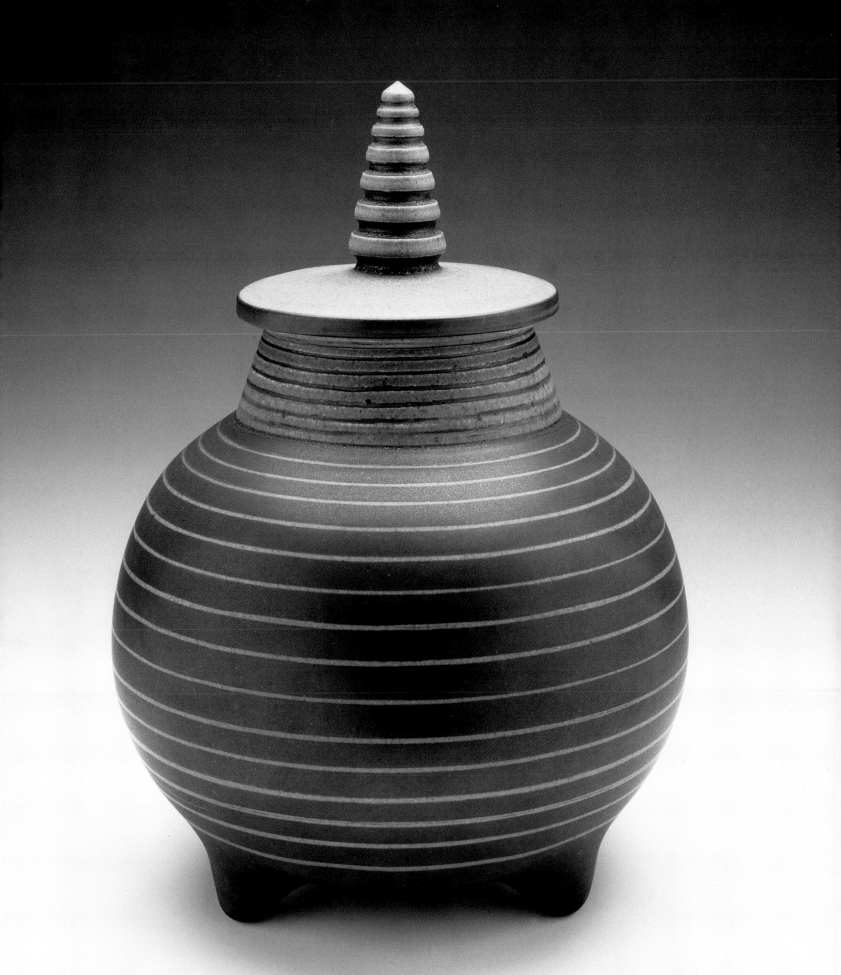

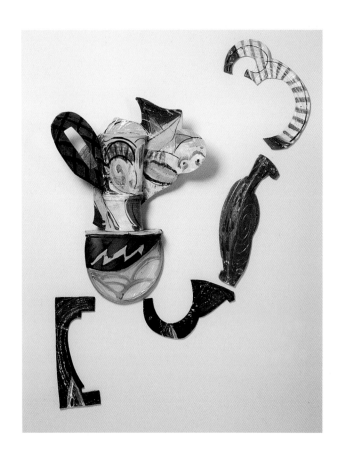

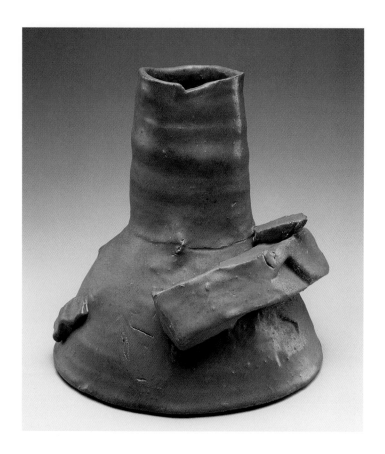

above
Betty WOODMAN, USA
Balustrade Vase 97–1, **88 x 53 x 8³/₄ in**
(2.24 x 1.35 m x 22 cm)
Earthenware, glazes

above right
Robert TURNER, USA
Canyon II, **10¹/₂ x 9¹/₂ in (27 x 24 cm)**
Stoneware, reduction fired

right
David SMITH, USA
Teabowl, **4 x 5¹/₂ x 5¹/₂ in**
(10 x 14 x 14 cm)
Stoneware, woodfired

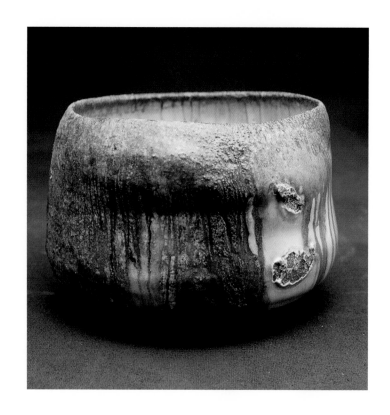

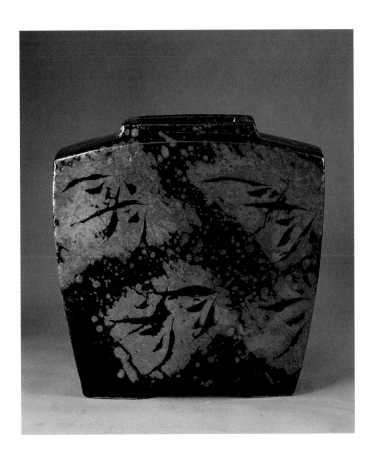

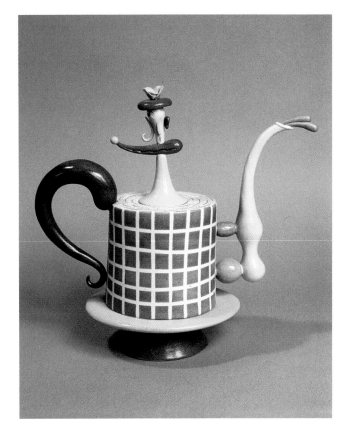

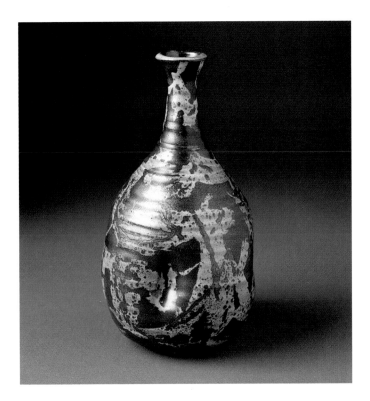

above left
Ray MEEKER, India
Vessel, ht 9 in (23 cm)
Stoneware, tenmoku and rutile, woodfired

above
Tom RIPPON, USA
Teapot, ht 12 in (30 cm)
Porcelain, lustres

left
Susan PETERSON, USA
Bottle, ht 10 in (25 cm)
Stoneware, reduction fired, wax resist, oxide decoration

man and beast

FROM EARLIEST TIMES clayworkers have squeezed and pinched out clay figures and animal forms. Making clay representations of man and beast seems to have been a pastime in all societies, for story-telling, for ceremonies and rituals, for the documentation of daily life. In some cases these figures served as funerary artefacts, burial deities and ways for the dead to remember life; in other cases it is believed that these small, pinched replicas of the living were toys for children.

From Neolithic times, about 8000 years ago, figures of the Mother Goddess have been found all over Europe, Turkey and the Near East. In ancient Egypt small *ushabti* statuettes of servants accompanied important personages to the Afterworld. In the Pre-Columbian civilizations of Peru, Mexico and other Central, South and North American regions, clay animals such as jaguars were created as objects of veneration; sacrificial vessels were invariably made in human or animal shapes. The marvellous hoard of 6000 clay figures of soldiers and horses known as the Terracotta Army, found in Xian, China, was buried in the tomb of the great emperor Ch'in Shih Huang Ti in about 200 BC; each represented a member of his court or an animal from the imperial stables, deemed a necessary accompaniment to the emperor in his journey to the next world. Lifesize clay figures dating from 500 BC have been unearthed in Nigeria; tiny statuettes of dancing men and women from the Harappa culture of c.3000 BC have been dug up in Pakistan. Magnificent sculptures of animals, realistic or stylized, are typical of many early Persian and Anatolian civilizations.

When the thickness of a claywork exceeds one to two inches, it should be built hollow, whether by pinch, coil or slab methods. Chinese Han dynasty pagodas, barnyards and other dwellings were built by traditional hand processes but were populated with pinched-out clay animals and people. Today, for reasons that are not clear, but following on a very widespread tradition, ceramic artists seem obsessed with figurative sculpture, animal, human and fantastical.

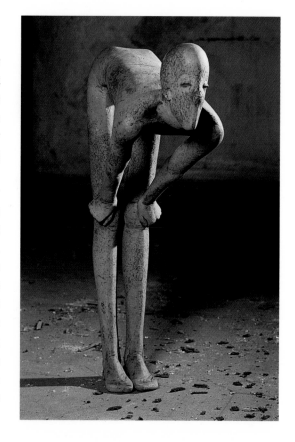

Ingrid JACOBSEN, Germany
Gegenüber (Opposite), **lifesize**
Stoneware

Paula RICE, USA
Lazarus, *48 x 22 x 14 in (122 x 56 x 35.5 cm)*
Stoneware, engobes, oxidation fired

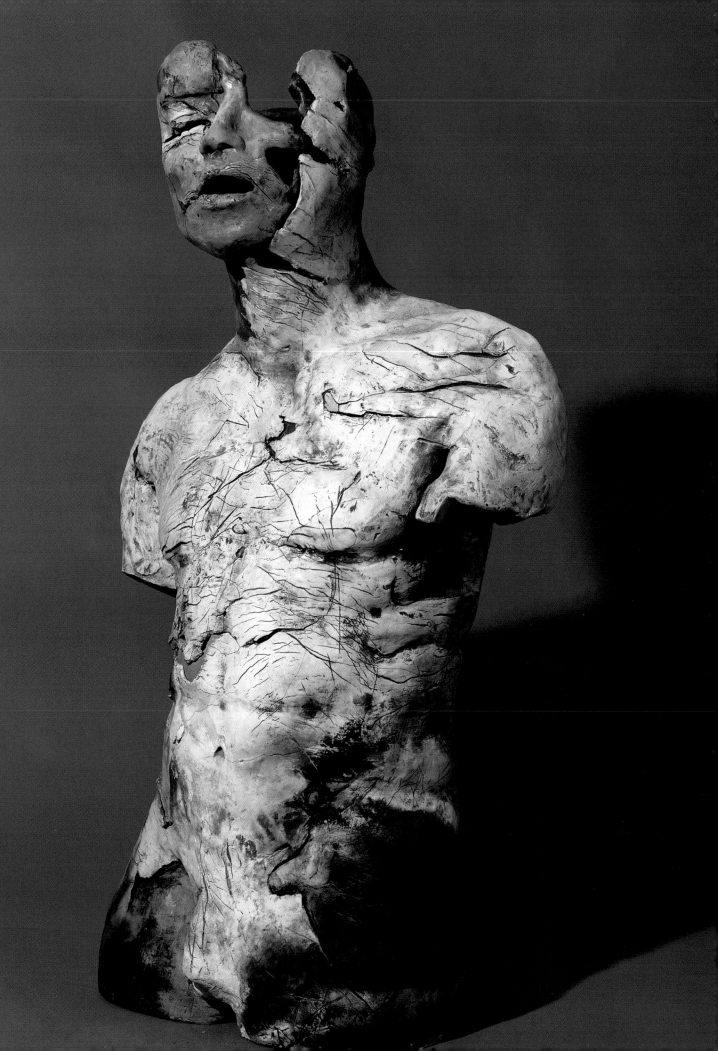

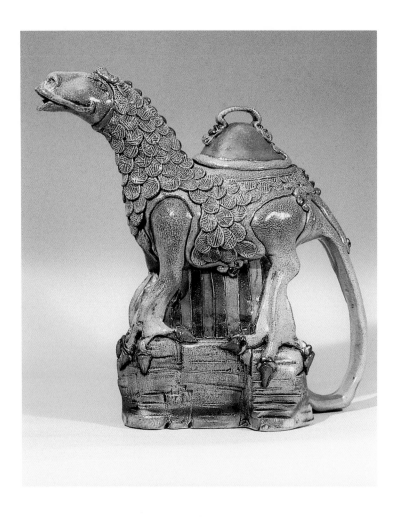

opposite
George McCAULEY, USA
Candleholder, 17¹/₂ x 12 in (44.5 x 30 cm)
Earthenware, soda-fired

left
Tim STOREY, Canada
Dragon Teapot, 8 x 6 x 8 in (20 x 15 x 20 cm)
Stoneware

below left
Joe BOVA and Cynthia BRINGLE, USA
Frog Teapot, 9 x 5 x 11 in (23 x 13 x 28 cm)
Stoneware (collaboration)

below
Richard SLEE, UK
Clown, ht 12 in (30 cm)
Porcelain

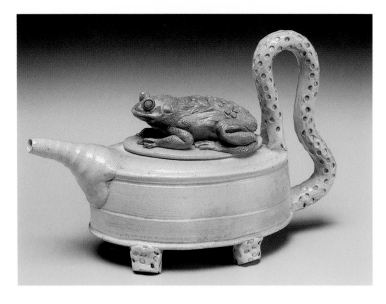

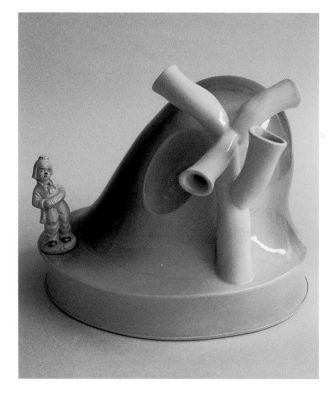

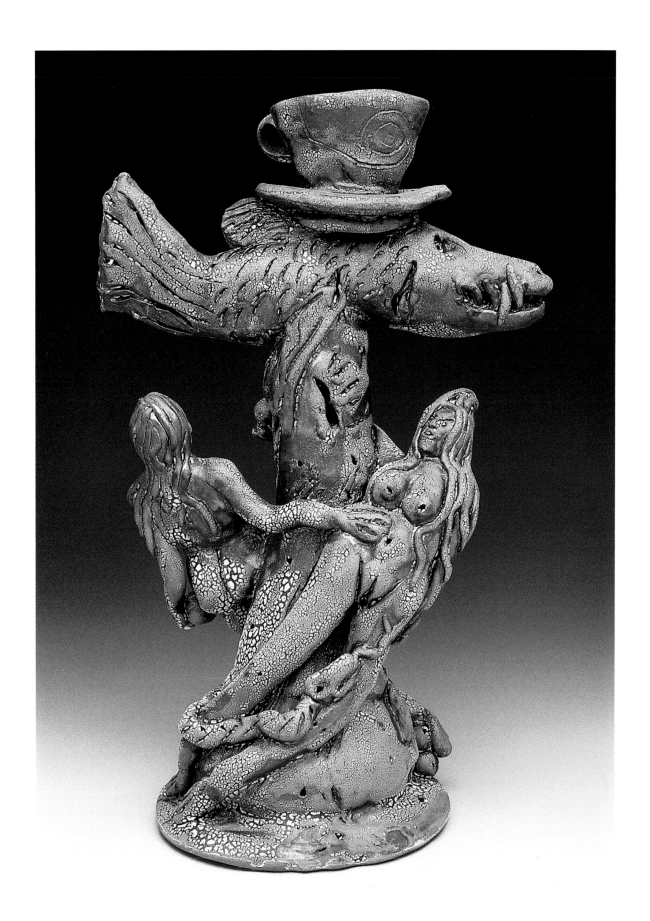

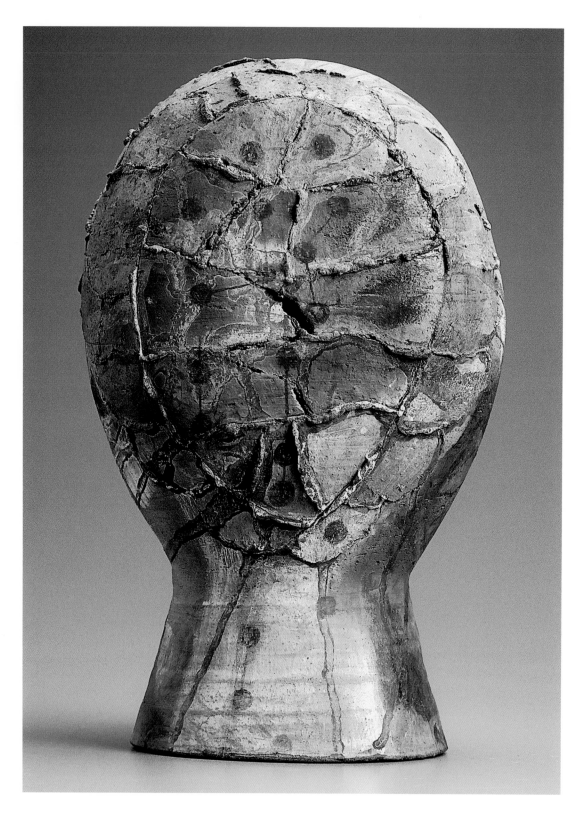

XIA De-Wu, China
Head, ht 24 in (61 cm)
Stoneware, woodfired

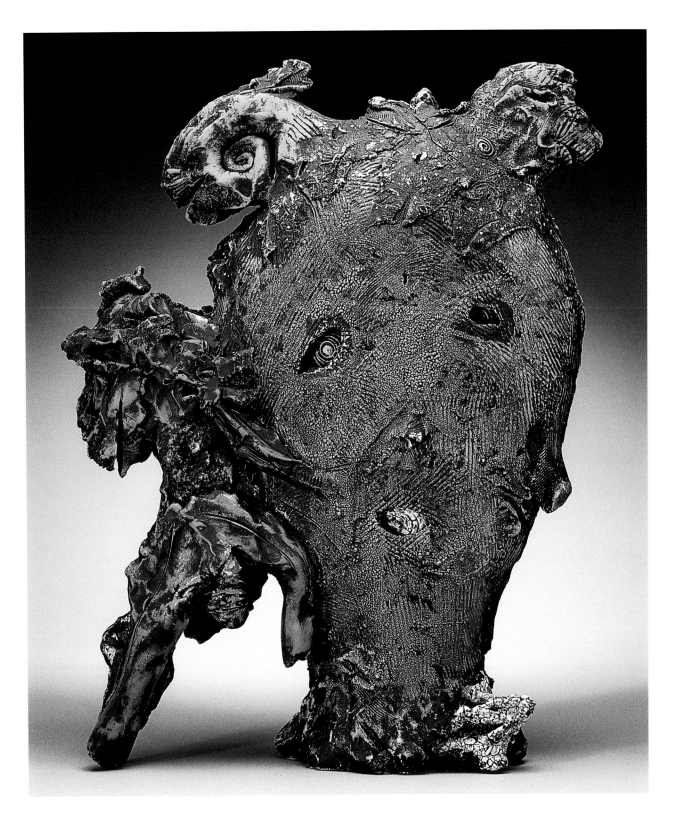

Andy NASISSE, USA
Orange Head, 26 x 19 x 8 in (66 x 48 x 20 cm)
Earthenware, textured glaze, multi-fired coil and slab

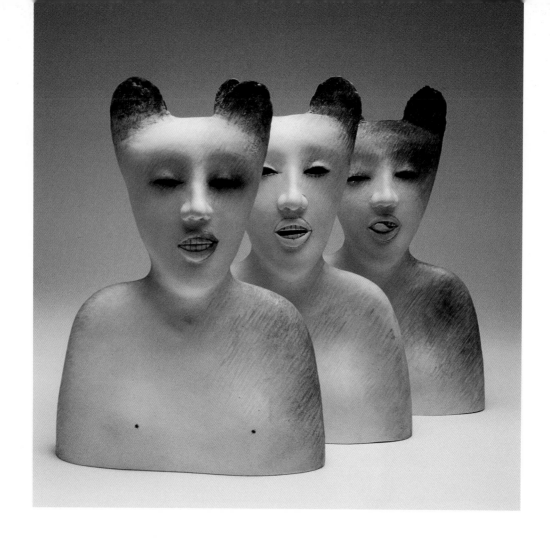

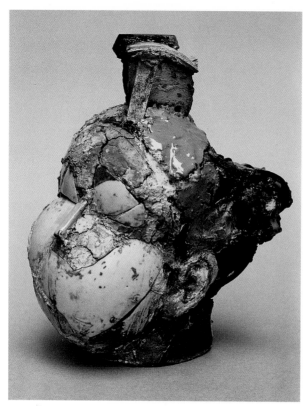

above
Jindra VIKOVÁ, Czech Republic
Conversation,
16 x 15 in (40 x 38 cm)
Stoneware

left
Gertrude MÖHWALD, Germany
Little Head,
ht 9 in (23 cm)
Stoneware and porcelain, glaze,
oxides, broken pieces

opposite
Amanda McINTYRE, USA
Chameleon,
$16^1/_2$ x $18^1/_2$ x $10^1/_2$ in
(42 x 47 x 27 cm)
Stoneware, engobes, glaze

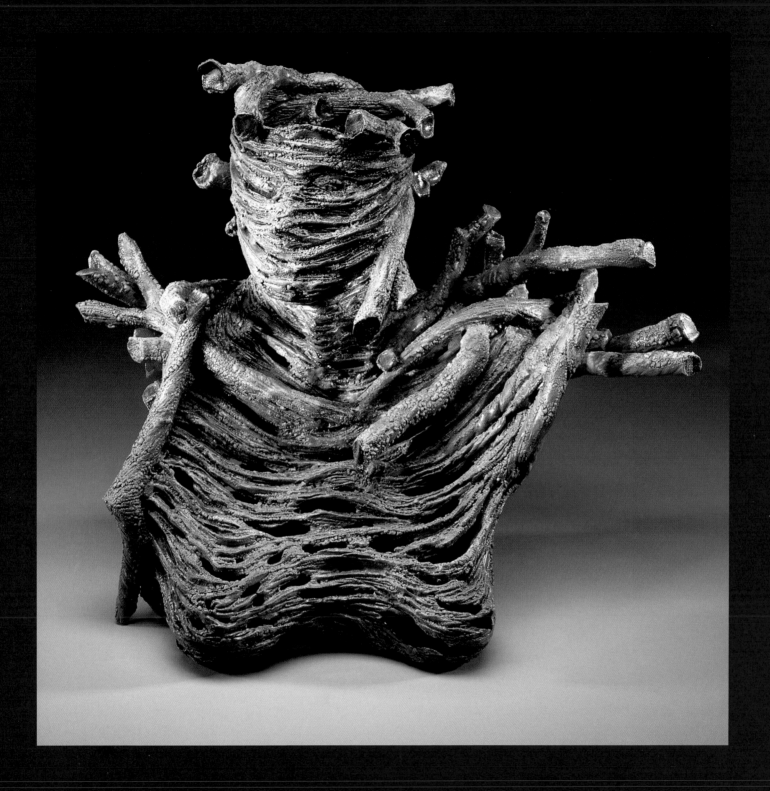

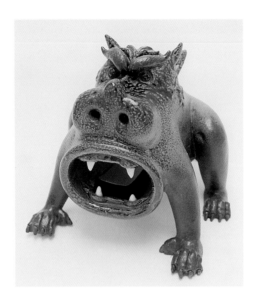

Clayton BAILEY, USA
Fire-Breathing Demon Dog, **14 x 18 x 12 in (35.5 x 46 x 30 cm)**
Stoneware, tobacco spit glaze, glass eyes

Jean-Pierre LAROCQUE, USA
Horse, **32 x 28½ x 14 in (81 x 72 x 35.5 cm)**
Stoneware, engobe, kiln shelf

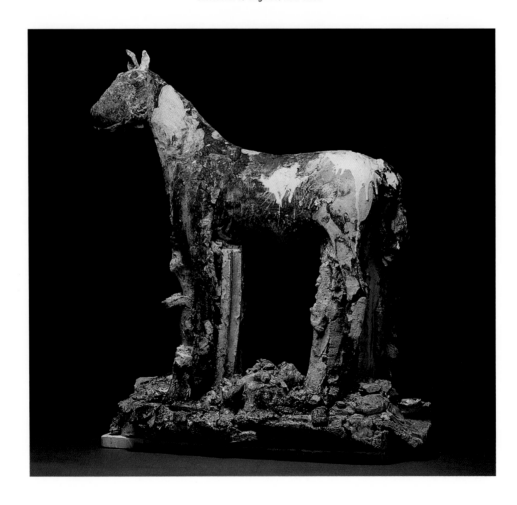

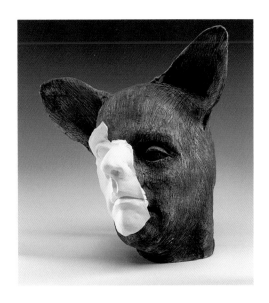

Margaret KEELAN, USA
Ghost Mask, 12 x 5 x 7 in (30 x 13 x 18 cm)
Raku

Ann Adair VOULKOS, USA
Graduate, 16¹⁄₂ x 15 x 4 in (42 x 38 x 10 cm)
Earthenware, glazes

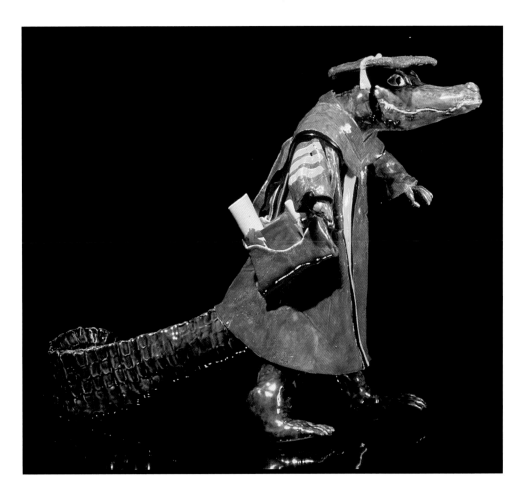

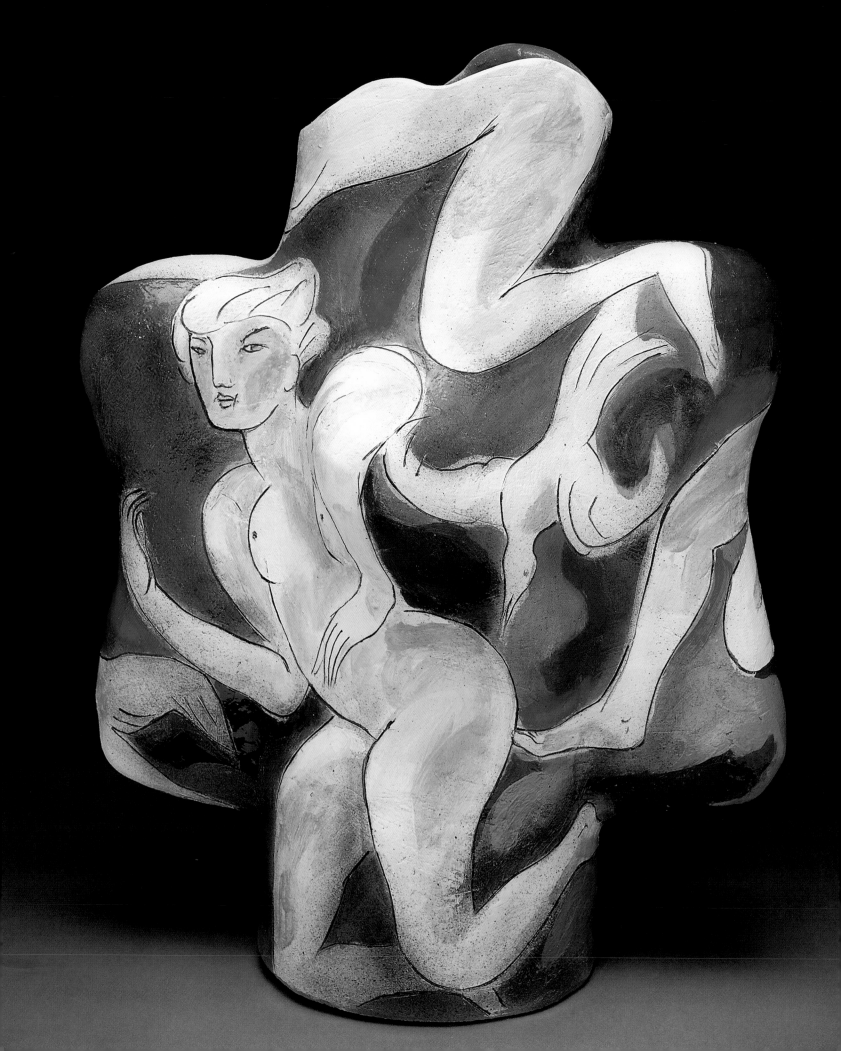

opposite
Rudy AUTIO, USA
Opening Nite, 37 x 32 x 17 in (94 x 81 x 43 cm)
Stoneware, underglazes, glaze

Hertha HILLFON, Sweden
Head, 24 x 18 in (61 x 46 cm)
Stoneware, oxides

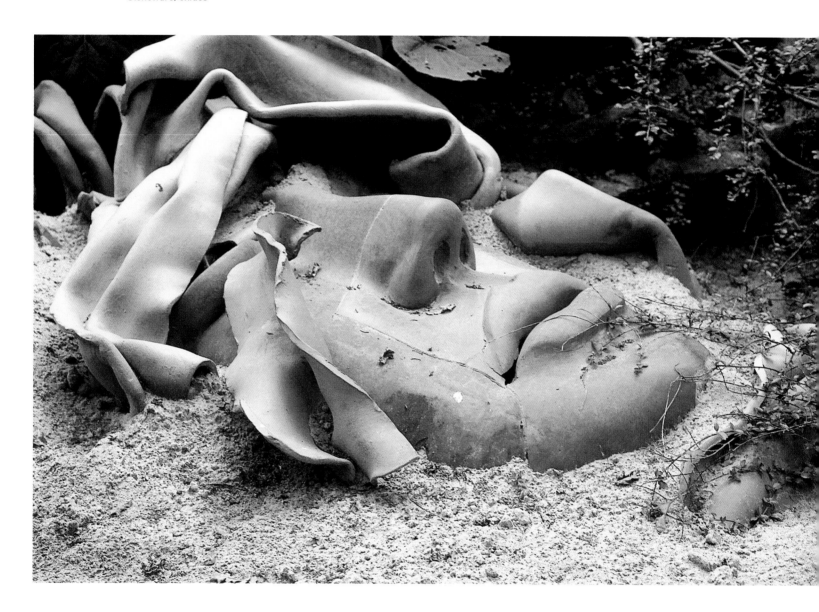

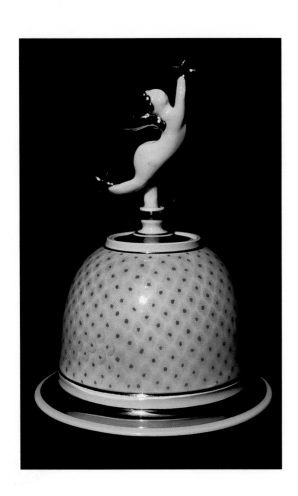

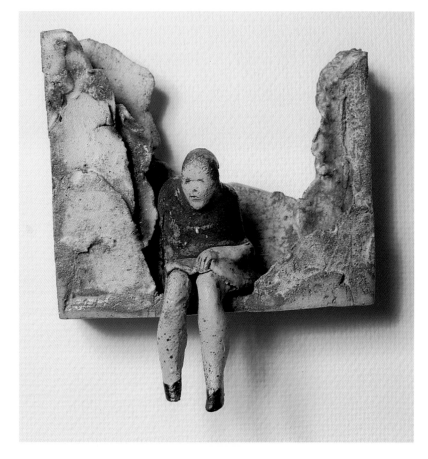

Keith CAMPBELL, Canada
As Sweet as Honey, ht 8¹/₂ in (21.5 cm)
Porcelain, underglaze, lustre

Lisa LARSON, Sweden
Stoneware Sculpture I, 11 x 11 in (28 x 28 cm)
Stoneware

opposite
Ken FERGUSON, USA
Basket with Hare, **16 x 16 in (41 x 41 cm)**
Stoneware

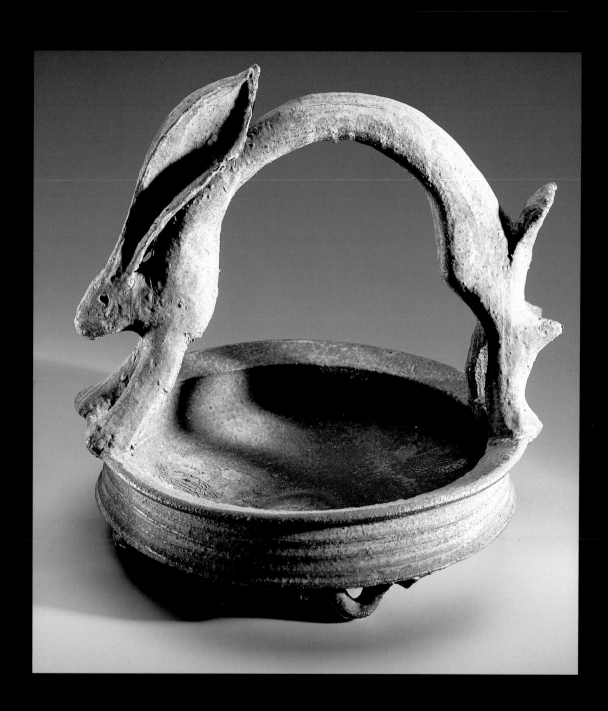

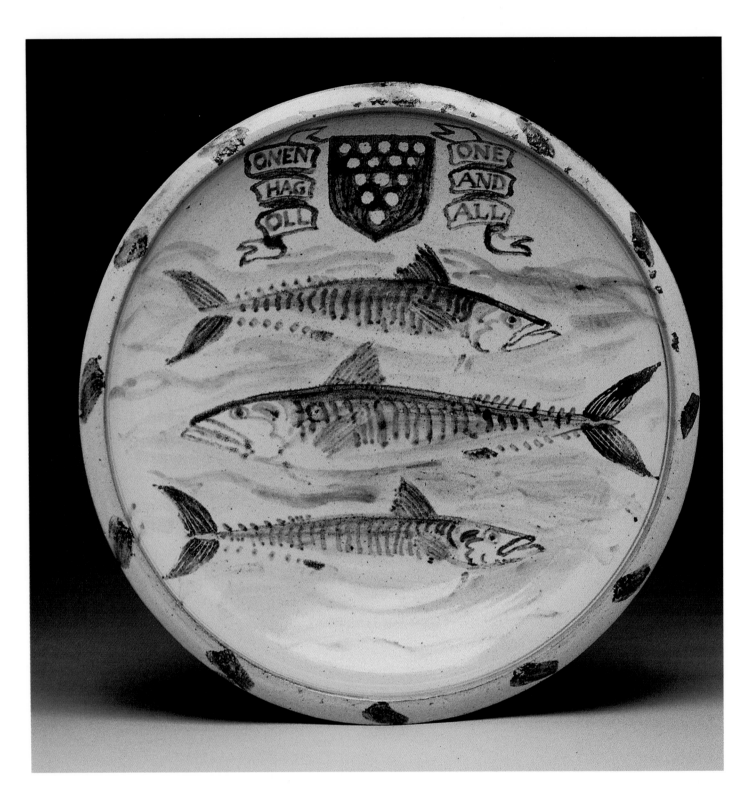

Seth CARDEW, UK
Fish Plate, dia. 25 in (63.5 cm)
Engobe drawing, stoneware

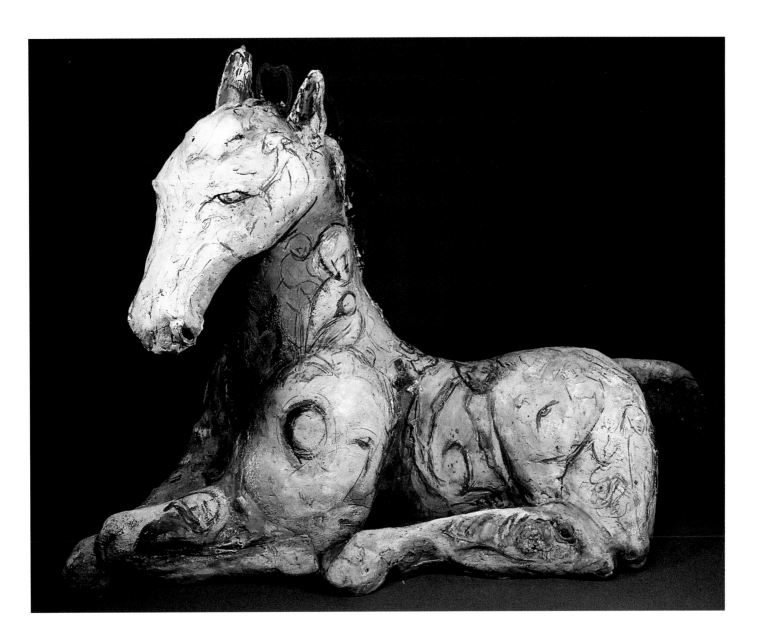

Gina BOBROWSKI, USA
Blaze, 54 x 48 x 24 in (137 x 122 x 61 cm)
Earthenware, oxides, fired horseshoes, found deerskin

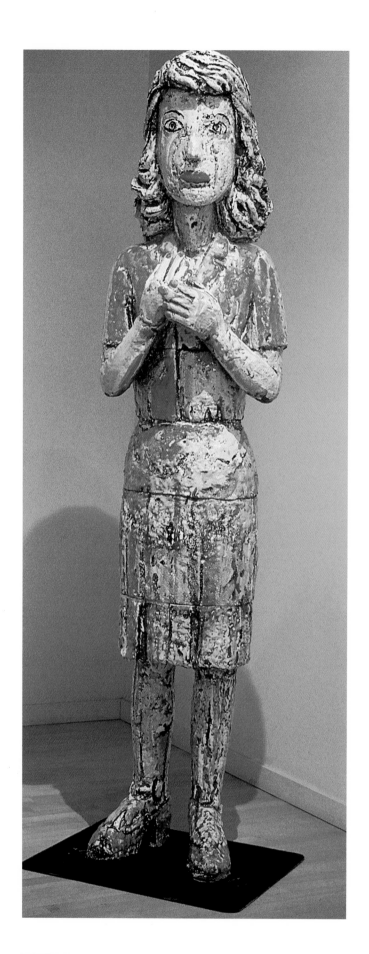

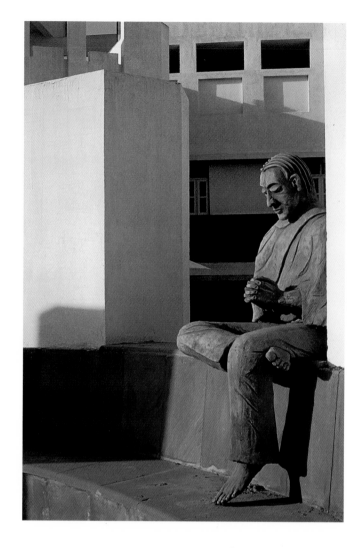

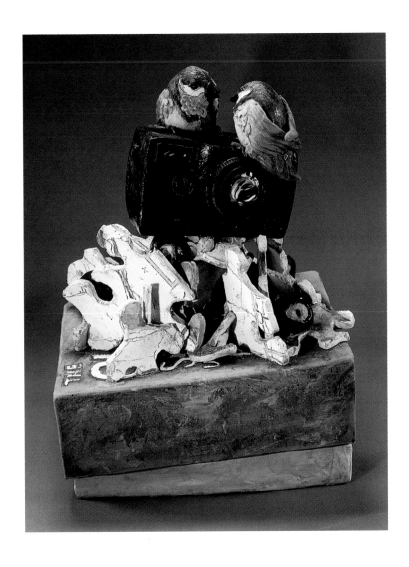

Tom SUPENSKI, USA
The Union, **18 x 10 x 12 in**
(46 x 25 x 30 cm)
Earthenware, engobes

Hirotsune TASHIMA, USA
Eat Well, Stay Fit, Die Anyway, **48 x 21 x 24 in**
(122 x 53 x 61 cm)
Stoneware, mixed media

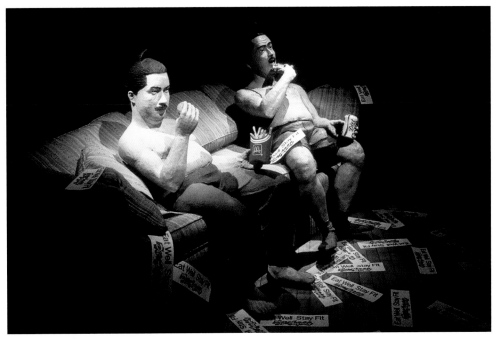

symbolism and narrative

EARLY HUMANS CREATED SYMBOLS by drawing simple pictorial outlines on rocks and the walls of their caves. All cultures and language types understand simple drawings, and certain symbols are universal. Artists sometimes use symbol as a step into conceptualism, expecting their work still to be understood by almost everyone, but different individuals may have different interpretations of symbolic references.

Clay artists especially know that form, line and colour can produce symbols that evoke emotions. Communication with our fellows is vital, hence the real need for generic terms that can be instantly appreciated. In ceramics or other three-dimensional forms, ideas can be transmitted by gesture or overt signals within the whole concept of the piece. Pictures, either visual or mental, have always been a better way to communicate than words, even if the language is comprehensible.

Artists for whom symbolism and narration are important make huge efforts to find the best way to project ideas for the viewer. Some symbols are clearly spelled out, others are hidden in the cloak of form. Story-telling as a means of giving information through clay can be graphic or conceptual, ancient or contemporary; narrative ceramics are found throughout history, from the earliest works discovered in archaeological digs or exhibited in museums to the creations of the present day.

Much is being 'said' now in clay. The undercurrent of mass communication exists in the veiled nuances of narrative sculpture or painting or carving on vessels. For some potters decoration and ornament demand content; for others, especially those who were involved with the Voulkos phenomenon of the 1950s, the abstract statement is enough.

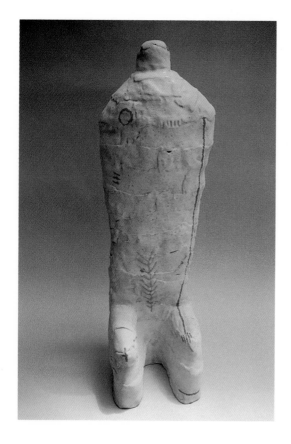

Robert BRADY, USA
Bombay, 28 x 8 x 6 in
(71 x 20 x 15 cm)
Earthenware, paint

Richard SHAW, USA
Speeding, 27 x 21 x 13 in
(68.5 x 53 x 33 cm)
Porcelain, engobes, glaze, decal

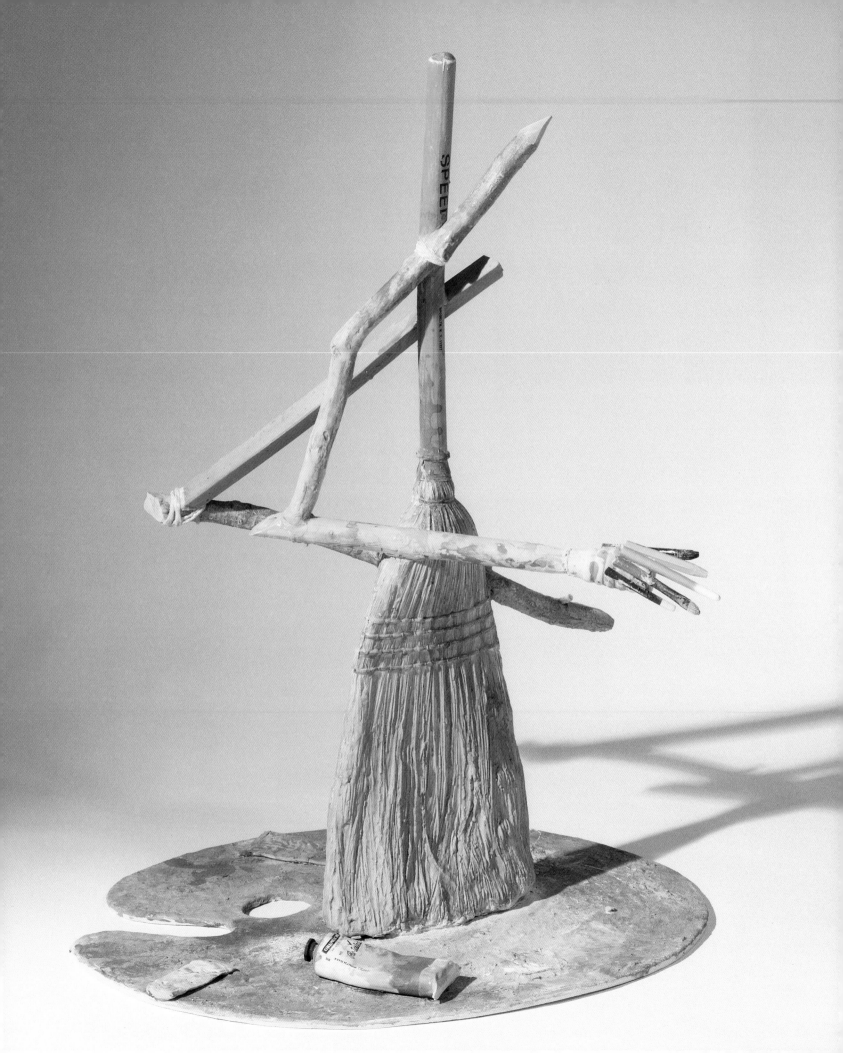

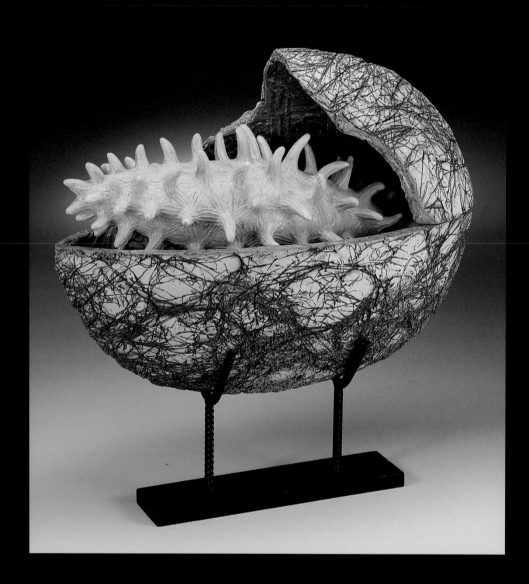

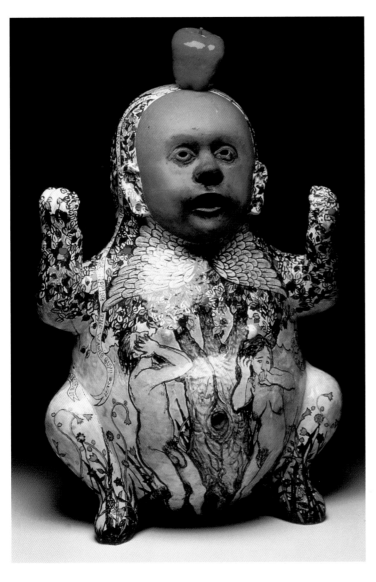

above
Kukuli VELARDE, USA
Adam and Eve's Tale I, **from the** *Isichaputu* **series**, 22 x 15 x 9 in
(98 x 38 x 23 cm)
Earthenware, majolica

right
Beth LO, USA
Swim the English Channel, **ht 20 in (51 cm)**
Porcelain, earthenware

opposite
Michaela DICOSOLA, USA
Her Eternal Gift, 31 x 36 x 15 in (79 x 91 x 38 cm)
Earthenware, welded steel

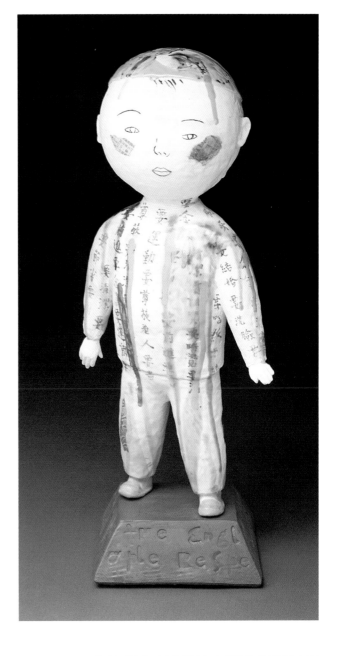

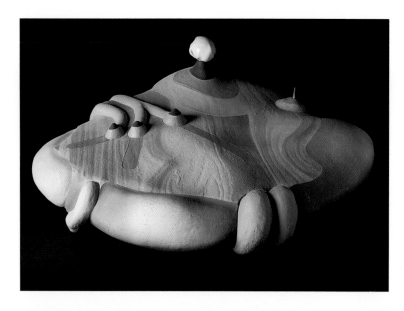

opposite
Keiko FUKAZAWA, USA
Exquisite Geisha Girl, **13 x 7 x 7 in (33 x 18 x 18 cm)**
Earthenware, glaze, oil paint

left
Fred OLSEN, USA
On the Other Side, from the Afra Series
24 x 24 x 12 in (61 x 61 x 30 cm)
Stoneware, coloured engobes

below
László FEKETE, Hungary
Go Nike, Go Shell, Souvenir from the Jungle, ht **11½ in (29 cm)**
Porcelain, gold, decal

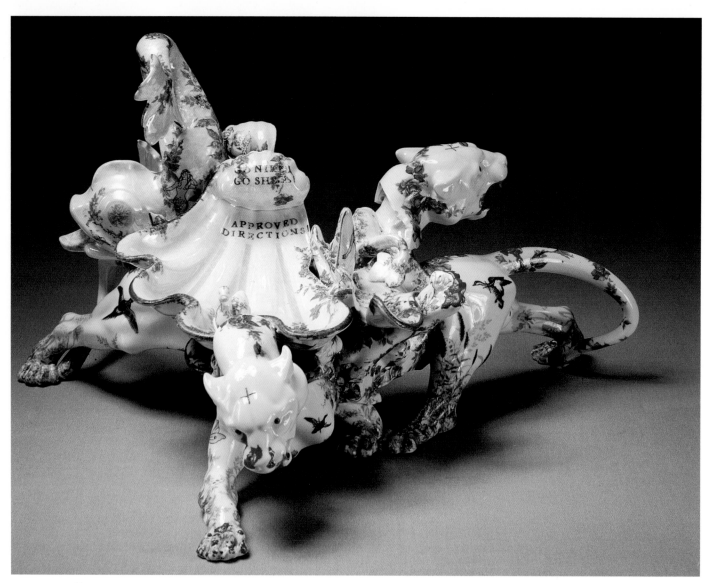

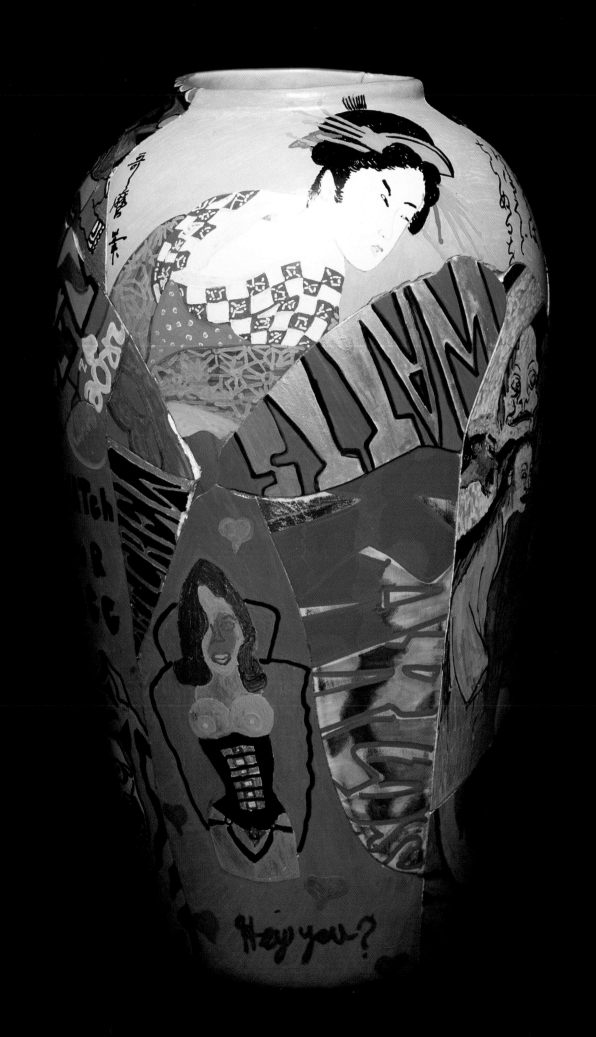

Lisa WOLKOW, USA
Seven No. 4, 18½ x 4 x 3 in (47 x 10 x 7.5 cm)
Earthenware

Bill STEWART, USA
Frog Foot, 74 x 23 x 14 in (188 x 58 x 35.5 cm)
Earthenware, engobes, glaze

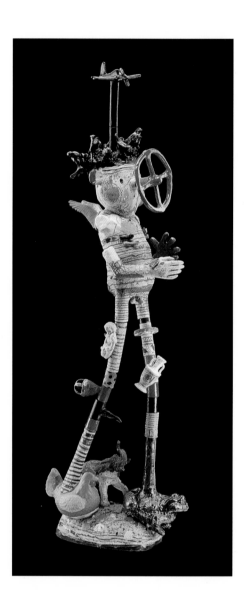

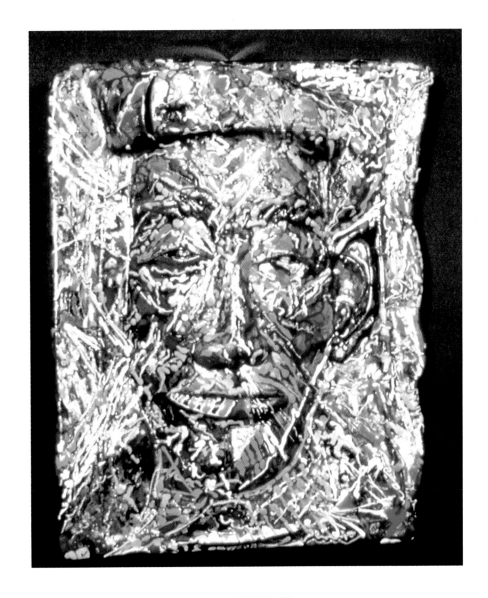

James TANNER, USA
Storyteller, 16 x 13 x 3½ in (41 x 33 x 9 cm)
Earthenware, engobes

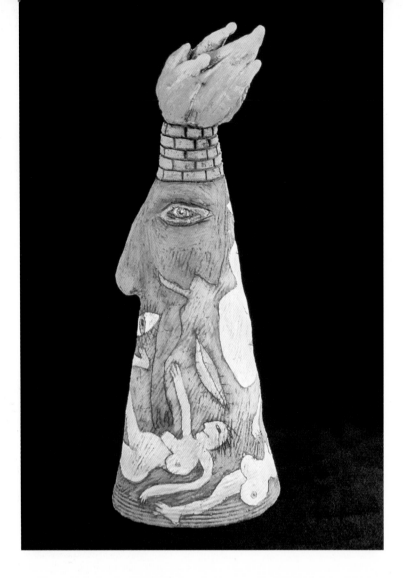

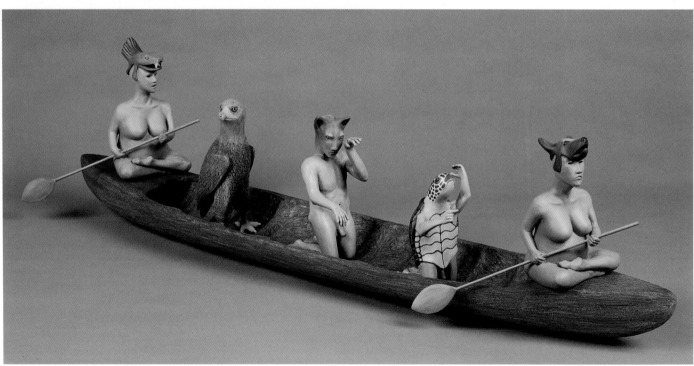

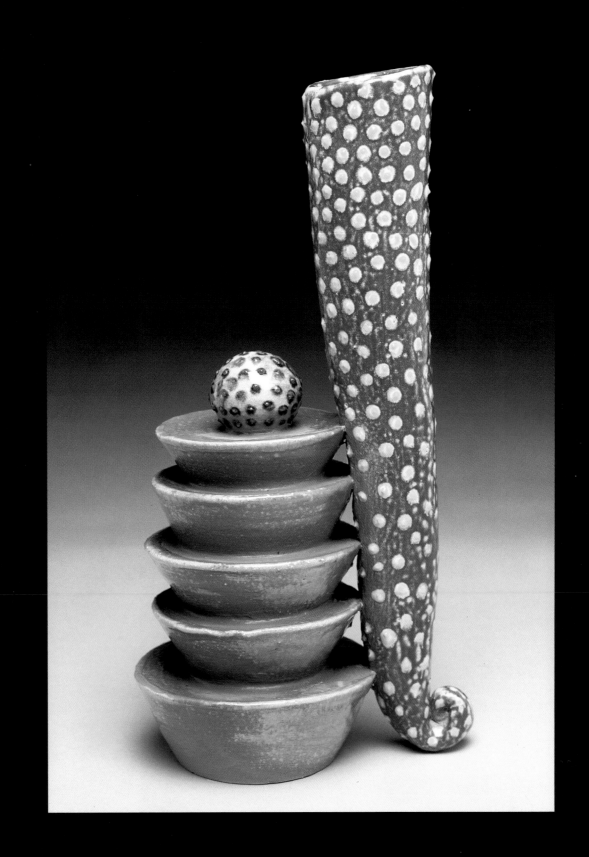

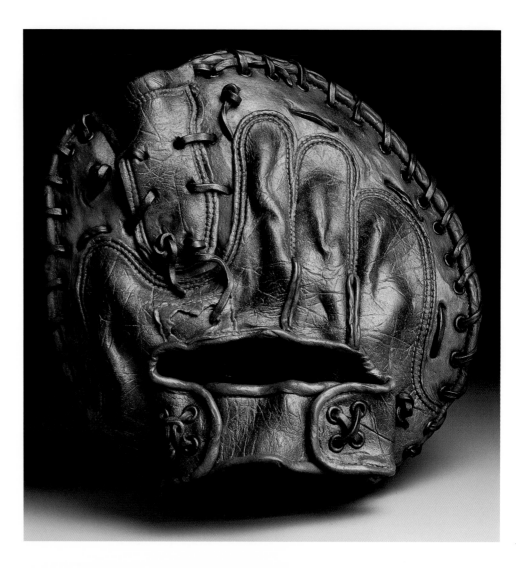

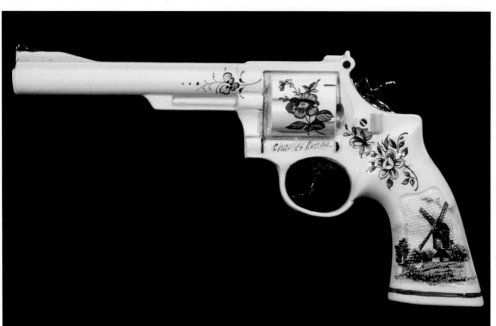

Richard NEWMAN, USA
Summer Reunion, 10¹/₂ x 10¹/₂ x 4¹/₂ in
(27 x 27 x 11 cm)
Stoneware, pigments, resin,
beeswax stain

Charles KRAFFT, USA
Porcelain War Museum Project (pistol),
6 x 11 in (15 x 28 cm)
Earthenware

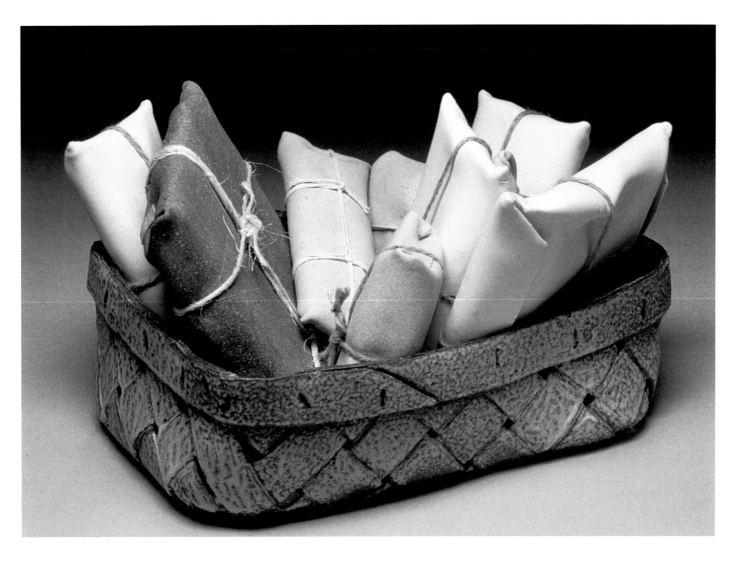

Sylvia HYMAN, USA
Peach Basket, 8 x 11 x 14 in
(20 x 28 x 35.5 cm)
Porcelain, stoneware

Randall B. SCHMIDT, USA
Bedside Comfort, 21 x 18 x 18 in
(53 x 46 x 46 cm)
Stoneware

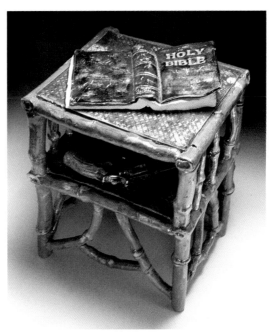

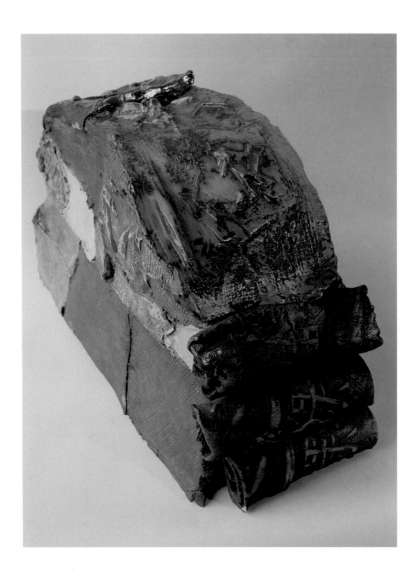

opposite
Jim LAWTON, USA
Tiered Casket, **18 x 12 in (46 x 30 cm)**
Earthenware

left
ZUO Zheng Yao, China
Food for Thought, **11¹/₂ x 21 x 7 in (29 x 54 x 18 cm)**
Stoneware, woodfired

below left
Richard NOTKIN, USA
Heart Teapot, **6¹/₂ x 9 x 6¹/₂ in (16.5 x 23 x 16.5 cm)**
Porcelain, woodfired

below
LI Jian-Shen, China
China Cart, **24 x 24 in (61 x 61 cm)**
Stoneware, woodfired, stains

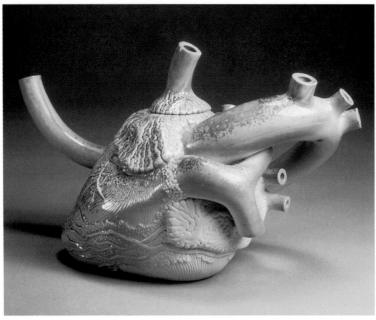

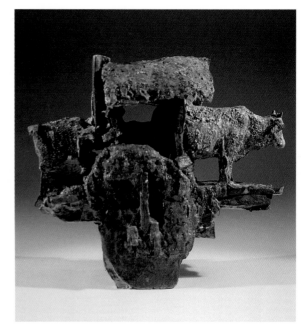

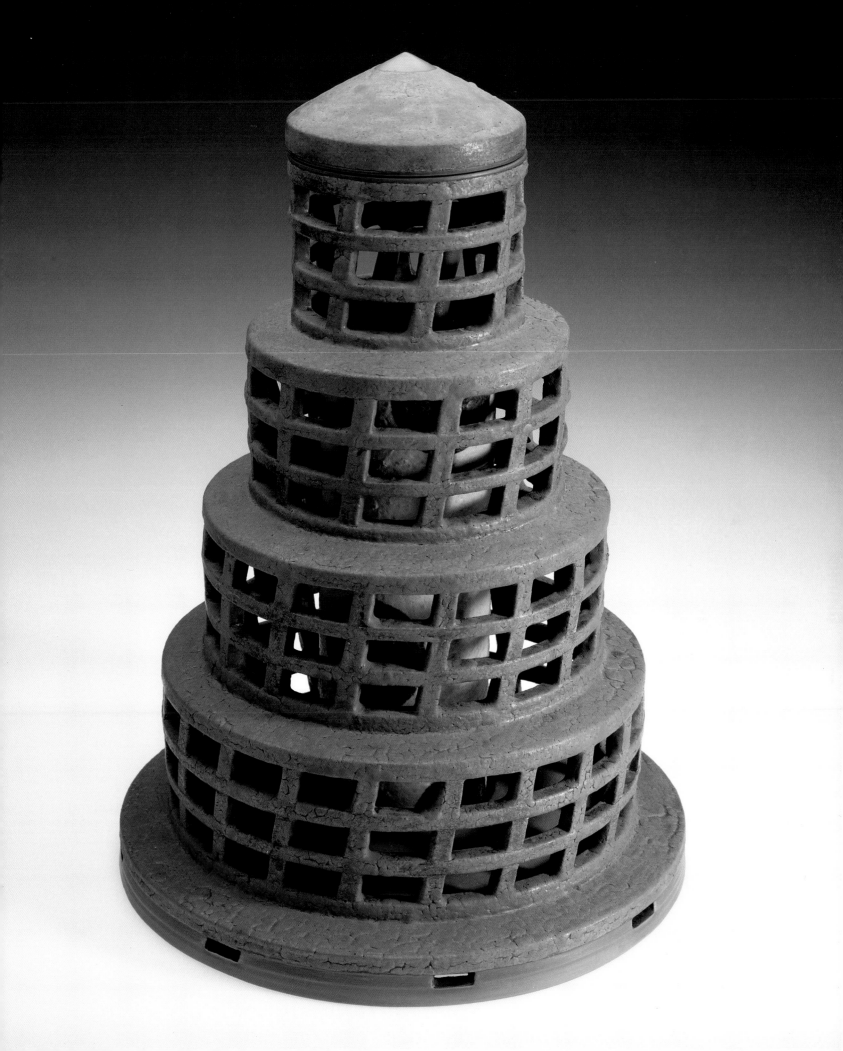

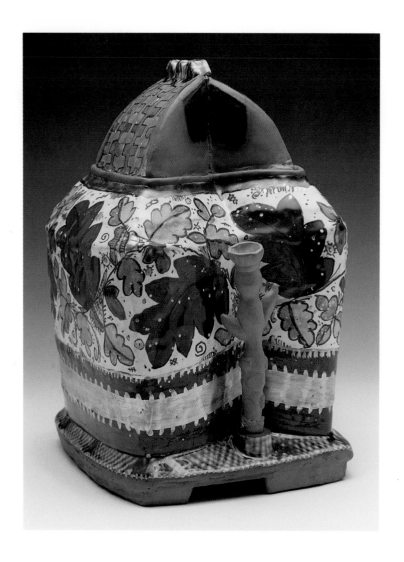

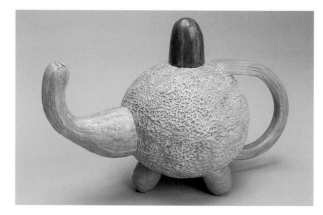

above
David FURMAN, USA
Darling Darjeeling, **8 x 13 x 5 in** (20 x 33 x 13 cm)
Porcelain, underglaze, glaze

left
Liz QUACKENBUSH, USA
White House with Flower, **14 x 8 x 7 in** (35.5 x 20 x 18 cm)
Earthenware, majolica glaze

below
Piet STOCKMANS, Belgium
Object No. 5 with 153 Vessel,
1 x 25¹/₄ in (2.5 x 64 cm)
Porcelain

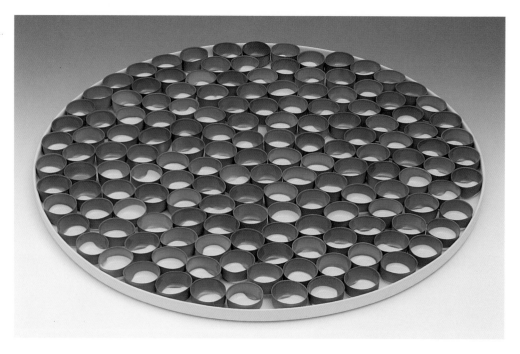

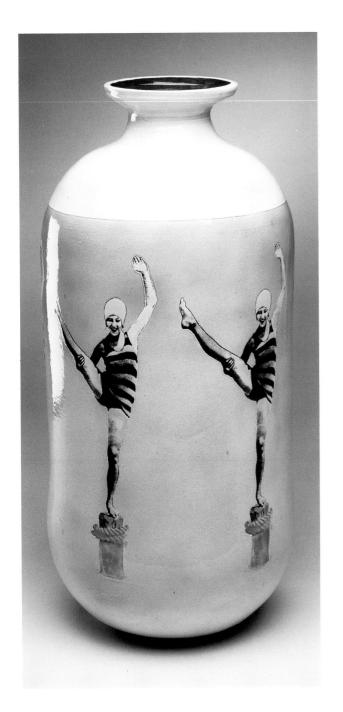

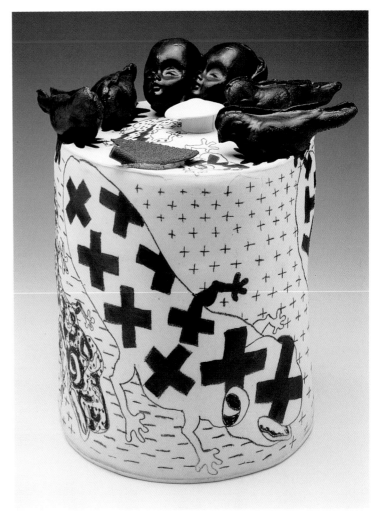

above
Philip CORNELIUS, USA
Z+X-T, 10 x 8 x 9 in (25 x 20 x 23 cm)
Porcelain

left
Vina SCHEMER, USA
California Beach Girl 1919, 21 x 10$^1/_2$ x 10$^1/_2$ in
(53 x 27 x 27 cm)
Earthenware, photo decal

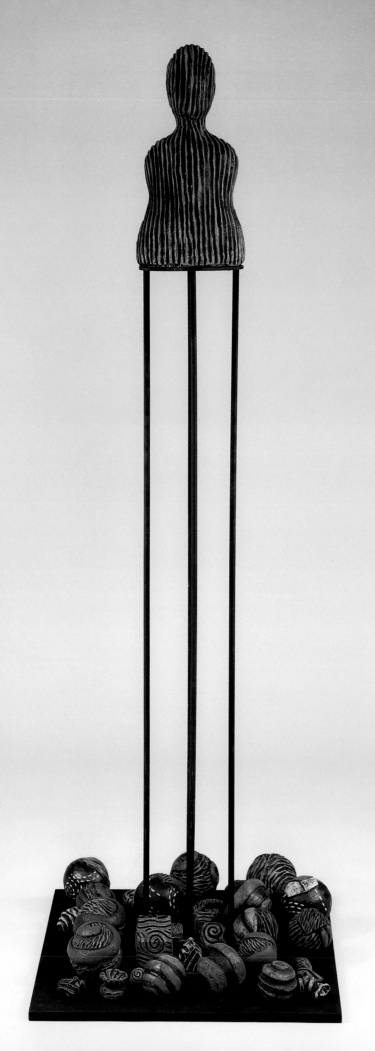

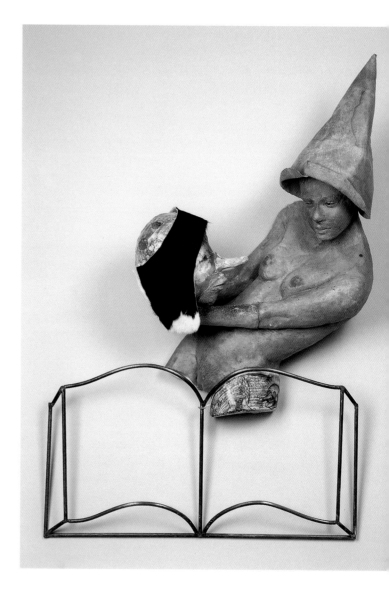

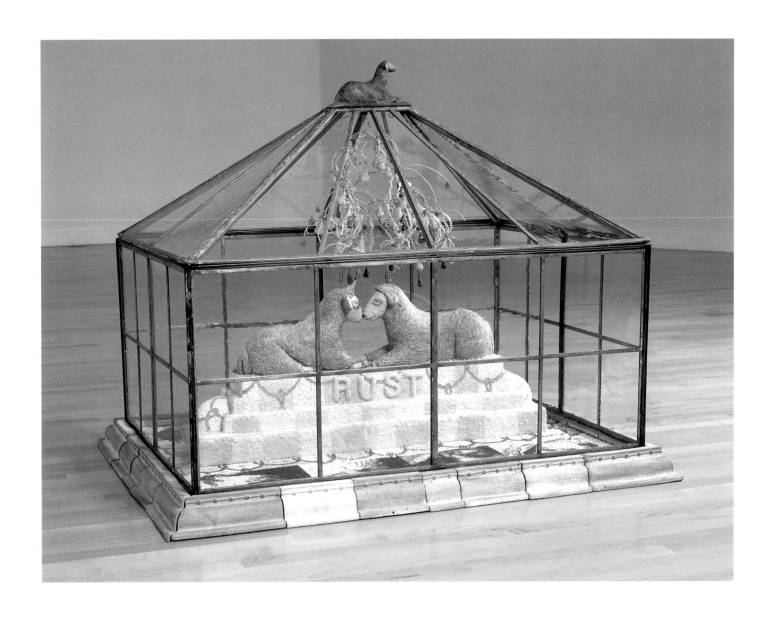

Mary Jo BOLE, USA
My First Dutch Lesson, 3 x 36 x 60 in (8 x 91 x 152 cm)
Earthenware, mixed media

survival of traditions

WITH A WORLD-WIDE ceramic history of at least 35,000 years, of which about six thousand years have been documented, some traditions that continue in their original areas, as well as countless incidents of chance similarities and actual influences, are bound to occur. Current ceramic art throughout the world is heavy with the imprint of the character and magnetism of the past.

As the British potter and author Peter Lane wrote to me, when I asked his permission to include his recent work in this section: 'Clearly, we absorb information and ideas from many diverse sources and our responses, sometimes, produce images arising from an amalgam of these experiences. The precise origins are not necessarily obvious. I have always had a preference for fairly simple, "classical" vessel forms, while attempting to give them extra interest by additions and/or subtractions to/from the initial profile or surface. I have made frequent trips to the Museum of Mankind [part of the British Museum in London] with my students to see the excellent collection of African and, especially, Nigerian pots. The Victoria and Albert Museum in London is likewise a regular attraction for its wonderful Chinese collection.

'Both displays include a variety of vessels with applied elements placed on opposite sides or with carved and pierced rims. Chinese bronzes also intrigue me, with wing-shaped additions set at opposite angles. Of course "simple" shapes can be transformed into different characters according to the choice of any additions, subtractions or surface treatments.

'Inevitably my work owes much to those historical, cultural and traditional aspects of ceramics that have continued to interest me since I began to work in clay. In that sense, I must acknowledge influences from many sources, including African. However I have to say that one has to stand back from the work from time to time in order to discover origins, where and why ideas have been generated. I am not sure that I have ever consciously based my work on the art, culture or tradition of any particular country or region, but how can anyone be immune?'

This is an apt comment, and absolutely true. If one is aware and alert one will be influenced. History leaves traces and we are all part of the universal heritage, free to emulate any strand from

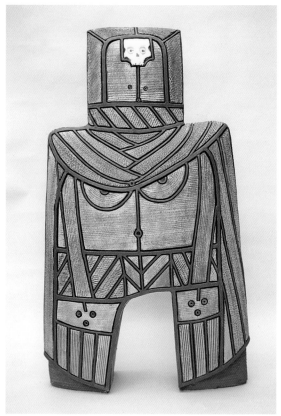

Bob KINZIE, USA
Cycladic Figure, **40 x 28 in**
(102 x 71 cm)
Stoneware; recalls Cycladic
sculpture

Richard Zane SMITH, USA
Coiled Double-Walled Bowl,
9 x 18 in (23 x 46 cm)
Local clays, engobes with
oxide decoration, kiln-fired;
American Indian tradition

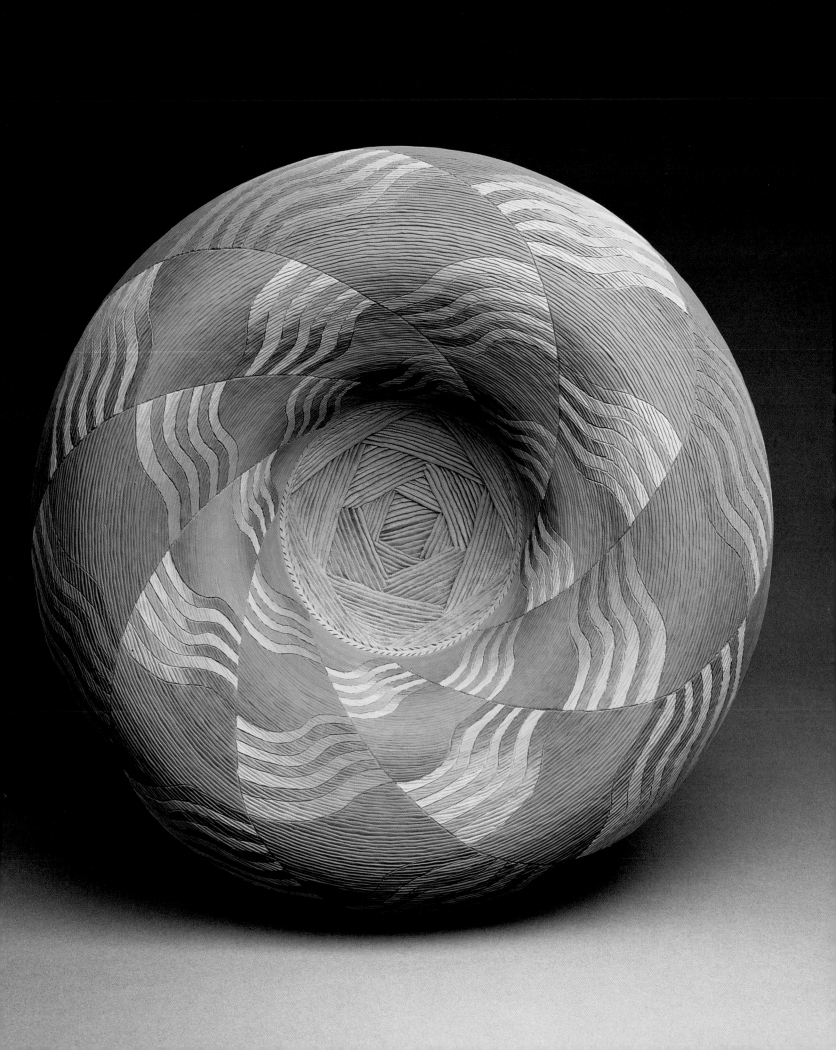

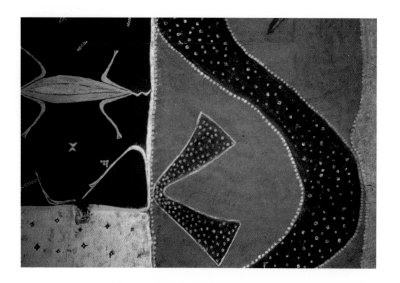

left
Folk art from Nigeria, Africa
Wall, Onitsa Shrine
Painted clay, contemporary ceremonial

below left
Vilma HENKELMAN, The Netherlands
African Lady, ht 59 in (150 cm)
Earthenware, engobes

below
Gillian HODGE, USA
Medea, 24 x 12 x 8 in (61 x 30 x 20 cm)
Indigenous clays, surfaced with ash and minerals;
reminiscent of a primitive mask

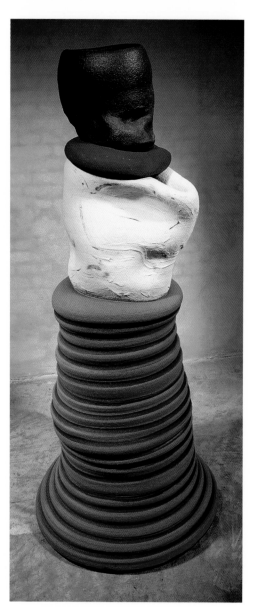

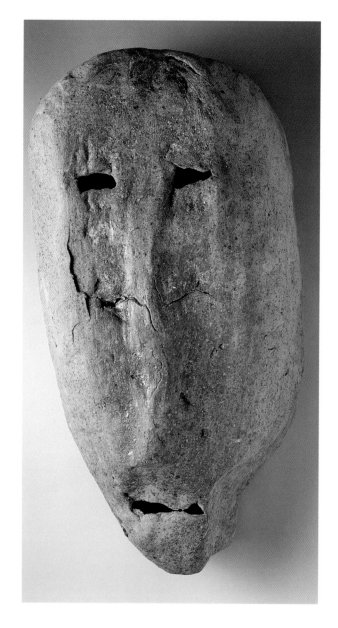

memory and experience. Personal creativity is an original act, not a function or a product of environment, such as folk traditions promote. The artist makes the choice to be as creative as his dichotomies permit.

One of the more interesting of continuing traditions in today's industrialized society is the ceremonial and ritualistic lifestyle still practised in the American Indian pueblos of the southwestern United States. These societies have made coil-built bonfired pottery for thousands of years, and still do. Among their people, however, are certain avant-garde potters who strive to cut new avenues from the old; a few are illustrated here.

Bill GRACE, Barbados
Reef Guardians, **37 x 28 in (94 x 71 cm)**
Stoneware, natural materials; reminiscent
of petroglyphs

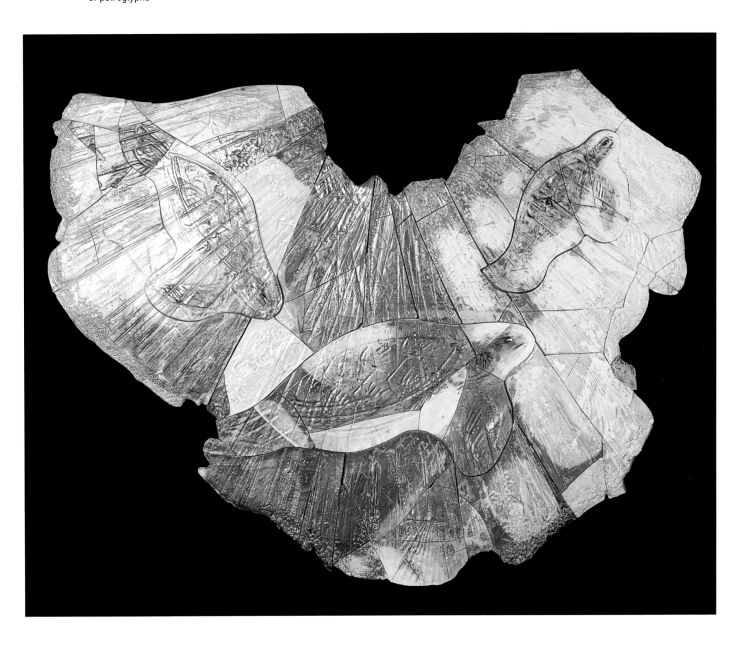

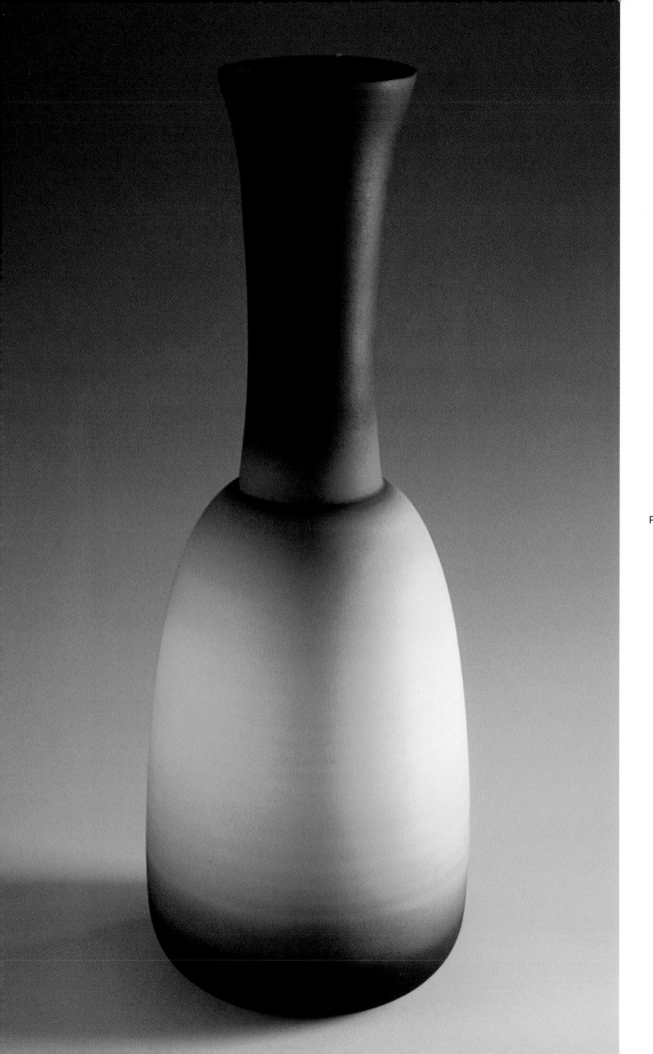

Peter LANE, UK
Sunrise, ht 9 in (23 cm)
Porcelain; African antecedents

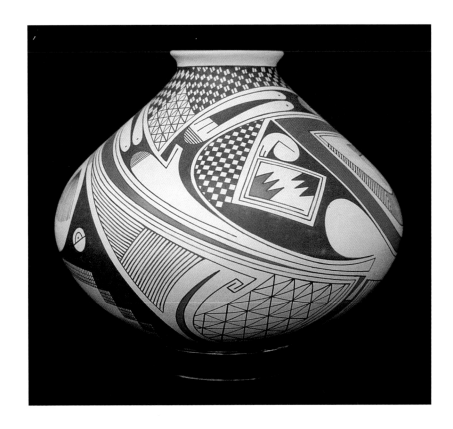

Juan QUESADA, Mexico
Olla, **9 x 9 in (23 x 23 cm)**
Earthenware, coil-built, burnished, natural pigments, bonfired; Casas Grandes style

Dorothy TORIVIO, USA
Miniature Bonfired Pot, **dia. 3 in (8 cm)**
Local clay, haematite pigment decoration, bonfired; American Indian tradition

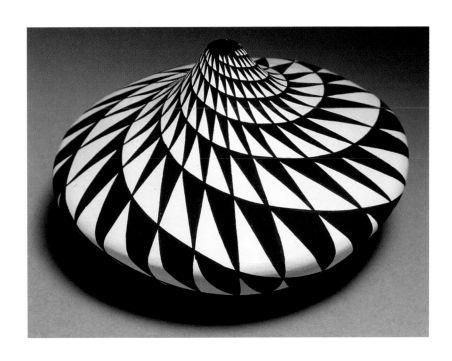

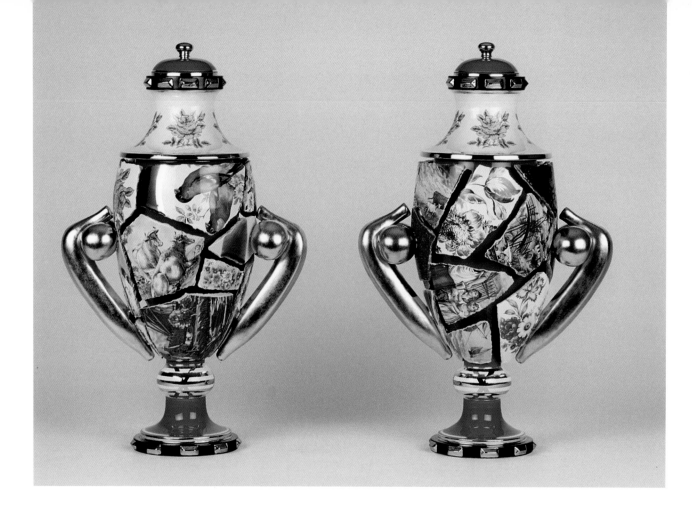

Richard MILETTE, Canada
Pair of Vases with Banana Handles, 25 x 10 x 5¹/₂ in (41 x 25 x 14 cm)
Earthenware; reminiscent of Sèvres porcelain, France

Grace MEDICINE FLOWER, USA
Miniature Vases with Incised Design, dia. 1¹/₂–2³/₄ in (3–7 cm)
Local clay, burnished, carved, bonfired; American Indian tradition

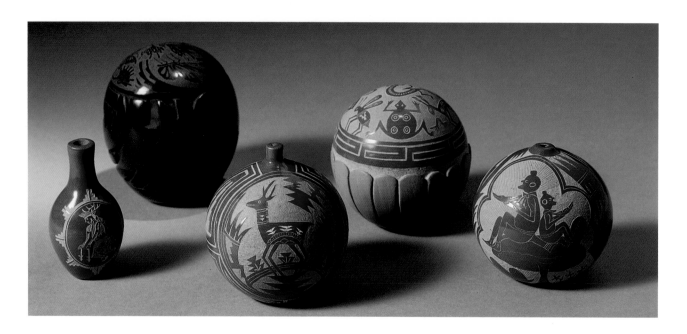

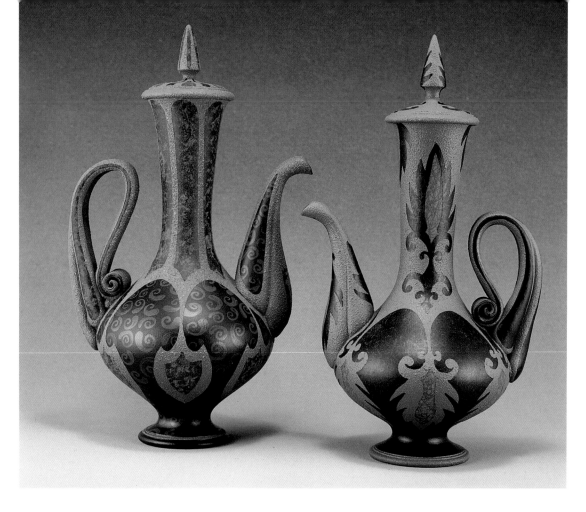

above
Greg PAYCE, Canada
Two Ewers, 27 and 30 in (68.5 and 76 cm)
Earthenware, natural clay sigillata; Attic Greek tradition

left
LI Ju-Sheng, China
Vase, 15 x 8 in (40 x 20 cm)
Porcelain, blue and white underglaze with red glaze; after Ming

below
Linda ARBUCKLE, USA
Notched Oval: Wisteria with Golden Handles,
13 x 9 x 8 in (33 x 23 x 20 cm)
Earthenware with majolica overglaze decoration; after Italian Renaissance majolica

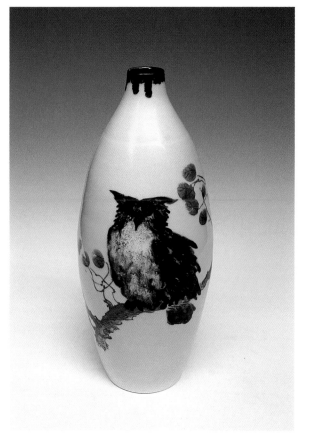

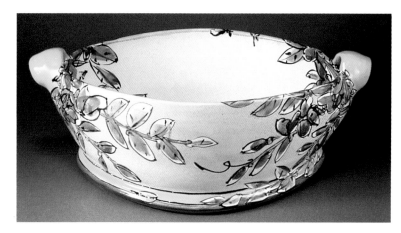

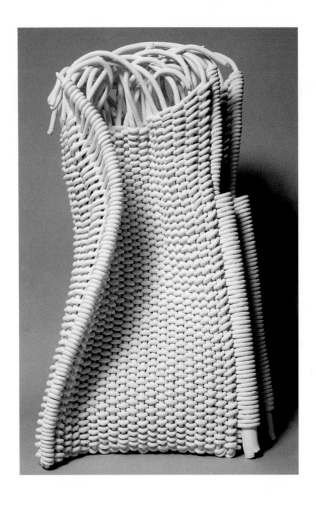

opposite
Andrea GILL, USA
Reverse Image, 26 x 20 x 12 in (182 x 51 x 30 cm)
Earthenware with engobe; with African implication

left
Rina PELEG, USA
White Basket Structure, 41 x 20 x 8 in
(104 x 51 x 20 cm)
Porcelain, coil-built

below
Nancy YOUNGBLOOD-LUGO, USA
Melon Bowl, 6½ x 13 in (16.5 x 33 cm)
Local clay, coil-built, carved, burnished,
bonfired, reduced black with horse manure;
American Indian tradition

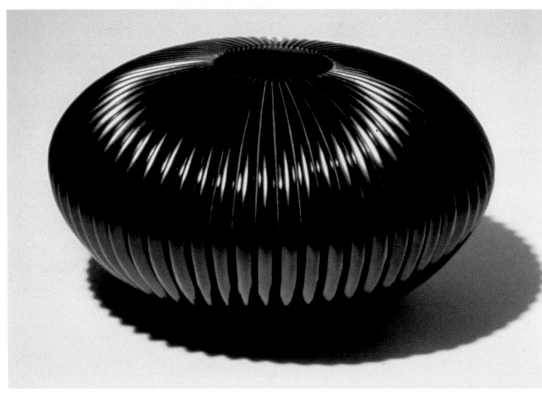

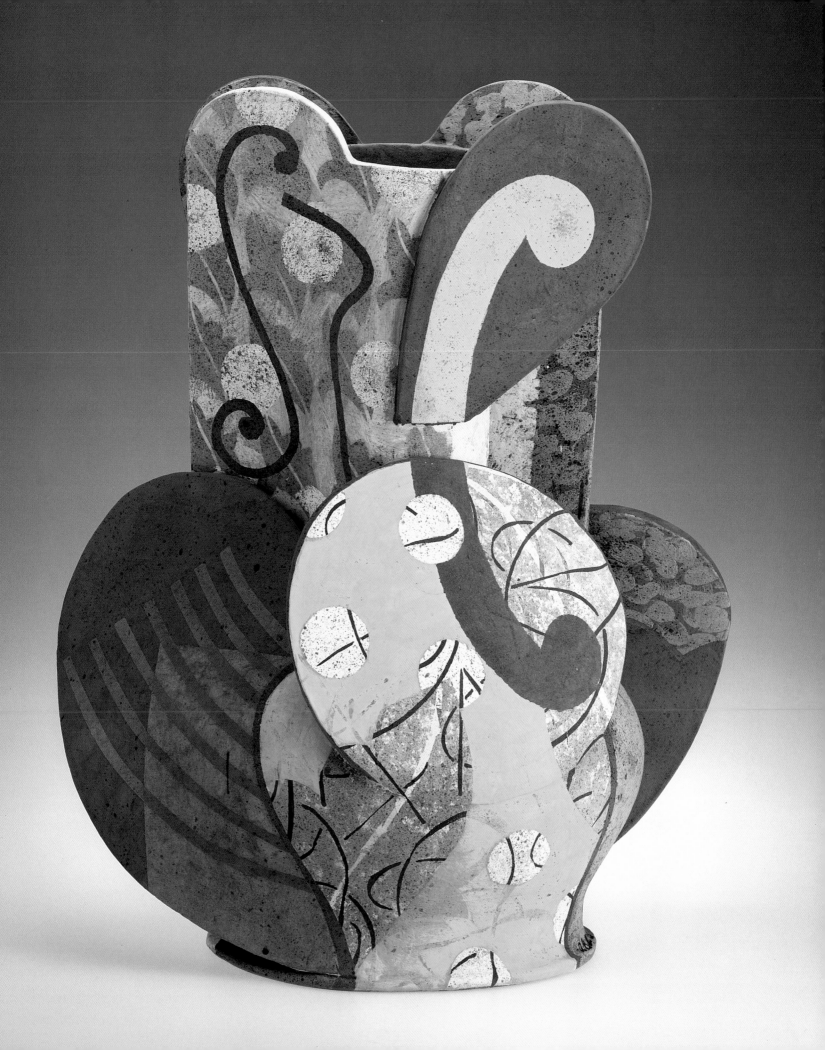

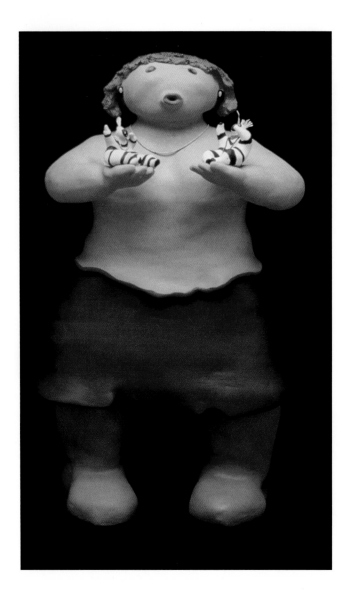

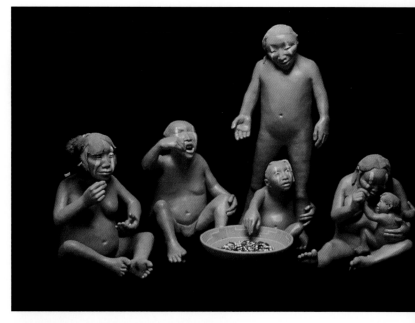

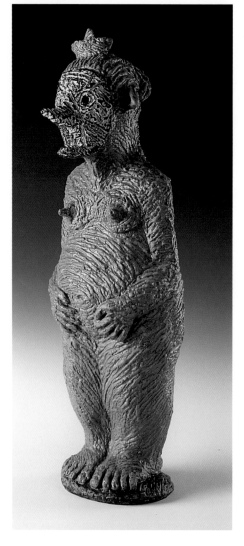

above
Nora NARANJO-MORSE, USA
Pearlene, 36 x 16 in (91 x 41 cm)
Local clay; American Indian tradition

above right
Roxanne SWENTZELL, USA
Tse-ping (Four figures and a bowl)
Figures ht 15½–31 in (39–79 cm); bowl 4 x 12½ in (10 x 32 cm)
Local clay, pigment decoration, kiln-fired; American Indian tradition

right
John McCUISTION, USA
Pre-Columbian Hostess, 28 x 9 x 8 in (71 x 23 x 20 cm)
Stoneware, oxidation fired; Central American Indian tradition

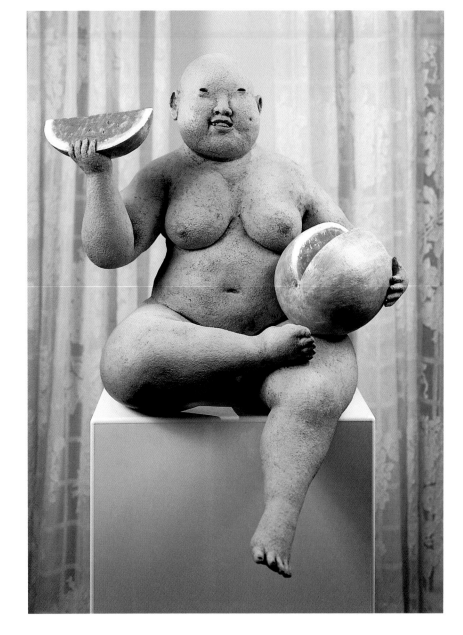

right
Esther SHIMAZU, USA
Untitled, ht 17 in (43 cm)
Earthenware, oxide wash; Mayan antecedents

below
LU Xiao-Ping, China
Shadow no. 3 1999, 13 x 9½ x 13 in (33 x 24 x 33 cm)
Redware clay (Zisha clay)

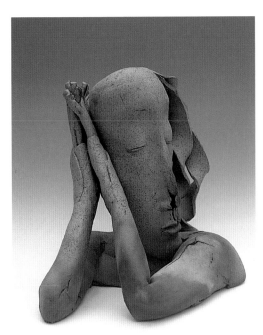

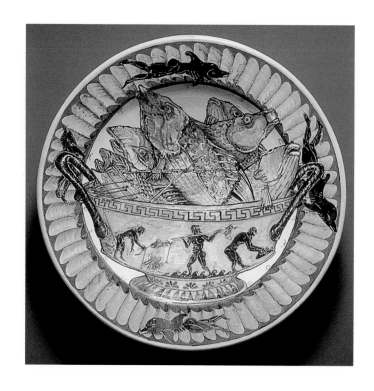

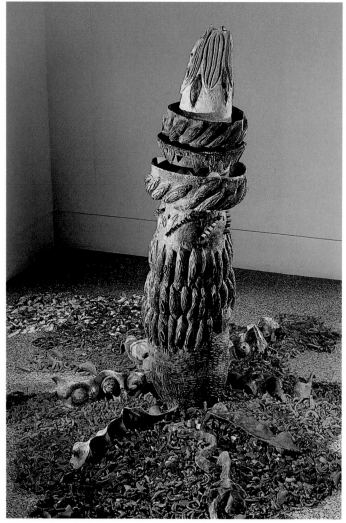

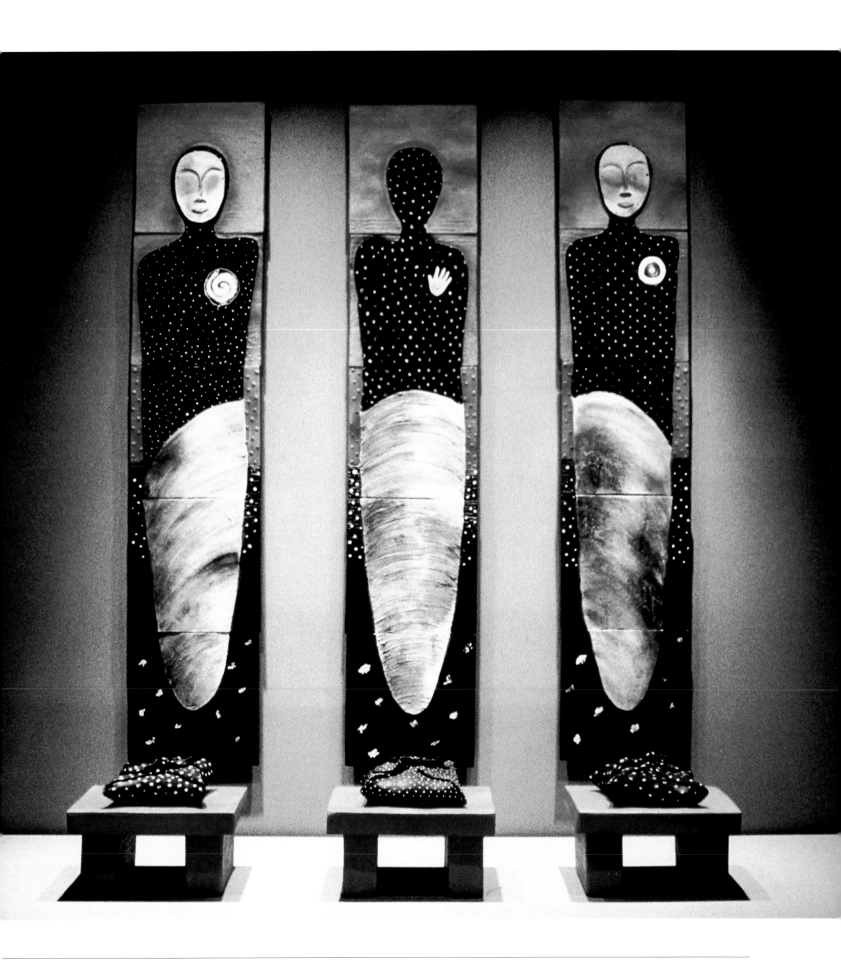

walls, tiles and mosaics

MAN HAS MADE MODULAR UNITS called tiles since the beginning of time from all kinds of clay, some for walking on and building from, some decorated for façades and walls. For hundreds of years the Portuguese, Spanish, Latin Americans and Italians have been famous for their brightly coloured, majolica-decorated tiles, the Persians for abstractly painted tiles covering mosques – many in lustre techniques – and the Chinese for large, hollow, three-dimensional tiles for screens, walls and roofs. Earlier, the Greeks and Romans were adept at fitting bits and pieces of clay mosaics into elegant patterns on walls and floors.

In the United States, functional and decorative tiles were partly or entirely hand-made, beginning in colonial times; among the most well-known traditional tile producers still functioning are Pewabic, founded in 1850 in Detroit, Michigan, and the Moravian Pottery and Tile Works, founded in 1898 in Doylestown, Pennsylvania.

Semi-vitreous glazed whiteware tiles for floors, walls and counters have been mass-produced everywhere, and in some countries stoneware and porcelain tiles are made. Unglazed architectural tile, modelled three-dimensionally, is commonly manufactured in many countries.

Today some ceramic artists are fabricating by hand large modular units for floors, walls and façades. Others are using commercially produced tiles as backgrounds for glazed decoration. A few commercial plants around the world, such as Arabia in Finland, Sant'Anna (since the eighteenth century) and Viuva Lamego (from the nineteenth century) in Portugal, Otsuka in Shigaraki, Japan, and Kohler in the United States have welcomed artists to experiment with their products, making sculptures, installations or vessels in their factories.

In Los Angeles, Dennis Caffrey, of The Tile Guild, Inc., produces 30,000 majolica-decorated tiles a month to sell, and has established an artist-in-residence programme with a studio where artists with substantial tile commissions can execute their work. Caffrey's programme offers kiln capacity of up to 750 square feet of tile per day.

Famous architects of the past, such as Gaudí and Frank Lloyd Wright, decorated the façades of their buildings with mosaics of crushed rock, ceramic and carved concrete. It has ever been thus. Painters such as Chagall, Matisse, Picasso and Miró installed their ceramic walls in sites throughout Europe and the United States. Today the ideas of contemporary clay artists for individual wall pieces, fireplaces, entire walls, building structures and freestanding walls have become expressions of 'fine art'.

Bruce BRECKENRIDGE, USA
Madison No.26, **78 x 72 x 10 in**
(1.98 x 1.83 m x 25 cm)
Earthenware, majolica glaze

Aurore CHABOT, USA
Cellular Synchronicity, **IEW-E**
mural, **12 ft 6 in x 20 ft x 1 in**
(3.8 x 6 m x 2.5 cm)
Glazed ceramic tile

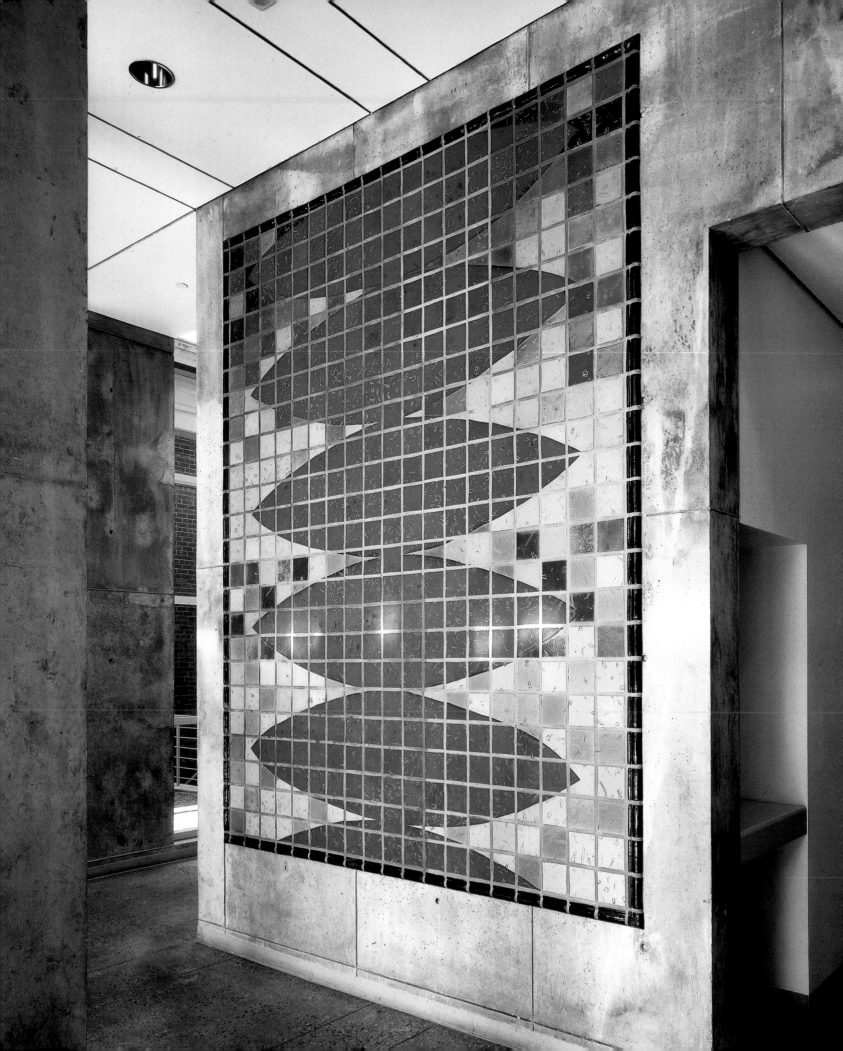

Ivana ENEVA, Bulgaria
Plant,
55 x 20 x 6 in
(140 x 50 x 15 cm)
Stoneware, glaze,
oxidation fired

BAI Lei, China
Broken Wall,
23 x 19 x ³/₄ in (58 x 49 x 2 cm)
Stoneware, woodfired

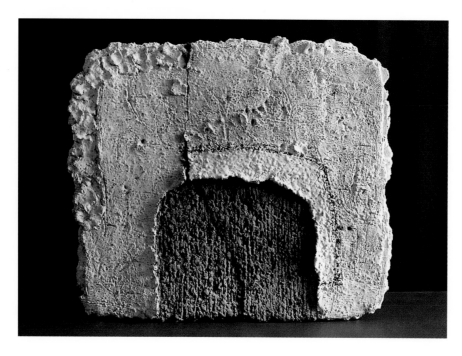

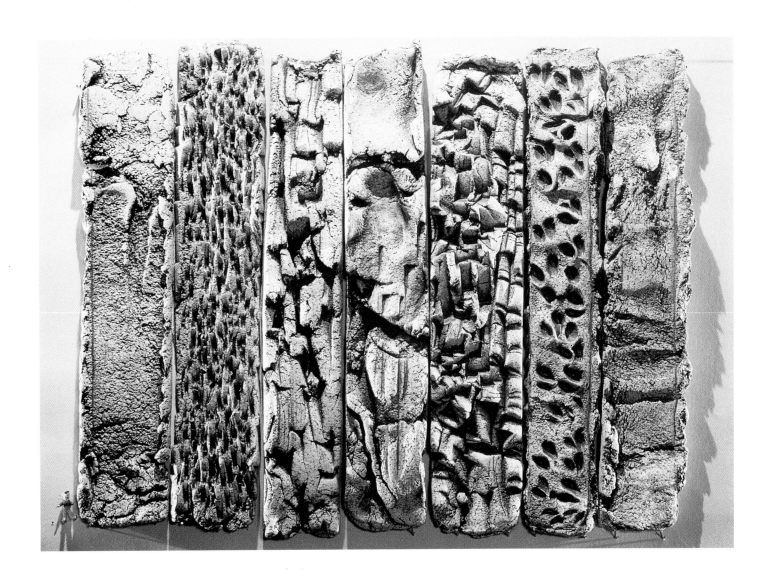

Yvette Hoch MINTZBERG, Canada
Maquette for Climbing Wall,
14 x 17 in (35 x 43 cm)
Stoneware, oxides

Robert WINOKUR, USA
Divided Wall, 14¹/₂ x 44¹/₂ x 7 in
(37 x 113 x 18 cm)
Brick clay, engobes, salt-glazed

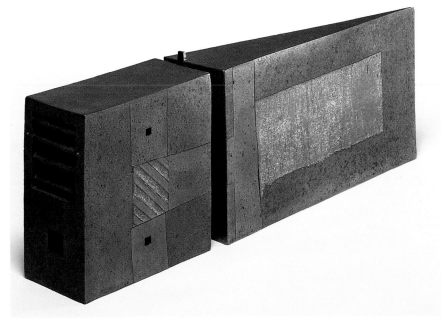

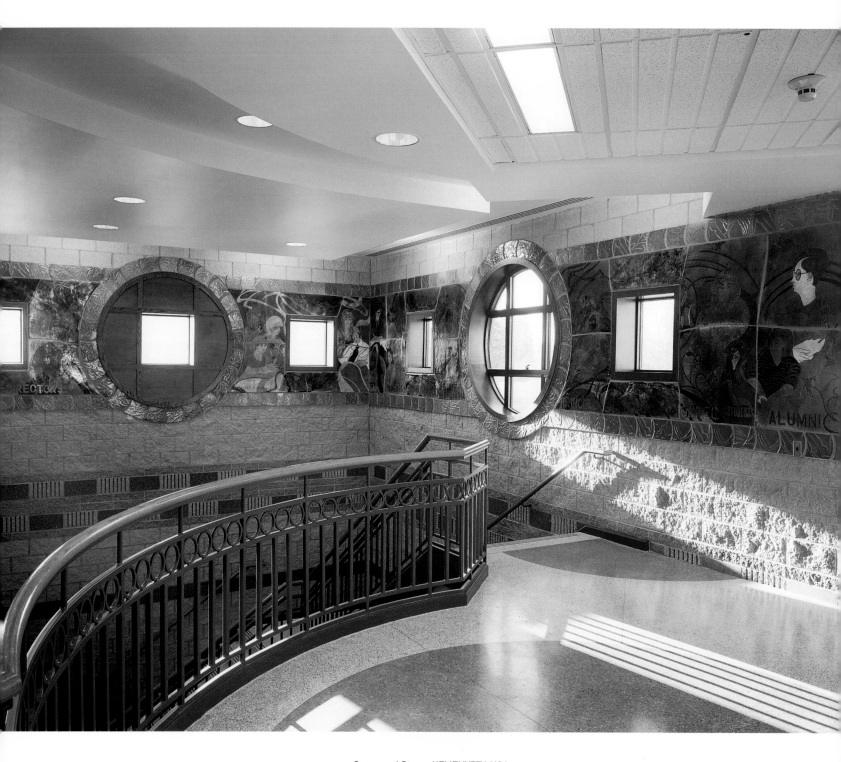

Susan and Steven KEMENYFFY, USA
East High School – South Wall, **50 x 5 ft (15.24 x 1.52 m)**
Stoneware, raku

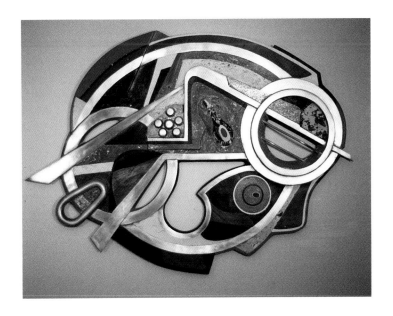

Bobby SCROGGINS, USA
A Forgotten Dream, **46 x 54 x 6 in (117 x 137 x 15 cm)**
Stoneware, mixed media

Karen KOBLITZ, USA
Orvieto Red Rooster Lunette, **23 x 41$\frac{1}{2}$ x 5$\frac{1}{2}$ in (58 x 105 x 14 cm)**
Earthenware, underglazes, glazes

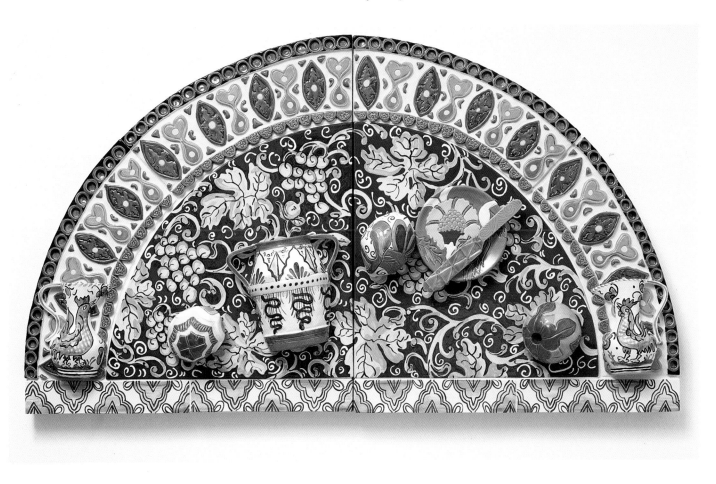

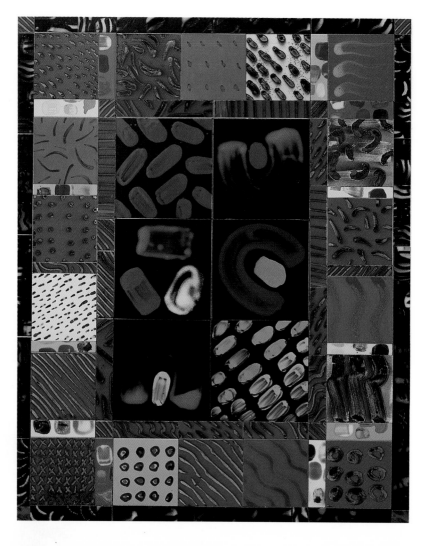

Marylyn DINTENFASS, USA
Negeve Imprint, 48 x 60 in
(122 x 152 cm)
White earthenware, low-fire glazes

Päivi ERNKVIST, Sweden
Satra, 48 x 30 in (122 x 76 cm)
Glazed porcelain

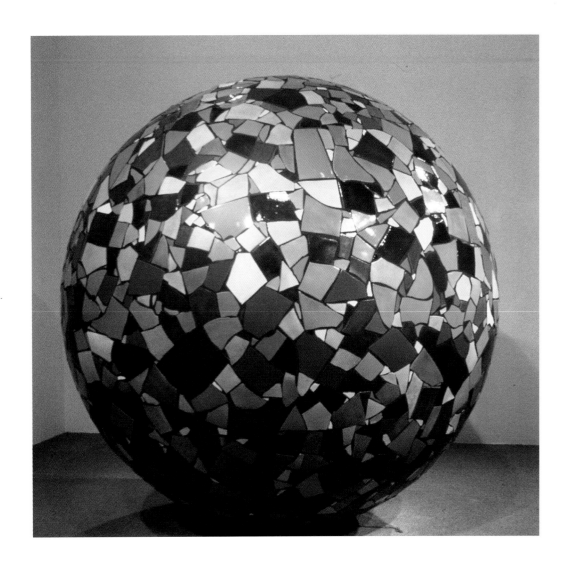

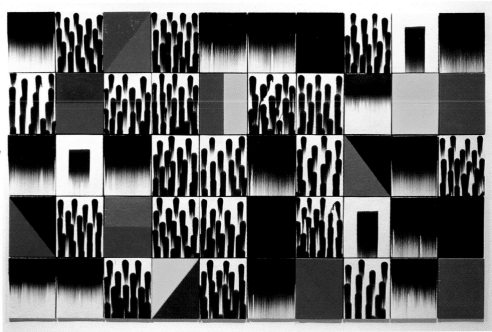

Gifford MYERS, USA
BIG WORLD small planet (for
Thom Chambers),
dia. 96 in (244 cm)
Earthenware, foam, steel, plaster

Jun KANEKO, USA
Dutch Wall, Image of Tulip,
7 ft 3 in x 21 ft 4 in (2.2 x 6.5 m)
White earthenware, low-fire glazes

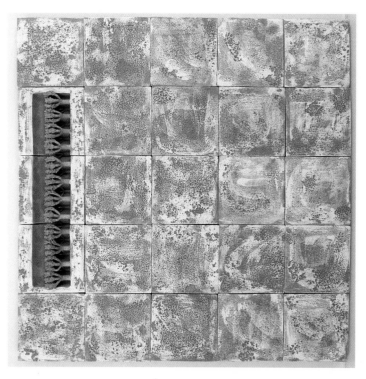

Gianfranco BUDINI, Italy
Agonia Amazzonica (Amazon Agony),
39 x 39 in (100 x 100 cm)
Eroded earthenware

Jeanne OTIS, USA
Solstice Vigil, $10^3/_4$ x 96 x $^1/_2$ in (27 x 244 x 1.25 cm)
Engobes, glaze, overglazes

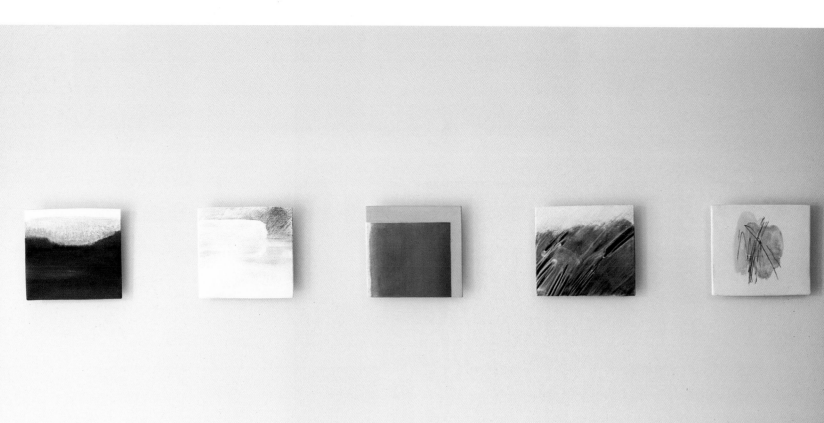

Pekka PAIKKARI, Finland
The Flow of Time,
79 x 118 x 59 in
(200 x 300 x 150 cm)
Bricks, stoneware

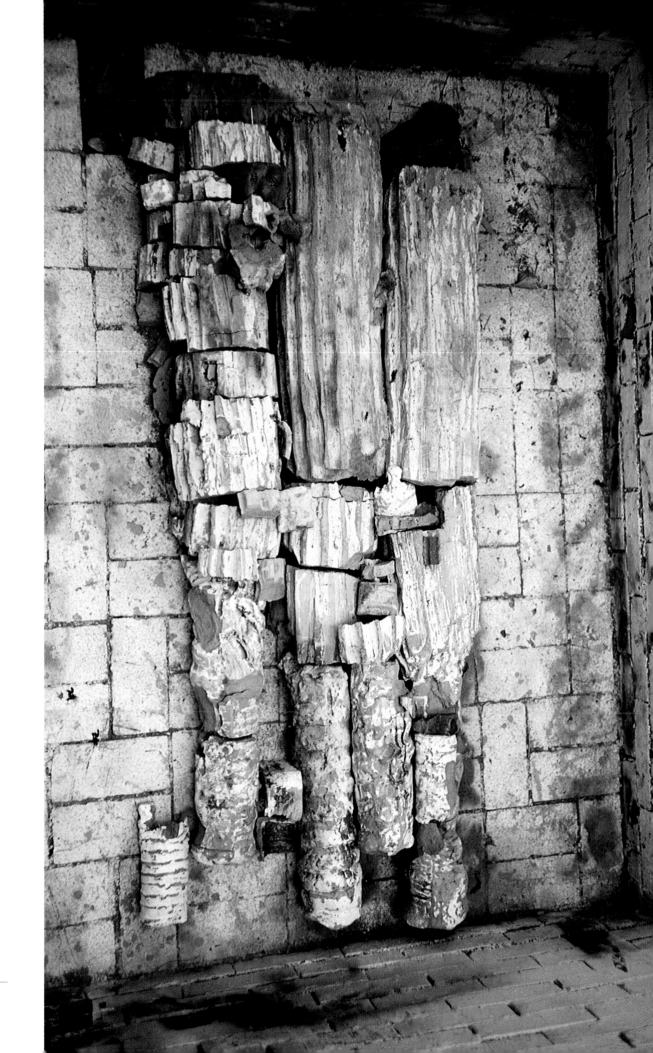

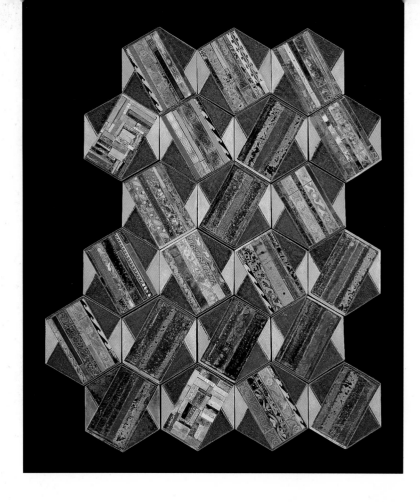

opposite
P.R. DAROZ, India
Door, ht 7ft (2.13 m)
Stoneware

left
Susan TUNICK, USA
Untitled, 45 x 37 x 1 in (114 x 94 x 2.5 cm)
Earthenware mosaic, glazed

below
John H. STEPHENSON, USA
Zone Two, 22 x 28¹/₄ x 3¹/₂ in (56 x 72 x 9 cm)
Earthenware, glazes

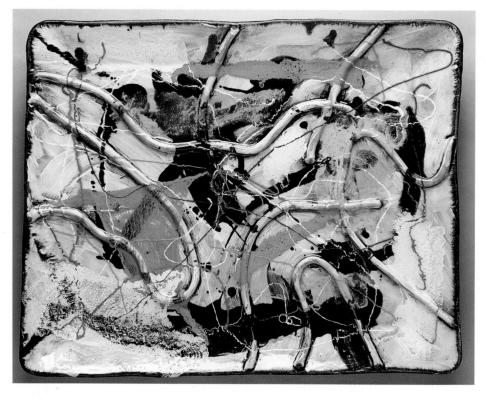

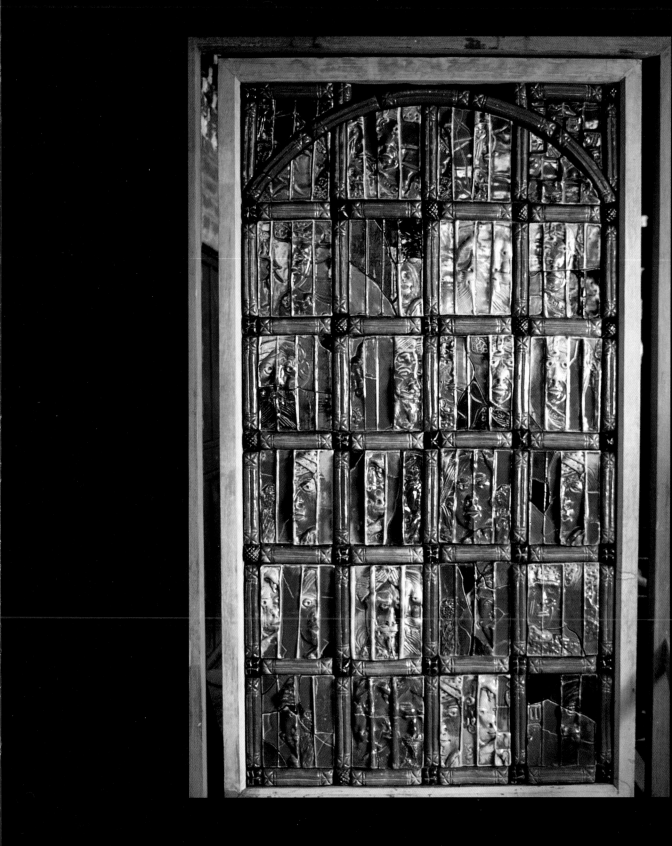

the artists

Jane Ford AEBERSOLD, USA page 29
B. 1941 in San Angelo, Texas. She received her MFA from Alfred University, New York, in 1971. A retired Professor of Art at Bennington College, she has been awarded an NEA Fellowship. Her studio is in Williamsburg, Virginia.

'I first really understood how wonderful pots can be when, in the late 60s, I came upon the many volumes of the 1956 edition of the Catalogue of the World's Ceramics. I have since aspired to make work as beautiful as "Fuyo", an Iga ware flower vase, and to think out of the box.'

AH-Leon, Taiwan page 53
B. 1953 in Taiwan. In 1976 he graduated from the National Taiwan Academy of Arts. He has travelled and lectured throughout the world. He lives and work in Taipei, Taiwan.

Dan ANDERSON, USA page 30
B. 1945 in St Paul, Minnesota. He received his MFA from Cranbrook Academy of Art, Michigan, in 1970. Anderson is Area Head of Ceramics at Southern Illinois University.

'My "water towers" and "gas/oil cans", an amalgam of vessel and industrial object, are full of irony – handmade replicas of machine-made objects – soft clay rendering soft objects, aged and impotent reminders of a once powerful era. The usefulness of machines in their original state is limited – as the products of progress, they are doomed to obsolescence – but by recreating them in clay (a "primitive" material), I believe they will endure through the ages.'

Linda ARBUCKLE, USA page 145
She gained her MFA from Rhode Island School of Design. She teaches ceramics at the University of Florida in Gainesville. She is the recipient of many awards and honours including a 1998 University of Florida Research Foundation Professorship.

'I like a practical form with spontaneous brushwork on its surface. Modulated colour and lively line quality add zip to the surface within an organized motif.'

Rudy AUTIO, USA page 112
B. Butte, Montana, in 1926. He headed the ceramics department at the University of Montana for 28 years and is now retired. He was a founding resident artist at the Archie Bray Foundation in Helena, Montana.

'My current work with the image in clay is really a reaffirmation of my interest in drawing the figure even though it has gone through many changes.'

Ralph BACERRA, USA page 54
B. Garden Grove, California, in 1938. He went to Chouinard Art Institute, Los Angeles, and received his BFA in 1961. He taught at Chouinard Art Institute before becoming Head of Ceramics at Otis Art Institute, California. His studio is located in Eagle Rock, California.

BAI Lei, China page 154
B. 1963 in Yu-gan county, Jiangxi Province. His work has won several awards including the Tokyo Ceramic Art Exhibition, Japan, and grand prize at the Fourth National Ceramic Art Review Exhibition, China. In 1998–9 his works were featured in the Chinese magazine Contemporary World Ceramic Art.

'Using the complex techniques of clay, glaze and kiln fire, I infuse these artworks profusely with humanity and cultural meanings. They arouse the spectator's imagination to those ancient broken walls weathered through thousands of years of rain and wind.'

BAI Ming, China page 22
B. 1964 in Yu-gan county, Jiangxi Province, he teaches at the Chinese Central Academy of Arts and Design. He is active in the fields of both ceramic art and abstract painting, and is also a member of the Chinese Oil Painting Committee.

'China's ancient civilization, attenuated by time and weather, nevertheless retains an everlasting spiritual magic, which provides me with my inspiration. My works express thoughts and feelings on change and the evolution of both human life and nature, and the way in which the spiritual dimension has been absorbed into clay by the passing of time.'

Clayton BAILEY, USA page 110
B. 1939 in Antigo, Wisconsin, he earned his BS and MS degrees from the University of Wisconsin at Madison. He has received many honours including the National Endowment for the Arts Fellowship in 1990.

'I like the magic of converting mud into stone.'

Gordon BALDWIN, UK page 49
He trained in Lincoln and at the Central School of Art and Design, London (1950–3). He is an Honorary Member of Contemporary Applied Arts in London.

'I work as an explorer. Each piece is a further movement into the unknown. I hope to visit with them spaces in the mind I have not been to before. I have no ultimate goal and no plans. I work at each piece until the event concludes itself and then start again.'

John BALISTRERI, USA page 77
He received his MFA from Kent State University in 1988. He lives in Ohio where he is an Assistant Professor at Bowling Green State University.

'My recent work continues to involve the ancient process of wood-firing, which I began concentrating on in 1994. The process is an attempt to make objects that resonate with age, both geological and human, transforming them into contemporary artefacts. This ties our contemporary condition to geological and human history, and also serves as a specific commentary on the genre of wood-firing.'

Bennett BEAN, USA page 46
B. Cincinnati, Ohio, in 1941, he received his MFA from Claremont Graduate School in 1966. His work is in the Whitney Museum of American Art, New York, and the 20th Anniversary Collection of The Studio Potter.

'I don't think most artists have more than four or five ideas in their lives that they find interesting enough to entertain them for the duration. Some that I am still exploring are to do with presentation: how you put an object into the work yet separate it from the world. Another is the idea of control, which in my case takes the form of refusing to let the fire have the last word.'

Jeroen BECHTOLD, The Netherlands page 91
B. 1953 in The Netherlands, he received his BA in ceramics from the Rietveld Academy. He lives and works in The Netherlands, maintains his own gallery, and is a visual computer expert.

'I do not make drawings in the traditional way. I visualize by means of computer as well as clay. Both have their own language and by speaking both, I allow them to interact. Sometimes the virtual object is the result of what started off in clay or in plaster, and sometimes a clay object results from the visual search for the right shape – like the teapot that began from my virtual daydreaming and was finally made in cooperation with Ku Wie Fen in Yi-Xing, China.'

Karin BJöRQUIST, Sweden page 88
B. Saffle, Sweden. She was a designer at the Gustavsberg Porcelain Factory from 1950 to 1986, since when she has been a freelance designer for the Hackman-Rostrand Company. She has won several awards including a Gold Medal at the Milan Triennale in 1945, the Lunning Prize in 1963, the Prince Eugen Medal in 1982 and the Swedish Excellence Award in 1987 and 1992. She designed the porcelain service for the centenary celebration for all living Nobel Laureates, made at Gustavsberg.

'Most of my life I have been designing everyday articles for mass-production, tableware and flowerpots. Also my Nobel Service is, before decoration, a basic design, for a banquet. In the studio I have created many unique objects and together with architects designed ceramic details for public building interiors, tiles for subway walls, and fountains.'

Gina BOBROWSKI, USA page 117
She studied at the Penland School of Crafts, Louisiana State University and the University of Georgia, Athens. Awards include the National Endowment for the Arts Fellowship; the Louisiana Division of the Arts Artist's Fellowship and the Mayor's Award, Corona, Italy.

'My work questions traditional ideas of beauty through intuitively derived form, arcane imagery and complex surface relationships. It communicates predominantly as a visual language that is highly physical, obsessive, intimate and narrative through a loose stream of associations. The figure, human or animal, represents the body, the vessel for the soul.'

Mary Jo BOLE, USA page 137
She earned her BFA and MFA at New York State College of Ceramics, Alfred University. She has received many grants including three from the Ohio Arts Council and a Research Grant from Ohio State University, where she is currently a Professor.

'My First Dutch Lesson is intended as a poignant tribute to the death of a child; the imagery, coloration and complete skinning in mosaic are for visual enticement and sincerity. While the lambs' noses almost touch, they are finally united above in the entwined, exploding fireworks. The other side of REST says RUST, the Dutch translation and hence the title.'

Joe BOVA, USA page 104
A Professor of Art at Ohio University at Athens since 1990, he studied in his native city at the University of Houston, Texas, and the University of New Mexico where he earned his MA in 1969.

'What the I Ching says about grace below is as close to a truth as I know about what are my concerns in work with clay. The I Ching says that the most perfect grace consists not in external ornamentation but in allowing the original material to stand forth, beautified by being given form.'

Robert BRADY, USA page 120
B. Reno, Nevada, in 1946. He received his MFA from the University of California at Davis in 1975. He is Professor of Art at the University of California at Sacramento. He is the recipient of two National Endowment for the Arts Fellowships.

'For the 70s and most of the 80s I explored ceramic sculpture. Beginning in the late 80s, I shifted to the use of wood. My subject is almost always the human figure and I intend for the sculptures to speak in a universal sense about the human condition, history, religion and myth. Equally important to me is the "conversation", or even ritual, that occurs between myself, the materials and the process: making decisions about ideas, appropriateness, scale, proportions, form, mass, volume, texture and so on, while at the same time hoping to suspend my ego so as to possibly learn as much as I impose in something I value and strive for. I am as excited today as I was in the beginning.'

Bruce BRECKENRIDGE, USA page 152
B. Chicago in 1929. He gained his MFA from Cranbrook Academy of Art in 1953. He has been a Professor of Art at the University of Wisconsin at Madison since 1968.

'My major preoccupation has been describing and defining space through the manipulation of colour. Recently, I have relied on a system based on the arrangement of geometric and architectonic images. Although the work often seems to take several concurrent directions, the impetus for creating it remains constant.'

Cynthia BRINGLE, USA page 104
B. Memphis, Tennessee, in 1939. She received her MFA from New York State College of Ceramics, Alfred University. She has had a working studio and gallery in Penland, North Carolina, since 1970.

'I feel fortunate to have found what really suits my heart and soul to do and make a living at.'

Harriet BRISSON, USA page 32
She studied ceramics and sculpture at Rhode Island School of Design and Ohio University. Having retired from teaching at Rhode Island College after 28 years, she now gives presentations and workshops.

'I approach my work with an educated intuition learned from the medium. The clay and surface treatment is selected and the work submitted to fire for completion. The result is random surface combined with highly ordered form.'

William BROUILLARD, USA page 150
Since 1969 he has taught ceramics at the Cleveland Institute of Art. He earned his MFA from New York State College of Ceramics, Alfred University, in 1976. He has been the recipient of many awards and honours including a Purchase Award in 1992 from the National Cup Show at the University of Southern Illinois.

'My most recent work is based on several ceramic traditions:

one tradition used ceramic vessels to tell stories and demonstrate wealth, and another used visual and verbal puns on vessels. I also try to inject familiar objects from the natural world and the man-made environment into the decorative/commemorative object.'

Gianfranco BUDINI, Italy page 160
B. 1941 in Piacenza, Italy. He studied for his MA at the National Institute of Art, Faenza, receiving his degree in 1960. He is Professor of Art at the National Institute of Ceramic Arts, Faenza.
'The voice of nature and the expression of artistic creation form the border to new explorations on the threshold of the third millennium.'

Peter CALLAS, USA page 31
B. Jersey City, New Jersey, in 1951. He received his Fine Arts degree at the University of Puget Sound. He then was a resident at the Archie Bray Foundation. Currently, his studio and anagama kiln are in New Jersey.
'History reflects the achievements of wood-firing over centuries of multiple use applications. Regarding the merits of anagama kilns, it is an elusive art form, but as a tool for modern art, this type of wood-fire kiln has helped me to reach pinnacles of self-expression.'

Keith CAMPBELL, Canada page 114
B. 1947 in Hamilton, Ontario, he studied at the Sheridan College School of Design. He has received over 30 awards, as well as grants from the Ontario Arts Council and the Canada Council. He is a Professor at Candor College, Ontario.
'The exploration and development of the vessel as a decorative object in both a functional and a sculptural aspect has been my main quest, using historical and contemporary forms, integrating innovative techniques such as airbrushing, flocking and applying lustre to achieve the ultimate effect.'

Seth CARDEW, UK page 116
B. 1934 at Winchcombe Pottery, Glos. He attended the Chelsea and Camberwell Schools of Art, taking a sculpture degree in 1960. He has worked at the Wenford Bridge Pottery in Cornwall for 25 years.
'I work in the idiom of my father Michael Cardew – who believed that pots should be useful – but in a different discipline, imparting a more visual appeal.'

Nino CARUSO, Italy page 80
B. 1930 in Rome. He has been making architectural façades and installations for many years throughout Europe.

Claudi CASANOVAS, Spain page 30
B. Barcelona in 1956. He first studied for the theatre in Barcelona and then trained as a ceramicist in Olot, Catalonia. In 1985 he won the Emilia Romagna Prize in Faenza and in 1986 the Grand Prix at the Vallauris Biennale, as well as first prize in the Third International Ceramics Competition in Mino, Japan.
'All that I learn in ceramics seems to be something that I forget completely. With each new piece either this comes back or it does not. One thing I don't know: once a finished piece disappears, in time or place, it is always a surprise when I see it again.'

Aurore CHABOT, USA page 153
She received her MFA from the University of Colorado at Boulder in 1981. Among her many grant awards she received fellowships from the Western State Arts Federation and the National Endowment for the Arts. She is Associate Professor at the University of Arizona at Tucson.
'I am guided by the seemingly discordant sensibilities of architectural, geometric or organic systems to create hybrid forms of sculpture. The pieces grow out of my meditations of time past and present, on the making and unmaking of the earth, and on what we can and cannot know from the palaeontological, geological and archaeological clues left by the earth's constantly changing cycles.'

Paul CHALEFF, USA page 64
B. 1947, he received his BA and MFA from the City University of New York. He also studied in Japan periodically between 1976 and 1981. He now lives and works in Pine Plains, New York.
'My recent works suggest primitive machines that imply the production of something to benefit many. These works exist without explicit historical contexts. The use of carving and pounding processes, as well as the layering of glazes, make these sculptures appear to be fabricated of either stone or metal. Their large scale and mass invite viewers to interact with them physically.'

John CHALKE, Canada page 18
B. England in 1940. He received his art training, from 1959 to 1962, and Teacher's Certificate in Art Education at Bath Academy of Art. He moved to Canada in 1968. He has since taught at both major Alberta universities and at the Alberta College of Art.
'All my kiln firings have contained glaze tests. A firing is not complete without these. What's more important, though, is what one is left with. At present there is a culled remainder of merely 20 glazes. I use cryolite from Greenland, barytes from Germany, talc from Wyoming, syenites from Ontario, and bone ash from South America.'

Ruth CHAMBERS, Canada page 25
B. Toronto, Ontario, in 1960. She attended Ontario College of Art and received her MFA from the University of Regina in 1994. She is an Assistant Professor at the University of Regina.
'Recent work uses the metaphors of internal organs, specifically the lungs, to explore relationships between materiality and immateriality, interiority and exteriority and the tangible and intangible. The history of anatomy and the overlay of ancient and contemporary media are important influences.'

CHEN Guang-Hui, China page 93
B. 1969. He received his MFA from New York State College of Ceramics, Alfred University, in 1998. He is the Head of the Ceramic Department at the Fine Art Academy of Shanghai University, China.
'As a form, the chair has a sense of position in culture, background and history. Even in the present, where one questions the issue of a computer generation versus nature, the form means something to everyone. Clay, a material with a history of its own, can help me find the answers to my questions. I have conversations with the clay and through glazing and the process of firing, which helps me clarify things.'

Cynthia CHUANG and Erh-Ping TSAI, USA page 24
Cynthia Chuang and her husband, Erh-Ping Tsai, were born in Taiwan. They graduated from the National Taiwan Academy of Arts and went on to earn MFA degrees from Parson School of Design in New York City.
'We studied Egyptian imperial jewellery, Oriental ceramic technology and folk arts for the making of everything from vases for emperors to Chau-ji ceramic, a decoration in Buddhist temples. The ideas for our designs come partly from these interests, but mainly from nature, including plants and animals.'

Sam CHUNG, USA page 91
B. 1970 in Minneapolis, Minnesota. He earned his MFA from Arizona State University, Tempe, in 1997. He has won numerous awards throughout the USA and is now Assistant Professor at Northern Michigan University, Marquette.
'I would like my pots to reveal a reverence for the history of the pottery-making tradition as well as present themselves as functional objects that make light of our own rituals. The pottery from the Koryo Dynasty in Korea and the Sung Dynasty in China reflect a refined elegance where beauty could be found in utility and vice versa. There is both a visual and a tactile preciousness to these pieces which have inspired my own forms.'

Antonella CIMATTI, Italy back cover
B. Faenza, Italy, in 1956. She studied ceramics, painting and art history at the Academy of Art, Bologna, in 1979 and the Italian National Institute of Ceramic Art, Faenza, in 1973 and 1975.
'My work is developed from observations of artistic forms produced in the past, which I then interpret into the construction of a functional object. The forms created are aesthetically accurate. They don't hide behind anything, instead they display a strong sense of femininity, grace, elegance and attention to detail.'

Jimmy CLARK, USA page 16
Since 1986 Executive Director of The Clay Studio, Philadelphia. He is President of the Board of the Greater Philadelphia Cultural Alliance and a member of the board of the Old City Arts Association. Awards include the First Prize at the Berlin Crafts Competition and the outstanding work award at the 1989 Studio Days exhibition, Chester Springs Studio, Pennsylvania.
'My work is an attempt to connect with the spirit and purity of the archaic. I find that certain primal forms encompass a universal appeal that bridges cultural differences and outlasts the passage of time. I approach the creation of these forms with an intuitive understanding as opposed to a cerebral preconception. I employ almost exclusively the ancient handbuilding technique of pinching, and restrict myself to forming the piece out of a single ball of clay. I

rarely begin with a preconceived notion of desired shape, but rather allow the vessel to grow into its final form.'

Tom COLEMAN, USA page 43
B. 1945 in Amarillo, Texas, he received his MA and MFA from Pacific Northwest College of Art in Portland, Oregon. He was awarded the Kurt Fax Award of Excellence as well as the Metropolitan Arts Commission Purchase Award to build the East Creek Anagama in Oregon.
'Since I moved to Las Vegas 12 years ago, my work reflects the surrounding environment. The new work involves the bright colours of downtown with a touch of the scratched, cracked earth of the desert.'

Philip CORNELIUS, USA page 135
B. 1934 in San Bernardino, California, he earned his MFA from Claremont Graduate School in Ceramics. He has received two National Endowment for the Arts Fellowships and is currently a Professor at Pasadena City College in California.
'In 1970 I began to concentrate on teapots and allied vessels. There were two reasons which brought me to this conclusion. The first was because no one was working on teapots at this time and the second was because I would be free to create, from my own point of view, a new vision for the teapot. Working with clay is like having a conversation with your maker.'

Anne CURRIER, USA page 77
B. Louisville, Kentucky, in 1950, now Associate Professor at the New York State College of Ceramics, Alfred University. She has been awarded many grants and fellowships, including a Visual Arts Fellowship from the National Endowment for the Arts.
'The ceramic sculptures express my curiosity about the physical and visual exchange of masses and voids in space. The use of light, shadow, projections and recession parallels the content and intention. Colour and texture enhance the ambiguity between the visual perception of surface and the reality of touch.'

Val CUSHING, USA page 84
B. Rochester, New York, in 1931. He received his education at the New York State College of Ceramics, Alfred University. He taught at the University of Illinois at Champaign-Urbana, and is now a retired professor of pottery at Alfred University.
'I search for a resolution where the useful and the beautiful have one voice. Pottery carries a message of life and humanity. To me, it is a symbol of the home. I want people to touch the pieces and I try to give my work sensuous qualities. I want my work to be seen and used in a home, where its presence might quietly add to the pleasures of daily living.'

Jim DANISH, USA page 62
He earned his MA from California State University, Humboldt. Both he and his wife have provided ceramic technical and design assistance in Peru, Guatemala, Mexico, Canada, Nepal, India, Myanmar (Burma) and Thailand.
'My ideas come from the unconscious; lately they refer to windows or openings, with references to Nepal, the minute vegetation of the forest floor where I live and the mood of the day and season.'

P.R. DAROZ, India page 163
B. 1944 in Hyderabad, Andhra Pradesh. He earned his degree in Applied Arts and Design from the College of Fine Arts and Architecture, Hyderabad. Among his many awards and exhibitions, in 1987 he received a medallion and trophy at the Biennial International OBIDOS, Portugal.
'Sculpture is to architecture what jewellery is to the body. The two are integral and complementary. Architectural space is challenging, both in function and structure. For me the earthenware pot is but a microscopic architectural space.'

Don DAVIS, USA page 43
B. 1948 in Jacksonville, Florida. He received his MFA from Rhode Island School of Design. He has taught at many institutions and is author of *Wheel Thrown Ceramics*.
'I would rather visit an ancient ruin or geological formation than go to a museum. That is not to say that I don't visit museums, because I do. Whenever I get the opportunity, I also wander in to galleries to see what friends and other contemporary artists are doing. However, my favourite exhibits are historic and prehistoric ones, and my main inspiration comes from ancient places. These pieces are not just about me and my visions imposed on the material, but also about the spirit in the clay and the fire.'

Bruce DEHNERT, USA page 65
B. Montana in 1956, he attended the University of Montana, receiving his MFA in ceramics from New York State College of Ceramics, Alfred University. He received the Fletcher Challenge Award three times.

'I try to make things that allude to my philosophical experiences but can function ambiguously enough for viewers to attach their own notions to the work, going their own way. With Red Room I was particularly interested in moving an idea along, not necessarily trying to make some statement about architecture but rather using architecture, that of my father's, for inspiration and presentation/reflection.'

Dora DE LARIOS, USA page 41
B. 1933 in Los Angeles, she graduated from the University of Southern California under Susan Peterson in 1957 with a BFA. In 1995 she was one of 31 American ceramic artists to be invited to show architectural ceramic art in Jingdezhen at the First International Ceramic conference involving artists from China, Taiwan and Japan.

'Art is a commitment to a way of life. Creativity is a gift that I was given in my life. The process of creation is enriching and cathartic. It replenishes the spirit. I have always acknowledged God as the fountainhead. I am filled with gratitude for my life and for the work that I was privileged to create.'

Tjok DESSAUVAGE, Belgium page 3
B. Izegem, Belgium, in 1948. He studied at the St Lucas Ghent Art Institute. He is a member of the International Academy of Ceramics, Geneva, and won the Fletcher Challenge Award in New Zealand.

'Archetypes are chosen as a starting point: cones, hemispheres, cylinders – and a kind of small-scale universe is created. On the upper side strong lines interact with the primeval form of the work: energy versus stasis: a magic field, a step into the unknown.'

Josh DeWEESE, USA page 89
He is a ceramic artist and Resident Director of the Archie Bray Foundation for the Ceramic Arts, Helena, Montana. He studied ceramics at Montana State University before going on to receive his BFA from the Kansas City Art Institute and his MFA from New York State College of Ceramics, Alfred University.

'I am interested in how pots can be used every day to bring art into our lives, enhancing our experience with food, adorning our homes, and providing a necessary ritual to nourish our souls and minds as well as our bodies. I try to make pottery which is successful in several ways: comfortable to use, enjoyable to look at, and interesting to think about. For me utilitarian pottery is an arena for "playing" with the plasticity of clay and its potential in the fire.'

Michaela DICOSOLA, USA page 122
B. 1958 in Sarasota, Florida; currently Associate Professor at Florida Atlantic University, Boca Raton. She earned her MFA from the University of Florida at Gainesville.

'The imagery of the boat/vessel series grew out of a personal exploration into emotional states, spiritual growth and confrontation with philosophical issues and questions of existence. This became a visual means or metaphor for Journey; the journey of the soul, mind and/or life. My sculptural work communicated to the viewer his/her own need of self-awareness and contemplation of certain behavioural traits within themselves and what effect they have upon the structural weave of a society.'

Marylyn DINTENFASS, USA page 158
B. 1944 in Brooklyn, New York, she earned her BFA from Queens College, New York. She has been the recipient of many awards and fellowships, including those from the New York Foundation for the Arts and the National Endowment for the Arts.

'Using small units as structural and conceptual components, the transition to tile production was a natural one. The images, colours and surfaces which I could produce with relative ease and the abundance of materials in the factory setting was a source of constant delight and endless possibilities.'

Pippin DRYSDALE, Australia page 38
B. Melbourne, Australia, in 1943. She began her training in ceramics in 1979 at Perth Technical College, where she gained an Advanced Diploma in ceramics in 1981. She received her BFA from Curtin University and regularly gives both professional and community workshops.

'The Australian landscape is a primary inspiration for my work: my responses to it are intuitive and emotional rather than prescriptive

and defining. Travel to other countries has broadened my understanding of form, texture and surface, but also underlined the need to describe the essence of what I feel about my surroundings and my land. I find that the more I am able to reduce the essence of my feelings into simplicity of form and depth of colour, the stronger the message I am able to convey.'

Ruth DUCKWORTH, USA page 57
B. Hamburg, Germany, in 1919, she lives and maintains her clay sculpture studio in Chicago, Illinois. After emigrating to England in 1936 she attended among others the Central School of Arts and Crafts, London (1956–8), where she taught from 1959 to 1964. She then went to teach at the University of Chicago, and has lived in the USA ever since. She is the recipient of an honorary doctorate from DePaul University, Chicago (1982), and is an American Craft Council Fellow (1983).

'Can I, in my work, express what I feel about life? About being alive? About the earth and its creatures, its beauty and fragility? My life and work are relatively unimportant these days compared to the drama of a sick planet. The health of the planet and how to keep it intact is what matters most to me. Can I express any of that in my work? I really don't know.'

Ivana ENEVA, Bulgaria page 154
B. 1944 in Bulgaria, she received her art degree from the National Academy of Arts in 1970.

Päivi ERNKVIST, Sweden page 158
B. 1946. She attended the Swedish School of Arts, Crafts and Design in Stockholm.

'The mood of my work is subdued and calm. The colours are mellow, natural, but not earthy, with light spiritual touches; the construction is liberatingly simple. My ceramics are often based on simple things, such as an apple or an hourglass.'

Paul ESHELMAN, USA page 89
He grew up in Iowa and earned his MFA in 1981 from Rhode Island School of Design.

'I have always been drawn to functional objects. I seek the age-old marriage of elegant function and visually interesting form. Aesthetically I have been guided by Japanese and Chinese crafts. European design movements and simple utilitarian objects such as those produced my American Shakers. The best wares of these movements are beautifully conceived and crafted and are thoroughly functional.'

Christine FEDERIGHI, USA page 136
Born and raised in San Mateo, California, she attended the Cleveland Institute of Art and New York State College of Ceramics, Alfred University (MFA, 1974). She has been Professor of Art at the University of Miami since 1974.

'The image or symbol of a figure and house have been constant to my ideas. Very often these images have inscriptions or carvings that wrap the surface and further narrate their symbolism. I live in three houses or homes – my birth home, my spiritual home and the home that is my dwelling. This idea seems to be expressed by the "stacked" quality of some of the pieces.'

László FEKETE, Hungary page 124
B. Budapest in 1949. He is a graduate of the Budapest Academy of Applied Arts (1974). Recent awards include the Ferenczy Prize, the Hungarian State Prize for Artists.

'I want my work to reflect something of the art of old, great spiritual traditions and, on the other hand, I flood them from time to time with vulgar, profane and sometimes aggressive imprints of the present world. The internal state of a given person will determine which trend is strongest in my work.'

Nazare FELICIANO, USA page 50
B. Portugal in 1960, she now lives in the USA. She received her MFA in 1999 from the School of the Art Institute of Chicago. She was awarded the Philip Morris Graduate Scholarship Award as well as a Ceramic Sculpture Award from Florida Atlantic University.

'My sculpture, Sanctuary, relates to cultural rituals and ceremonies and the loss of these traditions. It transmits the rituals and ceremonies of the past as a comparison to our present customs. It is a mediation and ceremonial piece with iconographic and tribal references.'

Ken FERGUSON, USA page 114
B. 1938 in Indiana, he studied at the American Academy of Art, Chicago, and the Carnegie Institute of Technology, Pittsburgh,

earning his MFA from New York State College of Ceramics, Alfred University, in 1954. He taught ceramics at the Kansas City Art Institute from the early 1960s until 1997 and is now retired.

'I want my pots to be direct. I will continue to seek after gesture, the pot that almost went its own way.'

Anita FIELDS, USA page 151
B. 1951 in Hominy, Oklahoma, she belongs to the Osage and Plains Indian community in Stillwater, Oklahoma. She attended Santa Fe Indian School and earned a college degree there. She is probably the first American Indian potter to create conceptual installation pieces.

'I was influenced by traditional Osage ribbon work, clothing and blankets. In my recent works, which are coil- and slab-built installations, the dresses convey my attitudes towards the strength of women and how native peoples show remarkable resourcefulness and adaptability towards their environment. By working with clay in the indigenous fashion of making hand-built earthenware, I feel that the material is transformed into this powerful medium because it was created by the natural forces of the earth and time.'

Ron FONDAW, USA page 24
B. 1954 in Paducah, Kentucky. He received his MFA from the University of Illinois at Urbana. He was recently awarded the Kranzberg Award from the St Louis Art Museum, as well as the Pollock-Krasner Award in 1997. He teaches at Washington University, St Louis, Missouri.

'Hand of Time is a site-specific sculpture made of adobe and inspired by the shape of the tree around which it is built. Its three walls are related to the three main branches that extend from the lower part of the trunk – the tree's support system. The work is temporary and as a result it will change its appearance over time. This process reflects my belief of the impermanent nature of the world we live in.'

Leopold FOULEM, Canada page 20
B. Caraquet, New Brunswick, in 1945. He received his MFA from Indiana State University and currently lives and works in Montreal, Quebec.

'My work is about ceramics and art or about ceramics as art.'

Viola FREY, USA page 118
B. 1933 in Lodi, California, she studied at the California College of Arts and Crafts, Oakland, receiving her BFA in 1956; she is currently a Professor of Art there. She earned her MFA in 1958 from Tulane University, New Orleans.

'Frey's work has been dominated by an interest in the figure; the life-size portraits of family and self from the late 70s have now become massive figures that stand up to 11 feet in height. The theme of them still revolves around the figurine. They "reveal the average, kitsch and the stereotype as mirrors of American cultural values" [Clark and Simms, 1984]' – Garth Clark, American Ceramics.

Michael and Magda FRIMKESS, USA page 90
Michael was b. 1937 in Los Angeles and attended the Otis Art Institute with Peter Voulkos. Magda was b. 1929 in Caracas, Venezuela. She attended the Escuela de Artistas Plásticas in Caracas and the University of Santiago, Chile.

'We've collaborated since soon after meeting in 1963. In 1972 Frank Ross (now deceased) showed us a fast-firing kiln at a summer job in Maine. I am refining, using the same kiln, but sped up a bit. Raul Coronel taught us how and we discovered that it could reach cone 11 in under one hour. Our Chun base colours are brighter and never run off the pots.'

Elizabeth FRITSCH, UK page 87
B. 1940 in Shropshire, England. She studied music before going to study ceramics at the Royal College of Art, London, 1968–71. She was awarded a Senior Fellowship of the Royal College of Art in 1995, and in that year was also awarded the CBE.

'Music informs my work: I am primarily occupied with audio-visual correlations. Melody translates as visual form and assemblages of form. Harmony translates as colour clusters and other colour relationships. Rhythm translates into the precise rhythm figures and cross-rhythms often used to give added dynamic, depth, or levitational airiness to a form.'

Keiko FUKAZAWA, USA page 125
B. Tokyo, she now lives in Pasadena, California. She studied art in Japan and at Otis/Parsons, Los Angeles. She teaches ceramics at California State Polytechnic University, Pomona.

'My artistic goal is to express my faith in spontaneity and

instinct without reason and logic in order to experience absolute personal freedom.'

David FURMAN, USA page 134
B. Seattle, Washington, in 1945. He earned an MFA from the University of Washington (1972). He has received three National Endowment for the Arts Fellowships, and three Fulbright Fellowships.

'My recent ceràmic pieces are sculptures of still lifes that exist in my studio. I have always had loads of pencils, brushes, chalk and crayons in my work space, so it feels natural for these items that exist in the real world to become my subject matter. In order to make things appear "real", however, I have discovered the necessity of making them a little "unreal", including the need to incorporate elements of abstraction into the work.'

Emidio GALASSI, Italy page 19
B. Imola, Italy, in 1944. He earned an Art School Certificate from the Public Institute for Ceramic Art in Faenza and a degree in Sculpture from the Accademia dei Belle Arti in Bologna. He teaches Ceramic Design at the Public Institute for Ceramic Art.

'In that very moment in which you approach the clay to make an "Ara" [altar] all the elements become necessary to complete the sacrifice: the air, the water, the fire.'

Angel GARRAZA, Spain page 76
B. 1950 at Allo, Navarra, he studied at the College of Fine Arts in Bilbao. Since 1976 he has been Professor of the Department of Culture in the Faculty of Fine Arts at the University of País Vasco, Bilbao.

'Emblems, the title of my current exhibition, manifests the reflections and the formal synthesis that define my recent creations; something already evident in the piece shown is this way of defining the relationship between the pieces, in pairs, through natural unity without forced strategies. The dual element is prevalent in this work as an idea of order, rhythm and sequence.'

Andrea GILL, USA page 147
She teaches at New York State College of Ceramics, Alfred University, where she earned her MFA in 1976. She has received a National Endowment for the Arts Individual Artist's Grant twice.

'My personal vision as an artist has focused on a format that is admittedly ancient: I am passionate about pottery form as a site for personal expression. I choose to make vases and bowls because those forms allow the most open interpretation of shape without losing the iconic identity of the object. My devotion to surface patterning has also proved to be an addiction that satisfies my love of stylized image. In the motifs of my overlaid figure/ground surface, I suspect I am often exploring my subconscious.'

Steven GOLDATE, Australia page 92
Founder of 'Intersect' (the International Society of Electronic Craft Transformation), b. 1959 in Melbourne, Australia. He studied Fine Art Ceramics at the Victoria College of the Arts and works in clay and digital media. He is an expert at computer-generated virtual ceramics.

'The beauty, finesse and elegance of porcelain is something that has always fascinated me. It has the power to represent concepts beyond clay, such as status, but it can also appear pretentious. The 'watercolours on porcelain' technique has also fascinated me for many years, through its possibilities of unique patterning and a smooth satin finish.'

Arthur GONZALEZ, USA page 136
B. 1954 in Sacramento, California. He received his MFA from the University of California at Davis. He is the recipient of the Ford Foundation grant in 1981, four National Endowment for the Arts Fellowships and the Virginia Groot Award in 1992. He is an Associate Professor at the California College of Arts and Crafts in Oakland.

'My figures capture the core of human spirit and character. I plumb the relationships between the human and the natural world, mining humanity's raw elements. My language is completely layered and rare, as I traverse the depths of the soul in determination for truth. A creator of unique forms, these transcriptions hover beautifully, in liminality – betwixt the between.'

Bill GRACE, Barbados page 141
Although he lives and works in Barbados, he studied in New York State, Spain and Nova Scotia before earning his BA from Acadia University in 1975. In 1997 he created the State Gift of the Government and People of Barbados to President Clinton of the USA.

'My work of the past three years focuses on the concept of being one with our environment. At the same time, it reflects the influence of Barbados, my island home, since our local environment was formed by a self-sustaining reef system. We Are Reef is a continuing series of sculptures in coral, clay and glass co-evolving with ourselves and Nature's boundless gifts. Marks of process of growth, weathering, fire, chisel, of composition, are integral points of reference.'

Phyllis GREEN, USA page 19
She received her MFA from the University of California at Los Angeles in 1981. She has been recognized by the National Endowment for the Arts in 1984 and the Pollock-Krasner Foundation in 1996.

'My current sculpture explores issues of gender in romance and in art, and issues of craft and decoration. The forms are hybrids of traditional male and female representation: soft and hard, perforated and projecting, inside and outside. They intend to tease our assumptions about gender, and identify as toys as much as precious objects.'

Roberta GRIFFITH, USA page 63
B. 1937 in Michigan, she received her BFA from Chouinard Art Institute in 1960. She earned her MFA in 1962 from Southern Illinois University. She was the recipient of many awards including a Fulbright Grant in 1962–4. Since 1966 she has been Professor of Art at Hartwick College.

'I seek balance and harmony of shapes, textures and hues that manifest an internal dialogue. As I create objects and installations that quantify and transform associations of places and their cultural manifestations into my own vocabulary, I want to objectify space, temporal relationships and movement, and dematerialize that with which I work through metaphorical transformations when appropriate.'

Chris GUSTIN, USA page 5
B. 1952 in Chicago, he grew up in Los Angeles. He began working in his father's ceramics manufacturing company. He received his BFA from Kansas City Art Institute in 1975 and MFA in 1977 from New York State College of Ceramics, Alfred University. He has taught at a number of universities including the Swain School of Design, New Bedford, Massachusetts, and the University of Massachusetts, Dartmouth.

'I use the pot context because of its immense possibilities for abstraction. The skin of the clay holds the invisible interior of the vessel. How I manipulate my forms "around" that air, constraining it, enclosing it, or letting it expand and sell, can allow analogy and metaphor to enter into the work.'

Peter HAYES, UK page 55
B. 1946, he studied at Birmingham College of Art from 1961 to 1964. He has travelled extensively, studying the ceramic tradition, to Africa, India, Nepal, Japan, South Korea and Europe with the Commonwealth Secretariat.

'One of the best things I did recently was to rent a studio in Cornwall. This provided a completely new environment, different spaces, different smells, a new exhilaration: walking along the shoreline, kicking pebbles; picking up pieces of driftwood and rusty iron, examining sea-washed bone, bits of broken hull studded with copper nails; visiting the Neolithic standing stones silhouetted against the skyline. I would like some of my new work to stand outside and be weathered by the elements. I want it to settle into a landscape and not compete with it.'

Hans HEDBERG, France and Sweden page 63
B. 1917 in Kopmanholmen, Sweden. He studied painting in Stockholm and at the Royal Danish Academy. He continued his education at the Institute of Art in Faenza, Italy.

'Nature has a fuller range of nuances than we humans can achieve with our hands. This applies to the stone with its lichens. This applies to the blade of grass and the leaf. But nature's beauty is transient in the extreme. The leaf is equally as wonderful in its delicate green hue in the spring as it is in high summer and the decay of autumn. Nature also rules in the kiln, and there it lasts – the clay, the minerals of the glazes all belong to nature. I am only the careful manipulator. I have constantly played with nature, and the egg took me close to the original patterns of the bird's nest. I left them in the end to play with nature in a new way.'

Ewen HENDERSON, UK page 18
B. Staffordshire, England, in 1934. He studied at Goldsmiths College, University of London, and continued his studies with Hans Coper, Lucie Rie and Colin Pearson at Camberwell School of Art, earning his degree in 1968.

'An aural instinct compels me to look up. There at 5,000 feet are 5,000 birds, fellow Londoners. Without warning some leave the main flock, and in lines and columns execute the best drawing I have ever seen – as good as Lascaux. I simply want to make images of this quality; if possible I would like them to be word-proof.'

Vilma HENKELMAN, The Netherlands page 140
B. Rotterdam, The Netherlands, in 1944, she is a self-taught artist. Her work is in prominent collections including the Stedelijk Museum, Amsterdam.

'I throw human-sized pots which I then shape into sculptures. It is essential to me to express both physical and spiritual vitality, to make reality emerge with the utmost intensity and purity. The process itself is what my work is about. I experience the act of throwing as a spiritual process. Innovation means accepting the outcome and constantly breaching conditions, looking and thinking.'

Wayne HIGBY, USA page 47
B. 1943 in Colorado Springs, Colorado. He received his MFA from the University of Michigan at Ann Arbor in 1968. He is a Professor of Ceramic Art at Alfred University, New York. Higby is an Honorary Professor of Ceramic Art at the Jingdezhen Ceramics Institute, China.

'Philip Rawson wrote of memory-traces and meaning in his book Ceramics. Perhaps it was there that I first connected with the thought of my work as a memory. Landscape has always triggered mental wondering. I am attracted by qualities of light falling on form, suggesting time and timelessness. I think of the past and present in concert with questions about the future. Memory and longing dissolve into a quiet void in which emptiness is fulfilling.'

Hertha HILLFON, Sweden page 113
B. Stockholm in 1921, she studied at the Konsfact School of Art and Design. She has received the Swedish Gold Medal and the prestigious Lunning Prize.

'Dough rises, and clay shrinks. I substituted clay for dough and went on baking.'

Richard HIRSCH, USA page 30
B. New York in 1944, he graduated from the Rochester Institute of Technology in New York with an MFA in ceramics. He is currently Professor at the School for American Craftsmen at the Rochester Institute of Technology.

'Formally, I use the archetypal vessels as a spatial membrane that also functions as the "presenter" for the man-made artefact. The allusion to surfaces like weathered stone and patinaed bronze are utilized as metaphors for time passages. While the weapon itself symbolizes human ceremony and activity, the base acts as an altar, pedestal or body.'

Curtis HOARD, USA page 82
B. 1940 in St Paul, Minnesota. He received his MFA from the University of Wisconsin in 1967. Since then he has been Professor of Art at the University of Minnesota.

'For a number of years the figure has been a point of departure in my work. More specifically, the emotional impact that surrounds it and the collective history that we share with it. The recent work investigates the figure in relationship to the vessel, historical implications, and the formal context of the object relationships. Narrative slips into the work as well and in certain pieces the story line is autobiographical.'

Gillian HODGE, USA page 140
B. 1927 in London. She attended Calcutta School of Art in India and Oxford University in England. Her work is in many permanent collections including the Victoria and Albert Museum, London.

'My work is profoundly influenced by my childhood in India and has a strong narrative component, often reinterpreting myths. The pieces can be read in multiple ways with many-layered meanings. I have retained interest in the indigenous materials and firing in kilns which deliberately provoke unforeseen accidents so my images can be richly decorated with surfaces from indigenous clays, ashes and minerals.'

Nina HOLE, Denmark page 15
She attended both the Arts and Crafts School in Copenhagen,

Denmark, and Fredonia State College in New York. She is a member of the Danish Artists' Union. She is also on the Board of Directors and Exhibition Board of the Ceramics Museum Grimmerhus in Denmark.

'I work with chance. I take many chances. I am so used to uncertainty, it has become part of my work. I am always alert, because if I get too comfortable I lose control. I reach into the past to grab the present. I use clay, man's oldest creative material. I call the process "Tracking".'

John W. HOPKINS, USA page 45
He received his BA, MA and MFA from the California State University at Fullerton. He teaches ceramics and sculpture at the Riverside Community College in California.

'Sculpture has always been my main interest, but I have been trained as a potter. Until recently I have kept my sculpture and ceramic forms separate. I have now started to bring my sculptural experience together with my ceramic knowledge. The pots become sculpture and the sculptures become pots. This transition and blending of ideas has opened some new and exciting possibilities for me to explore.'

Deborah HORRELL, USA page 71
B. Phoenix, Arizona, in 1953. She received her MFA from the University of Washington. In 1994 she was awarded the WESTAF/NEA Regional Fellowship Grant.

'My primary commitment has been to the "image" as content bearer. Frequently that image has been a vessel. This form has appeared throughout my art life, with diverse transformations in shape, content and medium (clay, wood, bronze, glass). My recent vessel explorations approach form without function. The vessel implies a rich history and reference beyond its physicality.'

HWANG Jeng-Daw, Taiwan page 21
B. Taiwan in 1963. He graduated from Tamsui Oxford College in 1968. His first solo show was in 1997 in the American Cultural Center in Taiwan, and in 1998 he was a resident artist at the Shigaraki Ceramic Cultural Park in Japan.

'I try to combine the classic methods and requirements in the spirit of tea vessels with a more open approach to the design and shape. To achieve this goal, I started with the classic Chinese Yi-Xing teapot creation techniques and travelled to the United States to learn about the different philosophies surrounding the tea vessel. Since then, I have tried to incorporate my artistic expression into the overall design of these works.'

Sylvia HYMAN, USA page 131
B. Buffalo, New York, in 1917. She has been honoured with the Lifetime Achievement Award and the National Museum of Women in the Arts Award in 1993.

'The current series questions the usual assumptions about works of art in general and sculptural work in particular. I am thinking about the nature of reality and its erroneous perceptions. The porcelain clay may look just like paper or the stoneware clay may look just like wood, but that's the medium and not the message. I also attempt to create a kind of mystery within the objects.'

Sadashi INUZUKA, USA page 76
B. Japan in 1951, he emigrated to Canada in 1980 and currently works and teaches in the USA. He received his MFA from Cranbrook Academy of Art, Michigan.

'I create site-specific installations which address the relationship between the natural world and human nature. I am interested in transforming a single object or whole environment through the juxtaposition of contrasting elements: raw clay and fired clay, variation and repetition, fact and fantasy, female and male, light and dark, natural materials and human labour.'

Ingrid JACOBSEN, Germany page 102
B. 1950 in Mielkendorf, near Kiel, she studied at the College of Art in Berlin from 1973 to 1977. In 1980 she founded a cooperative workshop with Dieter Balzer, Evelyn Klam and Michael Freiberg.

'My work is made from a specially prepared, highly grogged red or grey clay. The pieces are thrown or assembled from slabs of clay, then modelled and painted with engobe and treated with copper oxide. The firing is done in an electric kiln with an oxidizing atmosphere, to a temperature of 1060° C (1950° F).'

Leroy JOHNSON, USA page 25
He gained his graduate degree from Lincoln University in Lincoln, Pennsylvania. He lives and works in Philadelphia and teaches at The Clay Studio.

'My experience as an agent of change, an educator and therapist, as well as an artist, has made me aware of issues that have a direct impact on women and children. I find the inner-city areas – their schools, housing, and culture – to be a constant source of form, texture and palette in my work.'

Nancy JURS, USA page 61
B. 1951 in New York City, she received her BFA from Rochester Institute of Technology with the Bauhaus Master Frans Wildenhain in 1963.

Jurs has described her work as 'offering the effects of those things that are literal in the thoughts of others as well as those that are fantasy'. There is a highly charged personal relevance, whether specific to the understanding of the artist or to the emotional and/or psychological wellbeing of the viewer.

Vineet KACKER, India page 118
He learned pottery at the Andretta Pottery and Crafts Society in Himchal Pradesh; he was also apprenticed at Golden Bridge Pottery in Pondicherry, as well as attending various workshops with Ray Meeker and Deborah Smith, including Susan Peterson's at Pondicherry in 1997.

'As an artist I try to be open to what the clay itself suggests. The clay responds to my ideas, and guides me. Two important sources of inspiration are landscape and architecture. They make me think about texture and scale. Sometimes my work turns out meditative; at other times it is more playful – I find that the clay picks up all emotions, and the process of working transforms them.'

Jun KANEKO, USA pages 27, 159
He arrived in Los Angeles in 1964 and attended the Chouinard Institute of Art and Claremont College Graduate School in 1971. He maintains studios in both Omaha, Nebraska, and Japan. He has made and fired some of the largest monolithic clay sculptures of the 20th century. Recently he worked in low-fire white body and oxidation glazes at the Ceramic Institute, 'sHertogenbosch, The Netherlands, as opposed to his normal stoneware reduction firings.

'Walking through the fog is one of my favourite things visually. I see a shadow of some obscure grey object far off in the fog, suggesting some kind of shape, and that form gets sharper and sharper as I approach. The suggestion of the shape in my mind finally becomes a reality. I enjoy that short time, those moments between the realization that something is there and the time it becomes clearly visible. It is this point and this space I am interested in.'

Elena KARINA, USA page 88
B. 1931 in Tientsin, China, to Russian-American parents. She attended schools in Los Angeles: Jepson Art Institute, University of Southern California (BA, 1961), and University of California at Long Beach (MA, 1971).

'The ocean, the changing patterns of sand, and the action of wind and tides, fragmenting shells and sea creatures, have always been a fascination for me. Recently I have discovered the windswept beaches of southern Oregon where I walk, looking and photographing whatever interests me, and then collage my impressions into my website, a journal of my work in the studio and the things I see outside that influence it.'

Karen KARNES, USA page 29
B. 1925 in New York City, she now lives in Morgan, Vermont. Awards include: American Craft Council Fellow (1976), NCECA Honorary Member (1980), Medal of Excellence for the Society of Arts and Crafts in Boston (1990) and Vermont Governor's Award for Excellence in the Arts (1997).

'Clay is a totally expressive material, making permanent the most immediate, the most profound, or the most trivial image of the maker.'

Margaret KEELAN, USA page 111
B. Regina, Saskatchewan, Canada, in 1948. She earned her BA at the University of Saskatchewan and her MFA at the University of Utah, studying with Marilyn Levine. She teaches ceramics and is the Assistant Director of Sculpture at the Academy of Art College, San Francisco.

'My latest work consists of press-moulded portrait heads finished with such low-fire techniques as underglazes, stains, raku and smoked terra sigillata. The imagery explores our "inner landscape" or "the place we go within ourselves", and/or the masks and façades we present to the world as we go about our daily business.'

Susan and Steven KEMENYFFY, USA page 156
Susan, b. Massachusetts in 1941, received her MA and MFA from the University of Iowa in 1967. She was awarded a National Endowment for the Arts Fellowship in 1973 and 1977. She was the Chair of the Pennsylvania Council for the Arts in 1997.

Steven, b. 1943 in Budapest, Hungary, emigrated to the USA in 1951. He earned his MA and MFA from the University of Iowa in 1966 and 1967. In 1977 he was awarded a National Endowment for the Arts Fellowship and in 1996 and 1998 a Faculty Research Grant. He is Professor of Art in Ceramics at Edinboro University, Pennsylvania.

'Communities and individuals instinctively know they are the collective aspects of their minds, their bodies and their spirits; that to ignore one part is to imperil the whole.'

Maro KERASSIOTI, Greece page 70
B. Athens, Greece, in 1939, she attended the Athens School of Fine Arts, the YMCA School of Ceramics, and the Scuola d'Arte di Ceramica e di Porcelana, Florence, Italy. She has taught at the Reform School for Boys, Athens, the High Security Prison for Men in Alikarnassos, Crete, and in the Campus Arts and Sciences Private College in Athens.

'This forest of mine cannot be burnt, chopped down, or dry out; it can grow anywhere in minutes. It is the only forest around that I do not worry about. I wish that forests all over the world could be saved.'

Bob KINZIE, USA page 138
B. Chicago in 1932, he attended Manchester College (1952–7) and the University of Southern California (1957–60), where his mentors were Susan Peterson and F. Carlton Ball. He was a professional potter for 18 years, then became an architectural designer and builder. In 1996 he returned to being a ceramic artist and craftsman.

'While it is sufficient for a craftsman to master the discipline of his choice, design a line and live a craft lifestyle, the artist must put his skills to the service of interpretation at least, or innovation at best. The accumulated skills may then free up the possibilities, even point the direction in which the expression might flow. As with all actions which elate, one pursues the process for its own sake.'

Karen KOBLITZ, USA page 157
B. Hollywood, California, she has worked in ceramics for 30 years. She earned an MFA from the University of Wisconsin at Madison. She currently teaches ceramics at the University of Southern California.

'I have been working with still life imagery in my ceramic pieces since the late 1970s. Each piece juxtaposes various designs from a certain era or culture. The playful quality of the work is the realization of the enjoyment of the media. In my work I pay homage to the functional roots of ceramics while elaborating on historical and decorative elements.'

Joyce KOHL, USA page 23
B. Oakland, California, in 1949, she received her MA from California State University at Fullerton. She is the recipient of many grants and fellowships including the John Simon Guggenheim Memorial Fellowship in 1986. She is Professor of Fine Art at California State University at Bakersfield.

'Much of my work involves a juxtaposition of ancient and contemporary. I want viewers to bring their own interpretations, and consequently to reflect on the artefacts that we leave behind for future generations to ponder or trip over. My interest is in having the viewer consider the larger picture; to reflect on our impact on the environment, its impact on us and our place in time.'

Mikhail KOPYLKOV, Russia page 79
B. Leningrad (now St Petersburg) in 1946. He graduated from Mukhina Institute of Applied Art and Industrial Design and has been working regularly for the St Petersburg Artistic Foundation since 1972.

'The main theme of my work is lyrico-dramatic and shows the tragic aspect of the existence that can be revealed through the language of ceramics. The predominant method of execution is a combination of hand-building techniques, including slab, coil and pinch modelling.'

Charles KRAFFT, USA page 130
B. Seattle, Washington, in 1947. He is a conceptual artist who took a detour into clay to realize a new kind of millennial kitsch and memento mori.

'The Porcelain War Project is an explicitly decorative dialogue

on late 20th-century defence and destruction. It is about guns as cultural artefacts. The concept is to replicate a variety of light arms in use throughout the world and decorate them to resemble a room full of Delft, Meissen and Ming china.'

Elisabeth von KROGH, Norway page 47
B. 1947 in Bergen, Norway, she studied in Oslo, earning her diploma in 1971. One of Norway's foremost potters, she took part in the *Norway Now* exhibition in London in 1984.

'I work in English red clay and Norwegian earthenware, using engobes, stains and transparent glazes. In my latest works the inspiration of nature is put aside, and the forms appear more neutral and timeless in their expression. As the viewer walks around the objects, an interesting and ever-changing interplay unfolds. The utilization of the changing light/shade phenomena of the forms is an artistic intention.'

Yih-wen KUO, USA page 53
B. Taiwan, he has lived in the USA since 1985. He received his BEd from the National Taiwan Normal University and his MFA from Southern Illinois University in Carbondale, Illinois. Awards include the Illinois Arts Council Artists' Fellowship and the Pennsylvania Council on the Arts Fellowship.

'My sculptural work has evolved out of the traditional concept of the vessel, but my interest is not in making functional pots. I retain the understanding of a vase as a space container. However, my fascination lies in using the inside/outside space as a format for expression.'

Eva KWONG, USA page 129
B. Hong Kong. She received her MFA from Tyler School of Art, Philadelphia. She has been involved in many international exhibitions, including the *'99 Ceramics Art Millennium-end Invitational* at the Central Academy of Art and Design, China, and the NCECA Clay National in Ohio.

'Much of the inspiration for my work comes from my wonderment at the natural world within and around us. I am amazed by the tiny bits of matter that live and move within our cells. Under our skin is a life force that seems to carry on with both beautiful and horrific consequences.'

Jay LaCOUTURE, USA page 31
B. 1950 in Woonsocket, Rhode Island. He received his MFA from West Virginia University. He is a Professor of Art at Salve Regina University in Newport, Rhode Island, and is a past President of NCECA.

'I simply like to make pots, dishes, tableware that gets used and admired. Sometimes the pots become vessels and take on other metaphorical possibilities.'

Peter LANE, UK page 142
B. Cairo, Egypt, he studied at the Bath Academy of Art, Corsham, Wiltshire, England. In 1997 he was elected a member of the International Academy of Ceramics. He is the author of many books on ceramic art.

'I attempt to achieve a sense of harmony, balance and simplicity in my vessel forms and to express my responses to the immense diversity of the natural world. The variety in human form, and the positive radiation of light and colour in skies, sea and landscapes, together with the shapes, textures and patterns of floras, are a constant source of inspiration and delight to me.'

Elisabeth LANGSCH, Switzerland page 67
B. 1933 in Zurich, she trained at the Ceramic College in Berne; she also studied for a year in Aix-en-Provence, France, and another in Faenza, Italy. She won the KILN-Club Medal in Washington DC in 1963.

'The focus of my work is building ceramics. Together with the architect I create the walls, floors and other architectural elements of a building, either flat or with plastic form. This collaboration takes place at the planning stage in order to achieve the best results in terms of space and light.'

Jean-Pierre LAROCQUE, Canada page 110
B. 1953 in Montreal, he earned his BFA from Concordia University, Montreal, and his MFA in 1988 from New York State College of Ceramics, Alfred University.

'I am suspicious of any kind of premeditation. I may improvise on a theme like a horse or a standing figure with a horse, but I approach the art at any stage without a plan or a sketch. I follow whatever the material suggests and gradually an image emerges and is revealed. I do not start from an intention, rather it seems I slowly

discover something I have never seen before, although it seems I have always known before.'

Lisa LARSON, Sweden page 114
B. 1931, she studied at the University of Design and Craft, Gothenburg, 1949–54. She was a designer at the Gustavsberg Porcelain Factory from 1954 to 1980. She worked at A.O. Rosenthal Studio in Germany, 1982–5. For the last few years she has been working in a studio that is the sole relic of the sadly defunct Gustavsberg Factory.

'I rarely work on the basis of a sketch or with a definite plan. I usually let the clay itself decide what it is going to be. I rely on the unconscious and try to keep all my senses open and be receptive. I value humour and I strive for honesty, both in work and in life.'

Jim LAWTON, USA page 133
B. 1954 in Fairborne, Ohio. He earned his MFA from Louisiana State University, Baton Rouge, in 1980. He is Associate Professor, Artisanry Program, at the College of Visual and Performing Arts of the University of Massachusetts, Dartmouth. He received National Endowment for the Arts Fellowships in 1984 and 1986, and in 1990 a South Carolina Artist's Fellowship.

'Like the tailor, the approach I take in making pots is to configure enclosures – to contain and to reveal within the work some of the eccentricities of human life. In my view, meaning is held on both sides of these fabrics: an inner life of use and the outer one of appearance. It does not seem incongruent to me that ceramics and corporeal bodies share certain elemental connections.'

Jennifer LEE, UK back cover
B. Aberdeenshire, Scotland, in 1956. From 1975 to 1979 she studied at Edinburgh College of Art, and in 1980–3 at the Royal College of Art in London. She has spent time travelling in the USA to research prehistoric Southwest American Indian ceramics, and working at West Coast potteries.

'The pots I make evolve from each other. New forms develop through reference to test-tiles, sketches and from previous pots. The work is much more about the analogue between the spirit and external elements and, for me, my work is led by physical emotions and visual reactions, intuitive responses.'

Jean Claude LEGRAND, Belgium page 1
B. 1948 in Chièvres. He received his degree from the Academy of Fine Arts in Saint-Josse-ten-Noode in 1983 and is Professor at the Academy of Fine Arts in Charleroi. In 1987 he received the Grand Prize of the Second World Triennial Exhibition of Small Ceramics.

'Jean Claude Legrand measures off fragments of earth and adds his personal order to the natural order. Small markings and openings give relief to the texture and indicate the depth, what is beneath the surface, and what determines and feeds it. The clay matter contrasts with the geometry of Legrand's intervention, which renders intense life to the grey mass' – Jan Walgrave, Contemporary Ceramics in Belgium.

Marc LEUTHOLD, USA page 50
B. 1962 in Mount Kisco, New York; he earned his MFA from the University of North Carolina at Chapel Hill in 1988. Awards include the Kohler Art/Industry Fellowship and the Banff Center for the Arts Residency Grant. He teaches at the State University of New York at Potsdam.

'I cultivate repetition of simple forms within the circular matrix in order to create a complex, mobile, hypnotic effect, lulling the viewer into a quiet reverie. The deeply carved surface is intended to capture light and to increase the illusion of motion. Often the centre is emphasized: a focus point, a resting place or still point, eye, vortex, or porthole amid suspended motion. Also integral to the experience are elements that may be somewhat hidden or purposely mysterious to invite renewed interest and to suggest a possibility of continual discovery.'

Marilyn LEVINE, USA page 59
B. 1935 in Medicine Hat, Alberta, Canada, she studied at the University of Alberta, Edmonton. She received an MA from the University of California at Berkeley, and the following year her MFA in sculpture. She has received many awards and honours including two National Endowment for the Arts Fellowships.

'An acquaintance of mine, Marc Treib, described pretty neatly the two types of impact man has on the world, intent and trace; he defines intent as man acting consciously. This would include design, building and purposeful action. Trace on the other hand is the accumulation of marks left by the realization of man's intent, such as trampled grass, grease spots and dirt. In trace we find richness, a

humanity often omitted in intent. It is the ability of leather to accumulate the history of man's traces that has so fascinated me and kept me single-minded in pursuing this trompe l'oeil odyssey for the past 15 years.'

LI Jian-Shen, China page 132
B. 1959 in Jiangxi, China. He received his BFA and MFA from Jingdezhen Ceramic Institute in China in 1989 and another MFA from New York State College of Ceramics, Alfred University, in 1995. He has taught in China, Japan, the USA and Canada. He is the International Director of San Bao Ceramic Work Central in China and lives in both Jingdezhen and Toronto, Canada.

'My work reflects a deep affection for my Chinese culture, people and history. The human figure along with the cow, boat, cart, house and bridge appear all formed of clay and transformed by fire. As a result, the work suggests the physical nature of human life and its attachment to the earth, changed by fire into a story of victory, survival and hope.'

LI Ju-Sheng, China page 145
B. Boyang, Jiangxi Province, in 1944, he graduated from Jiangxi Normal University in 1968. He is currently an assistant professor and teaches at the art department at the Jingdezhen Ceramic Institute. He is a member of the Chinese Artists' Association and a permanent councillor of the Jiangxi Artists' Association.

Beth LO, USA page 123
B. 1949 in West Lafayette, Indiana, she has been Professor of Art at the University of Montana, Missoula, since 1985. After graduating from the University of Michigan in 1971, she studied at the University of Montana, receiving her MFA in 1974. Awards include a National Endowment for the Arts Fellowship in 1995, an American Craft Museum Design Award in 1986 and a Montana Arts Council Individual Artist Fellowship in 1989.

'Since the birth of my son in 1987, I have been interested in creating images based on events in my family's history: memorials to the major landmarks, such as my parents' immigration from China, or my father's death, as well as the daily challenges of raising a child in a loving and ethical way. In my ceramic and mixed media work, I try to incorporate aesthetics from both Western and Eastern cultures to express both parts of my dual heritage.'

LU Bin, China page 69
B. 1961 in Beijing, he graduated from Nanjing College of Art in 1988. In 1987 he won a silver medal at the First Chinese Modern Ceramics Art Exhibition in Shanghai.

'In ancient China, potters fired their names on the bricks they baked in order to protect the everlasting foundation of the emperors. Now the kilns are gone, leaving behind empty palaces and fired names on the bricks.'

LU Pin-Chang, China page 31
Born in Jiangxi Province, China, in 1962. He earned his MFA from the Sculpture Department of the National Arts Academy of China. Since 1994 he has been Associate Professor of Sculpture in China's Central Academy of Fine Arts. In 1998 he took part in the Modern Chinese Ceramics World Tour Exhibition, which travelled to London, Madrid and Copenhagen.

'The mastery of following one's feelings is the inspiration that I have inherited from Eastern Art. I don't like to create in a strongly predictable manner, because that way creation becomes a completely technical proposition. I endeavour to construct a certain relaxed and free atmosphere, resulting in a state of mind that allows me to readily express my moods and feeling. This enables a chance discovery to bring the work to an intense and unexpected completion.'

LUO Xiao-Ping, China page 149
He graduated with his BFA from Jingdezhen Ceramic Institute, China. He is the president and founder of the Yi-Xing Ceramic Art Association, Jiangxi Province, China.

'I live in a country that has a long history of ceramic culture and even my blood-vessels are filled with the deep spirit of Chinese traditional culture. I have been advocating the ideal realm of transcendence of Zen and I am unshakeably firm in a belief that the connotations of the Eastern philosophy have certain latent coincidences with some of the aspirations by modern artists.

Marilyn LYSOHIR, USA page 58
B. 1950 in Sharon, Pennsylvania. She received her BFA from Hoio Northern University and MFA from Washington State. Various fellowships and grants include a WESTAF grant and residences at Kohler Co., Wisconsin, and the Archie Bray Foundation, Montana.

She is co-editor of *High Ground*, a yearly art publication.

'*Art is a non-linear process and for me, my life experiences have a great influence on this process. What has come together to form the nucleus of my attitudes towards, and needs for, art is an ability to retain a strong visual memory of the past and a creative energy that does something with these images. The end result of all this in my work has never been just a simple narrative account, but rather a composite of ideas and I hope that people too can relate to the work on many levels.*'

George McCAULEY, USA page 105
B. Savannah, Georgia, in 1947. He earned an MFA from the University of Georgia at Athens, 1978. In 1973 he set up a ceramics programme for the South Carolina Arts Commission, *Project T.A.P.* He teaches ceramics at the Archie Bray Foundation, Helena, Montana.

'*As a process-oriented person, I am most concerned with the "making of objects". I use a number of techniques in my works, although mostly they are thrown, severely altered and have hand-built additions. Earthenware best suits my needs and soda-firing completes the soft, sensual feel I strive for.*'

John McCUISTION, USA page 148
He earned an MFA in 1973 from the University of Montana at Missoula. Since 1976 he has been a Professor at the University of Puget Sound. He has received numerous awards, including the Suzanne and George Ramie Prize at the Biennale Internationale de Céramique d'Art at Vallauris, France (1994), as well as a National Endowment for the Arts award, 1996.

'*The artwork I make is about history, myth, story-telling, religion, relationships, ceremony, civilization and humour. I am interested in the language of gesture, expression, texture, form and colour. Through my work I am able to contribute to the long tradition of the artist as teacher, recorder and seer. The life of an artist is as important and meaningful as any in society.*'

Harrison McINTOSH, USA page 99
B. 1914 in Vallejo, California. He studied under Glen Lukens at the University of Southern California in 1940 and at Claremont Graduate School. In 1947 he was apprenticed with Albert and Louisa King at their Lotus and Acanthus Pottery Studios in Los Angeles.

'*Simplification is a basic principle of mine, and I strive to purify and strengthen that. Craftsmanship is important only to the extent that it supports the spiritual content of the work. Form, emphasized by surface quality, must, above all, remain a very human expression; and the quality of a piece, at the end, depends on the human emotion it expresses or inspires.*'

Amanda McINTYRE, USA page 109
B. 1971 at Newport Beach, California, she was raised in the tropics of South Florida. She received her MFA from Arizona State University, Tempe. She lives in Omaha, Nebraska, and works at the Bemis Center for Contemporary Arts.

'*The human form as a canvas, as seen in the narrative tattooing of the Maori or the ancient tradition of body art in Papua-New Guinea, as well as fashion, has always interested me. Not strictly for the corporeal nature of its texture, patterns and designs, but for the concepts of these arts as protective and narrative – often exposing the personality or heritage. Keeping these concepts in mind, this work investigates surfaces and designs on the human form, as well as the internal characteristic either suggested or unveiled.*'

Warren MacKENZIE, USA page 94
B. 1924, he graduated from the Art Institute of Chicago in 1947 and was apprenticed with Bernard Leach in England for two years. He was Professor of Art at the University of Minnesota, recently retired. He lives and works in Stillwater, Minnesota.

'*A pot must be made with an immediacy, without unlimited change being possible, which is unique in the visual arts. For this reason each piece, in a sense, becomes a sketch or variation of an idea which may develop over hours, days or months and requires up to several hundred pieces to come to full development. One pot suggests another, proportions are altered, curves are filled over or made more angular, a different termination or beginning of a line is tried – not searching for the perfect pot, but exploring and making a statement with the language of the hand.*'

Anna MALICKA-ZAMORSKA, Poland page 71
B. 1942 in Lubien Wielki, near Lvov. She studied art at the Art Academy, Wroclaw, and earned her MA in 1965. Her work is in the National Museum of Wroclaw.

'*In life I am interested in art. In art I am interested in life. I like to be part of the world, where everything influences everything else. Life and death, light and darkness, earth and water, stone and air. I like hurricanes and running clouds. I like mysterious silence after sunset. I am an observer and I am observing. Life is beautiful.*'

John MALTBY, UK page 83
B. England in 1936, he studied sculpture before working with David Leach making ceramics in the 'Leach' tradition. He has won various awards including the Gold Medal, Faenza, Italy, in 1975. He was the sole judge for the Fletcher Challenge Ceramic Competition, New Zealand, in 1986.

'*I was trained in the studio workshop tradition, but my background in the fine arts and the monotony of repetition implicit in workshop practice eventually make me dissatisfied. I strongly believe in the difference between each work (and indeed the difference between each artist) as the most fascinating and exciting aspect of the craft.*'

Diane MANN, USA page 66
B. Indianapolis in 1942. After graduating from high school she married, and it was not until her children were in college that she decided to go back to school. She received her BFA in 1989 from Indiana State University.

'*Living on a farm, I feel a special relationship to ceramics. Much as a freshly ploughed field draws you in to pick up and feel the texture of the soil, I am especially drawn to the rough, torn edges that contradict the flat surfaces of clay. Rusted pieces of metal that have been discarded are added to my sculptures and seem to blend harmoniously with the natural look of the clay.*'

Janet MANSFIELD, Australia page 26
B. Sydney in 1934, she studied ceramics at East Sydney Technical College, 1964–5. She has had 30 solo exhibitions since 1968 in Australia, Japan and New Zealand. She lives and works in Sydney and Gulgong, New South Wales.

'*Success for me is measured by the pleasure achieved in making pots and the possibility of another gaining pleasure in using them. It is also measured by the continual acquisition of skill and understanding of the potter's art. I hope my motivation is strong enough to survive the bad times, because if I fail, I am only adding weight to the argument that it can't be done.*'

Bodil MANZ, Denmark page 86
B. Copenhagen in 1943. She attended the School of Arts and Craft there from 1961 to 1965, the Escuela de Diseño y Artesania, Mexico, 1966, and the University of California at Berkeley, 1966. She lives and works in Denmark.

'*Even before one has any knowledge of the sophistication of the various techniques these cylinders fascinate. Each piece, when it first meets the eye, has an impact, takes one by surprise. My fascination with the 'cylinder' is unmistakeable. No cylinder is ever the same as the one before or the next one, either by sheer will or by accident; accidents do happen in the realm of poured paper-thin porcelain. Each accident leads the artist to a new wisdom.*'

Tony MARSH, USA page 41
B. 1953, he received his BFA from California State University at Long Beach in 1978, was assistant to Mr Shimaoka in Mashiko, Japan, 1978–81, and earned his MFA from New York State College of Ceramics, Alfred University, in 1988.

'*Utilitarianism is the historical root for the existence of pottery. While my work does not specifically refer to historical pottery types, it pays homage to what pottery from around the world has always been asked to do; store, protect, offer, commemorate and beautify. The work derives what energy it might have from its dichotomous nature. It is both sensual and cerebral, organic and geometric, solid and weightless, male and female.*'

John MASON, USA page 68
B. 1927 in Nebraska, he went to Los Angeles, where he studied at the Otis Art Institute and was Susan Peterson's first ceramics assistant while training at the Chouinard Art Institute. He taught at the University of California at Irvine and at Hunter College, City University of New York. He is represented in museums all over the world, including the National Museum of American Art at the Smithsonian Institution, Washington DC, and the National Museum of Modern Art in Kyoto, Japan.

'*The sculptures continue a lifelong involvement with the characteristics of the medium. The slab-built sculptures demonstrate the malleability and plasticity of the clay, but also serve as a support for the coloured glaze surface.*'

Yuriko MATSUDA, Japan page 40
B. 1943, she gained her BA in Ceramics from Kyoto City College of Fine Art, Japan, and undertook graduate studies with Kenkichi Tomimoto, Yuzo Kondo and Kyubei Shimizu. She was the winner of the Gold Medal at Faenza in 1991.

'*Decoration for me says many things that I want to communicate. In Japan people think simplicity is at a higher level of importance, but I think decoration has more power. The Celts, who had no written language, used decoration for meaning. Many Japanese remove everything but lose power, so I use decoration to be strong. "If I have your piece in my house," people tell me, "I have energy like a vitamin pill." To me, decoration is meaning.*'

Berry MATTHEWS, USA page 78
She studied at the University of Wisconsin, and received her MFA in Ceramics from Ohio State University, Columbus. Her work has been exhibited in the USA and France, including a two-room installation called *Architectural Space* at the Herter Gallery, Massachusetts, 1996.

'*Just outside the line of vision, in the moment before things become clear, there is a chance to see things as they might be. My work creates a space where that could happen, a space made from a wire grid, with thousands of thin clay pieces that move in the shifting air, lit with neon.*'

Grace MEDICINE FLOWER, USA page 144
B. 1938 at Santa Clara Pueblo, New Mexico, she is Margaret Tafoya's niece. She is a self-taught ceramicist who has won many prizes: she is most proud of a Best in Show from the Gallup Inter-Tribal Indian Ceremonial some years ago.

'*I feel that our art today is in keeping with the traditional way of making and firing and that shapes and designs have to change as time changes. My art is considered contemporary, but the making and firing are traditional. Before the clay is taken from the earth, special prayers are offered to a spirit I call the "Clay Lady". I take the clay home and dry it for several days, then crush and soak it in water, screen it for impurities, and mix it with my feet and hands. I add some white sand-ash for temper and before I work I thank God for giving me the hands to create the pottery.*'

Ray MEEKER, India page 101
B. 1944 in New York City. He received his BFA in ceramics from the University of Southern California and in 1971 founded Golden Bridge Pottery, Pondicherry, South India, with Deborah Smith. His video on the building of fired houses in India won the Bronze Medal at the Millennium Ceramic Conference in Amsterdam, 1999.

'*After 14 years of working with form on a very large scale (fired houses) I am returning to wheel and clay and the more modest scale of pottery. While form remains the number one consideration, I simply cannot resist splashing engobes on to broad, leather-hard surfaces.*'

James MELCHERT, USA back cover
He received his MFA from the University of Chicago in 1957, and his MA from the University of California at Berkeley in 1961. From 1977 to 1981 he was the National Endowment for the Arts Director for the Visual Arts Program and from 1984 to 1988 he was Director of the American Academy, Rome. Awards include the Distinguished Alumnus Award, College of Environmental Design, University of California at Berkeley, 1999.

Enrique MESTRE, Spain page 62
B. 1936, he graduated from the Escuela de San Carlo, Valencia, in 1958 and immediately taught painting there. In 1963, he received the diploma of Technical Ceramic Expert and in 1970 that of Expert in Ceramic Art from the Escuela Práctica de Cerámica in Manises.

Enrique Mestre has gradually moved towards a rationalized dialogue with pure forms. Yet within this situation of coexistence the artist's increasing regard for space has also come to demand its own rights. Thus, space is generated by form, and individual spaces determine the physical limits of the formal constructions they pertain to, inhabiting their undeniable corporeity, increasing their mystery and the scope of their possible spirituality.

Richard MILETTE, Canada page 144
B. 1960 in L'Assomption, Quebec. In 1983 he earned his BFA from Nova Scotia College of Art and Design, Halifax, and in 1982 his DEC from the CEGEP du Vieux Montréal.

'*My work in general questions the politics of different branches of the art establishment. It is concept-oriented. It has nothing to do with process, neither with clay as a material. I make objects; I don't make pots.*'

Yvette Hoch MINTZBERG, Canada page 155
B. Budapest, Hungary, in 1941, she received her MA in Education from Harvard University, Boston. She lives and works in Montreal, Canada.

'I keep coming back to bowls. For me this form represents the paradox of fragility and endurance, much like the human condition. At the same time I dream of making large "functional murals" where alpinists can train to climb. I suppose this also becomes a paradox of fragility and endurance for both the climber and the wall, while bringing together two exciting forms of art.'

Cara MOCZYGEMBA, USA back cover
B. 1969 in San Antonio, Texas. She has travelled extensively and attended graduate school at California State University at Long Beach. Currently she teaches ceramic sculpture at the Earth & Fire studio in New Orleans.

In her current body of work, Moczygemba uses the form of the Roman portrait bust, and combines it with the impersonalized features of Pre-Columbian ceramic figures as a basis from which to explore different myths and mental states. Each of these sculptures can be seen as a self-portrait and a representation of her view of the world, culture, heritage and self.

Gertrude MöHWALD, Germany page 108
B. 1929, she was apprenticed as a stone-sculptor in Dresden from 1948 to 1950 and studied sculpture and ceramics at the High School in Halle, receiving her diploma in 1964. She teaches at the High School in Halle.

'I mainly make sculptures, built of several layers of clay or porcelain, decorated with glaze or engobe and inlaid clay or pieces of broken vessels. I fire them several times, first to about 1160° C [2120° F] in oxidation and the second and third times to about 1060° C [1950° F].'

Jeffrey MONGRAIN, USA page 59
B. 1955 in International Falls, Minnesota. He earned his MFA from Southern Illinois University in 1981. His many awards include the Louis Comfort Tiffany Foundation Award, 1999. He taught at Glasgow School of Art, Scotland, 1985–8, and has taught at Hunter College, New York, since 1995.

'The emotive and reserved presence of Gothic architecture and cryptal statuary has been a primary influence in my recent work. These reductive sculptures are based on recognizable forms that suggest an open narrative. The reading of this narrative may be as diverse as a personal reference or a generic icon. The physical characteristics of these sculptures are meant to imply the memorial-like qualities of permanence and homage.'

Steven MONTGOMERY, USA page 18
He earned an MFA from Tyler School of Art, Temple University, Philadelphia, Pennsylvania, in 1978. He is an art instructor at Grace Church School in New York. In 1991 received a fellowship from the New York Foundation for the Arts.

'My interest in industrial imagery is completely aesthetic, as I have almost no practical experience in any of the technical fields from which my work is derived. It has been through my understanding of the ceramic medium and its inherent limitlessness that I have been able to invent my own technology to suit my sculptural needs.'

Dominique MORIN, France page 23
He gained a degree in mechanical engineering from Valenciennes University. He works mainly in the field of contemporary Yi-Xing ceramics, which he studied under Ah-Leon in Taiwan.

'My Amsterdam teapot is a personal interpretation of how an element of tea could look. I have chosen the Body-Centred Cubic (BCC) element type, which gives a semi-virtual look to the pot, as the pot seems to be floating in the air. The use of bamboo sticks provides a vegetal tribute to tea.'

Ann MORTIMER, Canada page 89
B. Toronto, Ontario, in 1934. She earned her degree at Georgian College, Barrie, Ontario, in 1972. Awards include one at the Seventh International Ceramics Symposium in New York.

'For me, the journey is more important than the destination. The work is always about the material and what can be done with it, layered with the meaning of beauty. The environment serves as inspiration and material for much of my work. Two- and three-dimensional illusions occur in many of my sculptural forms. Of late, the delicacy of my cups and saucers, which are about the nature of cups, addresses the rituals of everyday life.'

Sana MUSASAMA, USA page 150
B. New York City in 1957. She received her MFA from New York State College of Ceramics, Alfred University, in 1987. She has received the Pollock-Krasner Award, Seagram's Art Award, and Hunter College Faculty Award. She is an Adjunct Teacher at Hunter College in New York City.

'The work that has dominated my career is a series of large ceramic pieces known as the Maple Tree Series. *These sculptures were inspired by the Maple Tree abolitionist movement in the late 18th century in New York and Holland. Dutch colonists, Native Americans and free indentured African servants joined together in protest against slave labour on sugar-cane plantations in the West Indies. They took as their symbol the maple tree – a source of sugar without exploiting slave labour. These sculptures explore links between trees and human sexuality, between trees and human agency.'*

Gifford MYERS, USA page 159
B. 1948, he received his MFA from the University of California at Irvine in 1975. He is the recipient of many honours and awards, including a National Endowment for the Arts Fellowship. For several years he has curated exhibitions in Italy, worked in ceramic studios there, and designed tiles for production.

'When I was a small boy and couldn't sleep, I would design tree houses, forts and coasters or pushcarts in my mind until I fell asleep. Things haven't changed much since.'

Ron NAGLE, USA page 46
B. 1939 in San Francisco, California. He is a graduate of San Francisco State College (BA, 1961) and took a summer session at the Art Institute in Ceramics from Henry Takemoto. He then went to the University of California at Berkeley to work with Peter Voulkos. He became Chairman of the Art Department at Mills College, Oakland, in 1978, where he now holds the Joan Danforth Chair. He is the recipient of three National Endowment for the Arts Fellowships and two Mellon Grants.

'Although my work is part of the ceramic tradition, it is not only the materials or processes that interest me. Rather it is the potential or intimacy inherent to the small object and the ability of colour to convey emotion that motivates me. I have been investigating the cultural, formal, ceremonial and sometimes functional aspects of the cup. That being said, it is my hope that the interpretation of my work will be as open-ended and ambiguous as possible.'

Kimpei NAKAMURA, Japan page 78
A third-generation heir to a Kutani kiln. His work is a search for new paradigms for ceramics. He is presently Professor of Ceramic Art, Tokyo.

'All my works, called Tokyo Ware, are part of a challenge and a search for meaning in our times through meta-ceramics. I seek to relate my tableware to the objects of daily life and the interior, while I relate each architectural work or installation to the natural environment and exteriors unique to them.'

Barbara NANNING, The Netherlands page 49
She has exhibited internationally, and also designs unique glass pieces at the Royal Leerdam Factory. She lives and works in Amsterdam.

'From 1990 colour has played an essential role in my work. I develop themes like constellations, Zen gardens and flower beds. I am doing a series of clay flowers with petals expanding like a fan, and large monumental works, huge flower beds, that are designed with computer programs.'

Nora NARANJO-MORSE, USA page 148
B. 1953, she attended Taos High School and the College of Santa Fe. In 1983 she went to Germany to teach and in 1995 attended the Women's Conference in Beijing. She lives a traditional American Indian life at Santa Clara Pueblo in New Mexico.

'My large figures are generally concerned with satirical notions in large conceptual installations that play on Anglo and Indian lore; they include several figures of "Pearlene", a Pueblo character I created. I feel it is essential to my creative process that I remain open to absorb information, feel emotions and ultimately react, whether I am forming a sculpture, filming or choosing words.'

Andy NASISSE, USA page 107
B. 1946 in Pueblo, Colorado. He has been a Professor of Art at the University of Georgia for the last 23 years. In 1995 he received the Albert Christ Janer Award for a Lifetime of Creative Research from the University of Georgia at Athens.

'For quite some time I have been using the figure, the vessel and the landscape as a primary, mythic image through which I could express some thought about the human condition. I work improvisationally, finding figures in the clay and developing them into an image that seems to have life. It is almost as if these figures are part of a family of images that find their way through my hands into the outer world. At their best they present an enigmatic expression, somewhere between whimsy and fear.'

Richard NEWMAN, USA page 130
He lives in Napa, California. He attended Paier College of Art in New Haven, Connecticut, and earned a BFA from the California Institute of the Arts, Valencia, in 1971.

'When I was young, my baseball glove and I were practically inseparable. Now as a ceramic artist, I carve and hand-build interpretations of these classic icons in clay, finding inspiration in their ability to reawaken emotional connections. My objectives are to challenge the viewer's perceptions by encouraging a second glance and to provide opportunities for catching wistful memories.'

Richard NOTKIN, USA page 132
B. Chicago in 1948, he studied at the Kansas City Art Institute, earning his BFA and his MFA degrees from the University of California at Davis in 1973. He now lives and works in Helena, Montana.

'The pieces in the Heart Teapot *series explore the origins of conflict in human culture – both the collective conflicts between various nations, ethnic groups, religions, etc., and those inherent in relationships between individuals. The message of each piece is intended to outlive its respective moment in history. The spirit and power of art is exemplified by a work of art's ability to transcend time and cultural boundaries.'*

Hana NOVOTNA, Czech Republic back cover
B. 1958 in Nove Mesto, Moravia. She earned her MA from the Academy of Applied Arts, Prague, 1985–91. She also attended the University of Industrial Art, Helsinki, in 1990. She is an assistant lecturer at the Fine Arts Department of the Technical University, Brno.

'There are people, often tired with this time and its crazy beat and chaos, who build places and shelters for the sake of their spiritual health; here they relax and recover strength among objects that they like, that they have found and chosen among the millions of others surrounding them. To be found and chosen: this is one of the great appraisals and motivations of the artist.'

Magdalene ODUNDO, UK page 2
B. Nairobi, Kenya. She studied at Nairobi, and at Cambridge, England, before getting her BA from West Surrey College of Art and Design, England. She earned her MA from the Royal College of Art, London.

Jeff OESTREICH, USA page 32
He studied ceramics at Bemidji State University, University of Minnesota, with Warren MacKenzie, and at the Leach Pottery in St Ives, Cornwall, England, with Bernard Leach. He is a recent recipient of a McKnight Foundation and a Jerome Foundation grant.

'I work under the umbrella of "utilitarian potter", exploring and rearranging the boundaries I have set up for what I believe constitutes function. My current work is thrown and altered, whether by faceting, stretching, or cutting and rejoining. Being fond of glaze and not willing to give up this surface altogther, I play with a ratio of glaze to clay surface.'

Fred OLSEN, USA page 124
B. Seattle, Washington, in 1938. He earned his MFA from the University of Southern California under Susan Peterson and Carlton Ball in 1967. He was also apprenticed with Tomimoto Kenkichi and Kondo Yuzo in Japan. In 1961–3 he became the first ceramicist to exhibit in Australia, and in 1963 he published *The Kiln Book*. In 1977 he was the recipient of a National Endowment for the Arts Fellowship.

'My sculptural pieces reflect my landscape, my sense of place, my sense of solitude, of living in the high desert. Each piece creates a stage set frozen in time and space of an imaginary tableau where my ideas play. For the viewer, it becomes a platform where they can create their own tableaux of surreal thoughts.'

Jeanne OTIS, USA page 160
B. Hackensack, New Jersey, in 1940. She received her MFA from Ohio State University in 1974. Her lectures include one at NCECA

on "Innovative Glaze Development". Since 1975 she has been Professor of Art at Arizona State University in Tempe, Arizona.

'My work is a continuous dialogue with colour, especially the quality of colour that is unique to ceramic materials. My current focus using glazes and overglazes in a finger-painting manner is a direct response to the ceramic materials and their colour quality in the wet state. The choice to use glaze, overglaze or coloured clay and engobe is a simple concern for the relationship of one colour, texture or surface next to another in an effort to solidify my personal colour preferences.'

Pekka PAIKKARI, Finland page 161
B. 1960 in Somero, Finland, he studied at the Kuopio Academy of Handicraft and Design from 1978 to 1983. He has been at the Arabia Ceramic Factory as an artist and designer since 1983.

'The material is the most important frame of reference to me. Clay is from the soil and it has a natural link with the earth. My works are related to application, but they are still pure structures like an image of a bottle and a picture of a pot. Copying nature is easy, but the genuine, the natural, is hard – and so is being able to leave something undone.'

Greg PAYCE, Canada page 145
B. Edmonton, Canada. He earned his MFA from Nova Scotia College of Art and Design, Halifax, and now teaches at Alberta College of Art and Design in Calgary.

'Through its developments over millennia and subsequent diffusion throughout the world, pottery has linked humanity, functioning as a primary vehicle for the transfer of cultural information between various peoples. Conventions of utility, craft and decorations have kept the language of pottery accessible. It has served and continues to serve as quintessential link between art and life and as a seminal mediator between nature and culture.'

Rina PELEG, USA page 146
She lives in New York City. She attended Bezalel Academy of Arts and Craft, Jerusalem, Israel, and got her MFA from New York State College of Ceramics, Alfred University.

'I grew up in Israel on a kibbutz. Almost everywhere one walked one practically stumbled over pottery pieces that are sometimes the only evidence of rich cultures that existed in the Middle East in the past. Working with clay became a way for me to make contact with the work outside the kibbutz and, ultimately, outside Israel. The idea of making clay baskets is also connected to the ancient custom of imprinting mats or other woven material into the surface of clay pots before they were fired.'

Gustavo PEREZ, Mexico page 42
B. Mexico City in 1950, he studied at the Escuela de Diseño y Artesania in Mexico City. He was awarded a two-year grant to study at the Sint Koost Akademie, Breda, The Netherlands. In 1984 he returned to Mexico and set up his own studio in Jalapa, Vera Cruz.

'I use incised graphic in my stoneware vessels. The pieces are made in press-moulds to create a simple exterior for accentuating the topography of the sculpture. My work is related to the composition of music. I think it also bears a distinctive relationship to my aesthetic heritage, as the culture of Mexico is full of sculptural history and ceramic traditions.'

Jane PERRYMAN, UK page 33
B. 1947 in London, she studied at Hornsey College of Art, London. She then went to Cardiff University where she gained an Art Teacher's Certificate. In 1996 she was awarded an Eastern Arts travelling grant to go to India.

'My work is vessel-oriented, with forms based on vases and bowls that evolve with the coiling process, which is both slow and meditative. Inspiration comes from ancient Celtic cultures as well as traditional pottery of Africa and India – burnished and fired without a kiln.'

Jan PETERSON, USA page 44
B. 1954 in Santa Monica, California. She earned her BFA in Ceramics from New York State College of Ceramics, Alfred University, New York, and her MFA in Jewellery from the University of Oregon at Eugene.

'I grew up in an artistic family, and was surrounded by artists most of my life. So perhaps choosing to make art as a living was a natural thing to do. I would say I am an object artist, I make objects of beauty, either for function or just to look at. I primarily work in bold, bright glaze colours on handbuilt porcelain. I enjoy the bright colours in bold patterns, and working with the malleable clay. I like

working with my hands, and over the years it has come to be very important to me. I feel as though it keeps me well grounded and connected with life itself.'

Susan PETERSON, USA pages 34, 101
B. 1925 in McPherson, Kansas, and raised in Grand Island, Nebraska. She received her BA from Mills College in 1946 and her MFA from New York State College of Ceramics, Alfred University, New York, in 1950. She built five ceramics departments: Wichita Art Association School, Chouinard Art Institute, University of Southern California, Idyllwild School of Music and the Arts (ISOMATA), and Hunter College, City University, in New York. Awards include a National Endowment for the Arts grant, Fellowship of the American Craft Council, Binns Medal, NCECA Lifetime Achievement, New York State Governor's Award, and Distinguished Achievement Award from Arizona State University. She is a Phi Beta Kappa and a Knight of the Order of the Lion of Finland. Her CBS television ceramic series of 54 half-hours is available on video.

'My clay work concentration has been high-fire reduction stoneware with natural clays and engobe decoration and a lifetime of experimentation with copper oxide blue and red glazes.'

Albert PFARR, USA page 81
He received a BA from the State University of New York at Potsdam in 1984 and earned his MFA from Alfred University in 1990. He has been a resident artist at the Archie Bray Foundation, Kohler Art Center, Cranbrook Academy and Watershed Center for the Ceramic Arts. In 1995 he moved to St Louis and is the technician for Washington University's ceramic department.

'I make parts, bits and pieces. I repetitively create shapes and gather found structures like rockers. There is always a certain amount of potential energy in objects like rockers, transferred very easily in and out of them. I create things that can change and build on themselves and be assembled differently every time I install the work.'

Todd PIKER, USA back cover
B. 1952 in New York City. He was apprenticed in England at Wenford Bridge Pottery with Michael Cardew and eventually created the Cornwall Bridge Pottery in Cornwall, Connecticut, with Svend Bayer.

'The potter's challenge is to use nature's palette – air, earth, water and fire – to create settings for domestic treasures, whether cooked, gathered or arranged. One well-designed pot made over and over, until its production becomes instinctive, will be a good pot. Good pots made by production potters now unknown, sold and used by other forgotten people, are now the most beautiful pots of antiquity, treasured by museums. Thus our pots, and we, enter into cycles of art and commerce, of time and value.'

Peter POWNING, Canada page 97
B. 1949 in Providence, Rhode Island. He attended the Royal Academy of Arts and the Croydon College of Art, London, and received an Honorary Fellowship from the New Brunswick College of Craft and Design, Canada.

'I am preoccupied these days with finding balance in my working life between the past assumptions of productions and the present obsession with self-expression. Nature, as I live in it and with it, is my informant, my muse. The tensions between the need for a livelihood, the desire for self-expression and living a life that finds meaning in work and work in pleasure that is an integral part of my whole life are a challenge to balance.'

Sally Bowen PRANGE, USA page 85
B. 1927 in Valparaiso, Indiana. She attended the University of Michigan at Ann Arbor, where she received her BA.

'My involvement with porcelain is linked to my very long interest and concern with Chinese culture. I do not know how to express it more clearly than to say that my in-depth work with porcelain is influenced by a "China myth" in my head, inherited during my early years from my parents who had lived in China for five years. They were deeply influenced by their experience; my affinity for this exotic culture grew as I made Chinese friends, read about China and finally travelled there in 1978.'

Ken PRICE, USA page 51
B. 1935 in Los Angeles, California. He received his BFA from the University of Southern California with Susan Peterson and MFA from New York State College of Ceramics, Alfred University, New York. Following a time in Japan he created a studio in Taos, New Mexico, as well as in Venice, California. He had a major solo show at Los Angeles County Museum of Art in 1978 and the

Minneapolis Museum of Art in 1995.

'Making is just the beginning. There has to be content over professionalism, the functional side can be metaphorical. I am always involved with colour – colour with form.'

Judith PüSCHEL, Germany page 21
B. 1955 in Berlin, she studied at the Art College of Halle Burg Giebichenstein and earned her degree in 1981. She went on to gain her post-graduate degree in 1982. She works in Berlin, teaching at the University of Art in Halle, and is an instructor for adult education courses.

QIN Xi-Lin, China page 40
B. 1942 in Nanchang City, Jiangxi Province, China. He is President and Professor of Art of the Jingdezhen Ceramic Institute of China. He studied at Nanchang No. 4 Middle School of Jiangxi Province and from 1960 to 1964 at Jingdezhen Ceramic Institute, where he earned his BFA.

'As a contemporary artist, one should ponder the following question: how to try one's best to make one's ceramic artwork possess international, national and regional features and one's own personality.'

Liz QUACKENBUSH, USA page 134
She earned her MFA from the School for American Craftsmen at Rochester Institute of Technology and was an apprentice at the Moravian Pottery and Tile Works, Doylestown, Pennsylvania. She has been a visiting artist at Cranbrook Academy of Art, the John Michael Kohler Arts Center, the Archie Bray Foundation and elsewhere.

'I call these pieces, inspired by ceramics made during the 13th to 17th centuries in France, Italy, Spain, Portugal and Iran, a crazy quilt approach to ceramics history. The bumpy surface underneath the gold lustre beckons back to the hammered metal dinnerware forms mimicked in earthenware in Iran of the 13th century. My goal is to make it bridge the gap between being elegant china and down-to-earth pottery.'

Juan QUESADA, Mexico page 143
B. 1940. His village of Mata Ortiz in Mexico has hundreds of potters now, although there were none when he began to make pottery in Casas Grandes style as a young man.

'When I was about 15 I wanted to make something beautiful so I started making pottery resembling the shards from the ruins near my village, which are prehistoric Casas Grandes ceramics. Then I developed my own style. Now even my brother and sisters work making their own pots, and also the number of potters in our village has grown to 300.'

Elsa RADY, USA page 56
B. 1943 in New York City, she studied under Ralph Bacerra and Vivika Heino at the Chouinard Art Institute, 1962–6. She received a Visual Artists Fellowship from the NEA and a collaborative grant (with Laddie John Dell) in 1983. Rady lives and works in Venice, California.

'I work with porcelain in a distinctive style, with even, glazed surfaces; a tense bowl form, and a lip that is cut into various Art Deco stepped shapes. In some cases these are assembled in groups of two or three on a granite slab that I call "Conjugations".'

Ingegerd RÅMAN, Sweden page 40
B. 1943 in Stockholm, she studied at the Swedish School of Arts, Crafts and Design, and later at the Istituto Statale d'Arte per la Ceramica at Faenza, Italy. She has her own studio for wheel-thrown pottery, and is also a designer of glassware for several factories. She has been awarded the Prince Eugen Medal by the King of Sweden and has also been honoured by the Swedish government.

'My work is always a link between simplicity, function and aesthetic values.'

Brian RANSOM, USA back cover
B. Portland, Oregon, in 1954, he teaches ceramics at Eckerd College, St Petersburg, Florida. He has been exhibiting and performing on his original ceramic musical instruments and sound sculptures for the past 18 years.

'My artistic research concentrates on the physical properties of sound and sound-producing objects that I use as elements in a sculptural or performance environment. Ceramics – the predominant resonating material in these objects – affects the specific character of the sound as well as the visual qualities of the objects. I often create the visual properties of my pieces through an exploration of sound.'

David REGAN, USA page 48
B. 1964 in Buffalo, New York. He received an MFA from New York State College of Ceramics, Alfred University, in 1990. He currently lives in Missoula, Montana.

'Pottery interests me as an art form because it nourishes both body and spirit. I do not consider my pieces as blank canvases on which images can be arbitrarily superimposed. Nor do I intend for the images to distract the viewer from their utilitarian focus. Rather, I hope to emphasize the possibilities that pottery can evoke of health, well-being and imagination.'

Anton REIJNDERS, The Netherlands page 75
B. 1955 in Venray, The Netherlands. He graduated in 1981 from the School of Arts in 'sHertogenbosch. Since 1987 he has been the workshop coordinator at the European Ceramics Work Centre in The Netherlands, and recently completed a residency at the Bemis Center for Contemporary Art in Omaha, Nebraska.

'As an artist working in clay, I am involved in the transformation of matter into things. The constant changing of identity of things during the making process is a source of inspiration, as well as the many layers of meaning these things evoke. In my work, I am exploring meaning as such and the relations between identity and meaning.'

Don REITZ, USA page 32
B. Pennsylvania in 1929, he received his MFA from New York State College of Ceramics, Alfred University. He was honoured as one of the 12 greatest living ceramic artists worldwide and is Professor Emeritus, University of Wisconsin at Madison.

'Clay, a very forgiving material, has become my personal scribe, recording each day my thoughts and emotions in a way no other material has. In my search to find my personal truth, clay has become my discovery channel.'

Paula RICE, USA page 103
B. 1944 in Amherst, Massachusetts. She received her MFA from the University of Wisconsin at Madison in 1979. She is Professor of Art at Northern Arizona University, Flagstaff.

'In the Lazarus piece, I was challenged to invent a human figure simultaneously dead and alive. I am drawn to the moment when life quickens, or significantly alters. Lazarus moves from the darkest night into bright light.'

Tom RIPPON, USA page 101
B. 1954 in Sacramento, California, he received his MFA from the Art Institute of Chicago, but was largely self-taught in ceramics. He is the Chair and Professor of Art at the University of Montana. He received a Visual Arts Fellowship from the National Endowment for the Arts in 1974.

'I have been using porcelain as my medium of choice for 30 years. Its plastic qualities allow my notions of building abstract forms to be realized almost effortlessly. The marriage of lustres applied to the smooth porcelain finish came about quite by accident while experimenting with ceramics in high school. I have used this technique ever since.'

Mary ROEHM, USA page 34
She earned her BFA from Dalman College in Buffalo, New York, in 1973 and her MFA from the Rochester Institute of Technology, also in New York, in 1979. She is Associate Professor of Art at the State University of New York at New Paltz.

'The teapots, bowls and cups that I make are fluid, translucent and seemingly still in motion. I work to create a tension between my viewer's visceral and intellectual reactions. I use wood firing to cone 12. It is important that the piece be well articulated in form rather than rely on the fire to make the work strong.'

Josef ROSCHAR, Canada page 19
B. Amsterdam, Netherlands, in 1943. He is a recipient of the Outstanding Achievement Award at the Second International Ceramics Competition in Mino, Japan, in 1989.

'My ideas are in constant flux. The challenge is to be consistently creative. Often the artist does not yet know what is coming and must be attuned to the awakening of the infinite power which is coiled up within himself. Sometimes I laugh, sometimes I cry; both are friends of mine. My works of art are born this way. Artistic creation is a beautiful process that develops within and becomes a touch of magic.'

Katherine L. ROSS, USA page 60
She received her MFA from Tulsa University, Oklahoma, in 1980. Since 1981 she has been Professor of Art at the School of the Art Institute of Chicago.

'Porcelain, glazed white, can appear antiseptic, sterile and cold. This is the format in which I investigate notions of anxiety, transcendence and purification. Porcelain tile is most often found in locations involving water and the body, such as bathrooms, surgeries, kitchens, pools, etc. My tiles evoke notions of similar places while the surface images are concerned with the psychology of water, cleansing, hygiene and contamination.'

Fritz ROSSMANN, Germany page 17
B. Kohn, Germany. He studied at the National School of Ceramics in Hohr-Grenzhausen and received his master's degree in 1983.

'Amphoras from the Greek and Egyptian dynasties. Precise throwing, unglazed surfaces. Elegant forms developed thousands of years ago. My work relies on the historical language of the vessel form. I exploit the characteristics that evolve while working with clay, using these discoveries to enhance forms and surfaces.'

Jerry ROTHMAN, USA page 84
B. Brooklyn, New York, in 1933. He studied in Los Angeles and earned his MFA from Otis Art Institute under Peter Voulkos. He has received many prizes and awards, including the Wichita National Purchase Prize for ceramics sculpture in 1962, the Louis Comfort Tiffany Award in 1963 and sculpture awards at the Ceramic Nationals in 1964.

'As a kid in New York my family had special vessels to celebrate important occasions. In California as an adult both the vessels and the importance of family occasions disappeared. This series of "Ritual Vessels" is an attempt to rewind us to the past.'

Kathleen ROYSTER, USA page 95
B. Cedar Rapids, Iowa, in 1958. She earned her BFA and MFA from the University of Utah, Salt Lake City. Her work has won her several awards and honours including a 1994–5 Utah Arts Council Individual Artist's Grant. She is Assistant Professor at Claremont College, California.

'Be Still is about emotional tension. The shape of the pear is feminine; the emphasis of the long stem embodies the delicate balance or lack of balance one might find in oneself. At the core of the fruit lies pleasure; the leaves act as a protective layer much like the peel of an orange or the tough skin of an avocado; slicing the pear exposes the layer beneath, adding the drama of vulnerability.'

Adrian SAXE, USA page 20
B. 1943 in Glendale, California, he studied with Ralph Bacerra 1965–1969 at the Chouinard Art Institute in Los Angeles, and received his BFA from the California Institute for the Arts in 1974. From 1973 he has been an Associate Professor at the University of California at Los Angeles.

Vina SCHEMER, USA page 135
She has been a studio potter and photo-ceramicist since earning her BFA in 1962. Since 1979 she has been the American Crafts Council Southeast Regional Director.

'I love working with images from old photographs. There's a fascination about taking a peek at an era I never knew, and converting what I see into rhythmical patterns as part of my surface designs.'

Randall B. SCHMIDT, USA page 131
B. Fort Dodge, Iowa, in 1942. He received an MA from the University of New Mexico in Albuquerque. He has been Professor of Art of Ceramics at Arizona State University since 1968.

'Inspiration for my work has always come from events in my life, or how I perceive events in the world. It's a way of pondering over and dealing with issues that occupy my mind. Humour is often a way for me to cope with the human condition and subjects that may be absurd or painful. I don't pretend to have the answers; only an attempt to deal with the questions.'

Lilo SCHRAMMEL, Austria page 73
B. 1949 in Burgenland. She received her Master's degree in Vienna. She has had exhibitions since 1978 in Austria, Germany, Switzerland, Japan and the USA.

'The circle, split up into different segments, results in a new flexible form that I feel relates to our continuous life without a beginning or an end. The flexibility enables White Spiral to spin around its own axis, resulting in two new positions and different angles of perspective. New possibilities open in all directions.'

Bobby SCROGGINS, USA page 157
B. 1954 in Kansas City, Missouri, he received his MFA from the

Southern Illinois University at Edwardsville in 1980. He has served as the Director-at-Large for NCECA, America's national ceramic organization, and is Professor and Head of the Ceramics Department at the University of Kentucky in Lexington.

'Several years ago I developed a sculptural technique called 'Mediaramics'. This research involved the use of clay and other materials such as steel, bronze, aluminium, exotic woods, natural pigments and plastic. Technically, the unique and most pivotal aspect of this work involves the use of the bonding vehicle, which is polyester resin. The needs for firing and glazing are thus eliminated.'

Nancy SELVIN, USA page 23
She received her Master of Arts degree from the University of California at Berkeley and is the recipient of two National Endowment for the Arts Fellowships. She has taught for more than 20 years at colleges and workshops internationally.

'These pieces hint at the familiar, re-examining the spaces we inhabit. Recorded in the clay surface is an investigation of process. The mark of the hand and the expressionistic quality of the colour remind the viewer how the work was built. Spare and poetic, these formal still-life compositions reflect on the tradition of use while emphasizing the history and the materialness of the work itself.'

Vaslav ŠERÁK, Czech Republic page 66
B. 1931. He graduated from the Academy of Applied Arts in Prague. From 1958 to 1989 he was a designer at facilities such as Chinaworks and the Institute of Housing and Fashion Culture. Since 1990 he has taught at the Academy of Applied Arts and in 1992 became a full professor.

'Rainbow Arch vaults over an imaginary entry into the small Moravian town of Bystrice pod Hostynem. It is an open gate, a place of meeting and games that reminds us of eternity and fugitive moments. Stone, ceramics, stainless steel, water and coloured rays of light are connected with a new arrangement of the town square, designed by the architect Bohumil Chalupnicek.'

Hein SEVERIJNS, The Netherlands page 28
B. 1936. He studied chemical technology in Germany, then studied art in The Netherlands at the Academy for Applied Arts and elsewhere. He worked for over 40 years as a product designer.

'My vessels are all hand-thrown, but are not functional. I am working with balancing glaze surfaces with the forms and colour of the vessels. The challenge of creating a perfect harmony within each vase is most interesting to me.'

David SHANER, USA page 73
B. Pottstown, Pennsylvania, he earned his MFA from New York State College of Ceramics, Alfred University, in 1959. From 1963 to 1970 he was the resident potter and director of the Archie Bray Foundation in Helena, Montana. He has received several awards, including the Louis Comfort Tiffany Scholarship in 1963 and a National Endowment for the Arts Fellowship in 1973 and 1978.

'I have always been interested in naked form, especially in what the form does when it meets a horizontal plane.'

Richard SHAW, USA page 121
B. Hollywood, California, in 1941, he received his BFA from San Francisco Art Institute in 1965. He studied at New York State College of Ceramics, Alfred University, and earned his MFA from the University of California at Davis in 1968.

'My work deals with trompe l'oeil. My dad was a cartoonist and I find humour convenient to my way of working clay. I take mundane objects and make pottery.'

Esther SHIMAZU, USA page 149
She received her MFA in ceramics from the University of Massachusetts, Amherst, in 1982. She teaches figurative sculpture at the Honolulu Academy of Arts in Linekona Education Center.

'Sculpturally, my bald female figures represent self-possessed and unselfconscious modern women. Women who delight in their sumptuous form and frisky nakedness. The forms provoke a rapturous interplay with the viewer: chatty, philosophical, languid and satirical, often appearing immersed in secret dialogues.'

Peter SHIRE, USA page 97
B. 1947 in Los Angeles. He attended the Chouinard Art Institute in Los Angeles, receiving his BFA in 1970. He was on the design team for the 23rd Olympiad, and an original member of the Milan-based Memphis movement and design group.

'Pottery is the love of my life. I like the way it smells.'

Sandy SIMON, USA page 95
She studied at the University of Minnesota, Minneapolis, 1967–70, and was a studio potter in Farmington, Georgia, from 1970 to 1978. In 1988 she received a National Endowment for the Arts Fellowship.

'For me, art is about communication. No other material or methodology touches my soul more directly than using a pot made out of love and inspiration for the simple task of service with food. As a maker of these objects, it is a kind of worship, which, when successful, is deeply fulfilling.'

Richard SLEE, UK page 104
B. 1946, he received his MA from the Royal College of Art in London. He is Professor of Art at Camberwell College of Arts and the London Institute.

'All ceramics should be shiny and reflective, the jackdaw's sensibility. My works are collections, sometimes around a theme. Often it seems to me to be almost a bargain sale of objects held together by their common craft or stylistic qualities. They are models with a history of romance and sentimentality. I create the landscape of my imagination, a fantasy that is both comforting and anxious. The sun always shines, the lights never go off.'

David SMITH, USA page 100
B. 1959. He received his MFA from the University of Montana, Missoula, in 1985. He is now Associate Professor of Art at Edgewood College, Madison, Wisconsin. He has lectured extensively on the use of the anagama wood-fired kiln.

'My sculptural objects express concerns for survival, and environmental co-existence. My most recent investigations are based on these concepts, which reflect the human struggle to live symbiotically with the environment. In addition to the action of the fire and ash, most of my pieces are glazed prior to firing. This is a continuation of my non-traditional approach to anagama wood-firing and serves to broaden the palette of the natural ash.'

Deborah SMITH, India page 96
B. 1942 in South Pasadena, California. She was apprenticed for one year with Yamamoto Toshu in Bizen and accompanied Susan Peterson for her research on Shoji Hamada. In 1971 she and Ray Meeker founded Golden Bridge Pottery in Pondicherry, South India, introducing a new craft to the region.

'My work involves supervising 14 employees in the production of hand-thrown functional stoneware – about 2,000 pieces per month. I personally handle most of the pieces, applying quickly-brushed decorative flourishes in wax resist or basic oxide pigments. My intent is to capture lively, harmonious gestures in the stasis of the fired pot.'

Nan SMITH, USA page 64
B. Philadelphia, she received her MFA from Ohio State University. She now teaches at the University of Florida and has been awarded several grants and fellowships.

'My research in the visual arts takes form as an investigation of installation-oriented figurative sculpture. The intent is to convey a sense of the psychology of human consciousness. I project life as a journey and human consciousness as evolutionary. Human gesture and the context of the figure within the compositions reveal moments of quiet contemplation.'

Richard Zane SMITH, USA page 139
A Wyandot American Indian, he studied at Kansas City Art Institute. In 1978 he worked as an art instructor at a Navajo Mission School in Arizona. In 1983 he received an award from the Heard Museums Annual American Art Juried Competition, Phoenix, Arizona.

'My art education began as a child at home in Missouri. During my art school years, my own native roots became something of an obsession. It was in 1978, as an art instructor at a Navajo Mission School in Arizona, that I was exposed to native clays. Having such a rich, yet mixed-blooded heritage has been difficult at times and still provides challenges. I am convinced that creativity is a gift from God.'

Paul SOLDNER, USA page 36
B. 1921. He has an MA from the University of Colorado and an MFA from the Los Angeles County Art Institute. He is Professor of Art Emeritus at Scripps College, and founder of the Anderson Ranch Arts Center. He was instrumental in beginning American-style raku, low-fire salt fuming.

'As an artist, I work with clay, bronze, photos and prints. From these mediums, I make objects for use, but their uses are varied.

Some are functional, some are not. They are meant to sometimes surprise, disgust or delight. Although made to be used, use need not be common. In its highest sense, such use is in the spirit of celebration, of life enhanced and made more special.'

John H. STEPHENSON, USA page 162
He completed his MFA at Cranbrook Academy of Art in 1958. He was Professor of Art at the University of Michigan at Ann Arbor from 1959 to 1995. He was awarded fellowships from the National Endowment for the Arts in 1986 and the Michigan Council of the Arts in 1989.

'I am committed as a ceramic sculptor to deal with space or its void in much the same way a composer of music uses silence in which to interject sound or noise. With my mind's eye and the ceramic process, I interject plastic clay form into a given space.'

Susanne G. STEPHENSON, USA page 52
B. 1935 in Ohio, she earned her MFA from Cranbrook Academy of Art, Michigan. Recently she was awarded an Honorary Doctorate of Arts from Grand Valley State University, Michigan. She is Professor Emerita at Eastern Michigan University.

'I delight in abstracting landscapes in low-fire earthenware clay. The brilliant range of colour at this temperature, transported in thick, juicy slips and engobes, sustains me. The plate, the bowl and the vase forms are where I capture image fragments from my travel experience. It becomes a celebration of colour.'

Bill STEWART, USA page 126
He earned his MFA from Ohio University at Athens. He is a Professor of Art at State University College of New York at Brockport. He is the recipient of a number of awards and research grants.

'I have been using the practical, spiritual, emotional and psychological history of tools, toys and body adornment as source material. These images are comments on human evolution relative to environmental and spiritual issues and development. The basic image is preplanned (observed), parts are produced and assembled but an aggressive, intuitive thought process is forced on the imagery and eventually pushes the limitations of the medium, attempting to eliminate any constraints on the imagination.'

Piet STOCKMANS, Belgium page 134
B. Leopoldsburt in 1940. He has been a freelance designer since 1989. He won the Official Prize from the Flemish Community in 1988 for Visual Art and was the Cultural Ambassador of Flanders in 1995.

'Creation is the result of activity and not of thinking. It is activity that generates ideas which, themselves, give rise to other ideas. It is a process in the course of which choices are made in a mysterious way. It is the automatism with which the farmer ploughs the fields, a phenomenon that can be compared to the way prayers are used, mantras recited or everyday gestures repeated. It is a quest for simplicity, peace, and physical well-being.'

Tim STOREY, Canada page 104
B. 1951 in Manchester, England, he emigrated to Canada in 1953. He attended Sheridan College School of Design from 1970 to 1973.

'Clay for me is the most fertile of media. Each day in my studio I transmogrify lumps of it into fur, feathers, wood, stone, scales, leather, foliage, fruit, metal, skin, brick and boilerplate. To make the clay resemble these things is not the hard part, it is making the clay look like it's enjoying the deception that's hard!'

Dong Hee SUH, Korea page 64
B. Taegue, Korea, in 1947. He received his PhD in Art Education from the University of Missouri, Columbia, in 1991. He was a Fulbright Scholar in residence at West Virginia Wesleyan College, 1996–7, and has been teaching ceramics full-time at Konkuk University, Seoul, Korea.

'Cracks are a part of nature and life. For me, cracks are the important patterns, contributing textures and value to the beauty of the whole piece.'

Tom SUPENSKY, USA page 119
B. Columbus, Ohio, in 1938. He attended the University of Southern California, Los Angeles, and received his MFA from Ohio State University.

'My work is narrative dealing with situations that arise in my life.'

Øyvind SUUL, Norway page 14
B. 1967 in Trondheim, Norway, he received both his BFA and MFA from the National College of Art and Design in Oslo. In 1995 he received the Judge's Commendation, Fletcher Challenge Ceramics Award.

'My work is about association and individual experience. During the working process I find it important to capture and build visual tendencies that could influence and stimulate the viewer's perception and imagination. Together the tendencies make an ambiguous reservoir that should generate visual questions instead of answers.'

Goro SUZUKI, Japan back cover
B. Toyota City, Japan, he has his studio in Fujioka, Aichi Prefecture. He has worked at such institutions as Cranbrook Academy of Art in Michigan and Rhode Island School of Design.

'I live and work in the Oribe tradition and in the traditional area of old Oribe, but I rebel against my strict training in traditional ceramics.'

Roxanne SWENTZELL, USA page 148
B. 1962 in Santa Clara Pueblo, New Mexico. She studied at the Institute of American Indian Art, Santa Fe, and then went to the Portland School of Art, Oregon, for one year.

'I would say I am still communicating with figures. I want to symbolize women, and my culture, and humanity. I am trying to say things to the world, and the response has been amazing! My pieces are crossing cultural and all kinds of boundaries. People from all over the world see things in my pieces. It has been very, very exciting to me, the ultimate communication.'

Toshiko TAKAEZU, USA page 55
B. Pepeekeo, Hawaii, in 1929, she studied at the Honolulu School of Art and at Cranbrook Academy of Art in Michigan. She has been honoured with travelling retrospective exhibitions of her work by the American Craft Museum, New York City, and the Museum of Modern Art, Kyoto, Japan. She taught ceramics for 25 years at Princeton University.

'Sculpture was my first interest when I was a student many years ago in Hawaii. At that time I realized that to do sculpture one had to give oneself totally to it, and I wasn't prepared then to commit my life in such a way. I thought ceramics might be different, so I began to study clay. I was later to find out that clay was much more demanding than I had first anticipated.'

Akio TAKAMORI, USA page 74
B. Japan, he studied at the Kansas City Art Institute, USA, where he received his BFA. He later earned his MFA from New York State College of Ceramics, Alfred University. He lives in Seattle, where he has a studio and is Associate Professor of Art at the University of Washington.

'I create my figures from memories. I examine and visualize the meaning of scale, space, material and dimension of my memories. I refer my work to the historical drawings of Eastern Asia and turn great focus towards the grouping of figures, as well as the relationship between the oriental paper and ink, and how it compares to the clay and underglaze of my work.'

Joan TAKAYAMA-OGAWA, USA page 35
B. 1955, she studied at Japan's International Christian University, University of California at Los Angeles, Stanford University (MA, 1979), and Otis College of Art and Design (1985–9).

'Oftentimes, the spirit or impression of a previous experience guides me throughout the lengthy ceramic process. In fact, when I am working on a body of work, I daily recall the atmosphere or sensation of the original inspiration, reminding me of the attitude I want to maintain.'

James TANNER, USA page 127
B. 1941 in Jacksonville, Florida. He received his MFA from the University of Wisconsin at Madison. He is Professor of Art at Minnesota State University, Mankato. He has been active in NCECA for the last 30 years. He was a recipient of the McKnight Foundation Fellowship in 1991.

'My work is about visioning. It takes on the human face as an abstraction with references to landscape, natural vegetation, and the idea of astro projections – spirit and essence of things, exploring the spiritual in relation to the physical. I believe we are all part of a whole.'

Hirotsune TASHIMA, USA page 119
B. Japan, he received his BFA from Osaka University of Arts, Japan,

in 1993 and his MFA from New York State College of Ceramics, Alfred University. He has been artist-in-residence at the Clay Studio, Pennsylvania, the Banff Centre, Canada, and Shigaraki Ceramic Cultural Park, Japan. He now teaches in Astoria, Oregon.

'Traditionally there weren't many self-portraits of artists in Japan. This was caused by the social situation in our culture. In the West individualism has been appreciated, but in our country it is not appreciated – in fact, it is discouraged. Working in the West has allowed me to make my self-portrait. Making a self-portrait is like an exploration of the inner self. When I make my self-portrait I look at myself in a "mirror". I see not only my image, but also my thoughts, feelings, emotions and ideas.'

Kuriki TATSUSUKE, Japan page 39
B. Seto, Aichi Prefecture, Japan, he graduated from Kyoto Art University; thereafter he worked first at a glass works, then as a ceramics designer of mass-produced ware. By 1982 he had been awarded nine major prizes.

'My interest in creating ceramic works lies in the vessel. However, I am not just interested in the form and decoration of the plate, bowl or jar. I believe that the vessel stands as an eternal form, as a container of life, memory and time. For this reason, the vessel has been the centre of my life's work. During the past 30 years, I have meditated on vessels and through this meditation I have been inspired. My theme is the "Elaboration of the Vessel".'

Sandra TAYLOR, Australia page 128
B. Sydney in 1942, she graduated from East Sydney Technical College in 1966. She taught for 26 years at various institutions, then established a creative retreat in 1993, for workshops and live-in residencies..She is the recipient of many grants including the 1994 Fellowship from the Visual Arts/Crafts Board in Australia.

'This work is about the frailty of human nature, and the battle to find one's pace and meaning of life. Watching war on TV night after night, seeing great ominous billowing of smoke, gives this mental picture of people fighting – for peace, power, love, whatever. Suddenly, they are all swallowed up in a tremendous earthquake, but they go on fighting deep in the bowels of the earth. Our inner conflict just echoes out into the larger world.'

Byron TEMPLE, USA page 36
B. 1933 in Centerville, Indiana. He attended Ball State University, the Brooklyn Museum Art School and the Art Institute of Chicago. From 1959 to 1961 he was apprenticed with Bernard Leach in St Ives, Cornwall, England. He has taught at Philadelphia College of Art, Pratt Institute, Haystack, and Penland.

'I have wisely refrained from a public display of words, and confined myself instead to creating art – a subtle fusion of aristocratic and popular culture. Pots, like children, have to make their own path in the world, eventually.'

Neil TETKOWSKI, USA page 17
He earned an MFA from Illinois State University in 1980. His work is in the American Craft Museum and the Museum of Ceramic Art at Alfred, New York.

'These new works. . . have evolved from the expressionistic disk forms which were often embedded with old iron, spikes and nails, the debris of closed factories. The metamorphosis from plate-related disks of socio-historic reference, to objects which are more three-dimensional and sculptural, also represents a departure. . . towards objects of a stranger yet more aspiring, surreal presence with more intriguing spiritual references and even more magical substance.' – Ronald Kuchta, editor of American Ceramics Magazine.

Jack THOMPSON, USA page 128
B. 1946 in Los Angeles. He earned his MFA from Tyler School of Art, Philadelphia, in 1973. He is the recipient of numerous grants and awards such as the Fulbright Scholar Award for Mexico, 1996–7.

'Funerary ceremonies of the Norsemen, Egyptians and others who used boats as literal or symbolic transportation into the next worlds have been an inspiration along with the Mexican "cult of the dead" and "Día de los Muertos" fiesta. My sculptures combine my own imagined afterlife journeys with these mythological ones while occasionally incorporating my continued interest in the erotic. These boat images attempt to portray the transmigration of the spirit and the transitory nature of the life force.'

Dorothy TORIVIO, USA page 143
B. Acoma Pueblo, New Mexico, in the 1940s. She is recognized for her innovative work in the exaggerated seed-pot forms that were initiated by Lucy Martin Lewis and Marie Chino in the

previous Acoma generation.

'I look at a pot, visually divide it in half, then in quarters, then eighths, sixteenths and more, and keep dividing until there is no room on the surface. After this mental gymnastics, I begin to paint. I cover my vessels with black and white or polychrome patterns freehand.'

Susan TUNICK, USA page 162
B. New York City in 1946. She received her MFA from Bennington College, Vermont. She lives and works in New York City.

'Many of my tile wall medallions include ceramic shards and/or antique tile borders which I have collected over the years. Some have powerful patterns and colours and others have interesting surprises. I have also discovered the importance of dishes as a part of each person's family history.'

Anne TÜRN, Estonia page 98
She studied at Tallinn Art University, Estonia, and did postgraduate studies in Germany. Awards include a Merit Award at the Fletcher Challenge Award Exhibition, New Zealand, in 1997 and the Grand Prize at the Fifth World Triennial of Small Ceramics in Croatia, 1997.

'When I started to grow this long hair on my animals, I just tried to figure out, how many drops of slip can you add? What is the limit? The limit of my patience, but . . . it is kind of fun too.'

Robert TURNER, USA page 100
B. Port Washington, New York, in 1913, he studied painting in Philadelphia, and went to New York State College of Ceramics, Alfred University, graduating in the first class after World War II. He taught at Black Mountain College in North Carolina until 1951, when he returned to Alfred to set up a studio. He eventually chaired the Department.

'Absorption in the process of making brings things together for me – from thoughts, memories, readings jumbled in the intuitive.'

VAEA, USA page 80
B. 1929 in Tahiti and educated in France. In 1952 he met Kawai Kanjiro, along with Hamada, Leach and Yanagi. In 1963–4 he returned to Japan to study with Kawai Kanjiro. In 1966 he. studied with Peter Voulkos and in 1973 joined the University of California at Berkeley.

'Most of the colouring and texture of my ceramic comes from different oxides and carbonates of metals, incorporated in various clays, subjected to the firing in the kiln, returning these oxides to their metallic origins. For me the process is a ritual of endless discoveries, coaxing the inert, intransigent matter, embracing a multiplicity of thoughts and, I hope, sharing them with the viewer.'

Netty VAN DEN HEUVEL, The Netherlands page 24
B. 1956 in Zevenaar, Netherlands. She graduated from the School of Arts in 'sHertogenbosch in 1981. She recently completed a residency at the Bemis Center for Contemporary Arts in Omaha, Nebraska.

'My work, an open structure built up with coils of porcelain, is based on a fascination for constructions. These constructions are sometimes related to building and at other times to the mineral world.'

Kukuli VELARDE, USA page 123
She is a Peruvian artist who has lived in New York since 1987. She studied ceramics in Colombia, Mexico, and at Hunter College, City University of New York, with Susan Peterson. She won the full-year residency scholarship at Clay Studio, Philadelphia.

'Clay provides me with a voice to speak about life, its contradictions, its bitterness and its wonderful gifts. My work is a dialogue from "hear" to "hear", a conversation with no shame and in which nothing is hidden. I do not believe in subtlety. Since the interaction between the viewer and the art work is similar to a conversation, it does not matter how obvious the narrative of an art work is, people will always get their own readings out of it.'

Jindra VIKOVÁ, Czech Republic page 108
B. Prague in 1946. She attended the College of Art from 1960 to 1964 and the University of Applied Arts in Prague.

'My personal need to relate my own message is based on my desire to have certain mysteries, as yet unrevealed to other people. Most often this feeling of mystery and my desire to solve problems are based on those fleeting moments when you perceive a fraction of some action or story. The meanings may escape you, but you then return to these moments in your memories, because this fragment, be it a view, a conversation or a gesture, seems to have some meaning – although you don't know what it is.'

Ann Adair VOULKOS, USA page 111
B. 1936 in the Panama Canal Zone, Central America. She attended the University of California at Berkeley. She taught at both the University of California at Davis and the University of Fine Arts, San Francisco.

'The alligator animal form has always been in my being. When I get up in the morning and greet my cats and dogs I think back and remember, still feeling that great animal form inside me. I first saw this form in Panama, where I grew up. I naturally thought they were connected to me. I have also always loved their skin and textures, both the top and the bottom.'

Peter VOULKOS, USA page 37
B. 1924 in Bozeman, Montana, he studied at Montana State University under Frances Senska. He received his MFA from California College of Arts and Crafts in Oakland in 1952 and proceeded to change the way people view ceramics today. Voulkos lives and works in Oakland, California.

'My scale comes out of what I see. I always liked large things. Take New York skyscrapers. Those are more awesome to me than mountains. You take a mountain for granted, but a skyscraper just blows my mind. You can put a little thing in the middle of New York – that's something else. Man-made is a different trip – like even those spaces between buildings in New York – they're fantastic. I always wanted to work large.'

WANG Jian-Zhong, China page 65
He earned his BA from the Central Academy of Arts and Design, Beijing, in 1982. He gained first prize in the Exhibition of Achievements of the Ministry of Construction of the People's Republic of China in Hebei, 1989.

'For many years I have been involved in the teaching, research and design of ceramics. I am very knowledgeable about traditional Chinese art, especially ceramics. I emphasize the incorporation of modern design principles with traditional Chinese culture. Current research activities are in the area of study of form and computer-assisted design, combining traditional and contemporary ceramic art.'

Grace WAPNER, USA page 71
B. 1934 in New York. She attended Bennington College, earning her BA, as well as Bard College Summer Program.

'My new work is about the body: the body in motion, the body at rest, the body in relation to the body of another. As such the body has been the centre of my attention for some time, and long experience of both materials and themes has won me the freedom to say whatever I want and need to say, the freedom to try anything out, the freedom to make art that addresses, with great intensity, those issues that are uniquely mine.'

Kurt WEISER, USA back cover
B. 1950, he received his MFA from the University of Michigan at Ann Arbor. He was awarded the Asian Cultural Council Fellowship and travelled to Japan for research in 1998.

'For years the work I did was about ceramics. As interesting as this was to me, I always had this vague feeling that the best expression of the nature of ceramics only came as a gift from nature. The problem was, nature and I never really got along that well. Somewhere in the middle of all this I realized that the materials are there to allow you to say what you want to say, not to tell you what to say. So I gave up trying to control nature and decided to just try and say what I thought about it.'

Stan WELSH, USA page 48
B. California in 1951, he received his MFA from New York State College of Ceramics, Alfred University, New York, in 1978. He is Associate Professor of Art at San Jose State University, California. In 1990 he was awarded the California Arts Council Grant in Ceramics and the National Endowment for the Arts Fellowship in 1986.

'It is important to note that my initial interest in ceramics began with the desire to learn how to make pots. I have had a continuing passion for the tradition of the vessel, and many aspects of my current sculptures are being influenced by this personal history with vessel forms.'

Gerry WILLIAMS, USA page 92
B. Asansol, India, in 1926, the son of missionaries. He attended Woodstock School, India, and Cornell College, Iowa. He holds an honorary doctorate from Cornell College and is the publisher and editor of the influential Studio Potter magazine.

'I consider myself a functional potter influenced by the

Gandhian swadeshi movement and by the Leach/Hamada/Yanagi tradition of beauty through use. My studio work consists of functional pots, social/political sculpture, architectural murals, large handbuilt forms and psycho-ceramics of an interpretative nature. I have essentially pursued education as the discovery of self, and believe in the ethics of service to others through shared information and literature.'

Paula WINOKUR, USA page 56
B. 1935 in Philadelphia. She received her BFA and BS Ed from Tyler School of Art, Pennsylvania, and did graduate studies at New York State College of Ceramics, Alfred University. Since 1973 she has been Associate Professor at Beaver College, Glenside, Pennsylvania.
 'The earth itself, particularly cliffs, ledges, crevices and canyons, and the effects of wind, earthquakes and other natural phenomena such as geological shifts and rifts, interest me. The many ways man has marked and scarred the land (through ploughing, roads, fences, etc.) provide an interesting perspective and point of view, real, illusory and aerial. In retrospect, I believe that my work is mostly about memory: places that exist and yet do not exist, of a collection of places that I have, perhaps, seen.'

Robert WINOKUR, USA page 155
B. 1933 in Brooklyn, New York. He received his MFA at New York State College of Ceramics, Alfred University. Recently he was invited to participate in the First Yi-Xing International Ceramic Art Conference in China.
 'When I look about me I see similar patterns and structures. I want my work to have the same abstract references as photographs taken of the earth from the air. . . a kind of intentional confusing of the processes of map-making. The drawings on the surfaces are how I abstract the landscape as I map it.'

Lisa WOLKOW, USA page 126
B. New York City in 1954, she studied at Hunter College with Susan Peterson, and received her MFA from Cranbrook Academy of Art in Michigan.
 'One simple impulse can trigger the creative process. As an

artist, it is extremely important, indeed crucial, to recognize and seize this electric charge. The "need to create", as a concept, can generate work that comes from the heart. This quality of need is brought forth from deep interior places where knowledge and experience reinvent and reinterpret.'

Betty WOODMAN, USA page 100
B. Norwalk, Connecticut, in 1930. She received her MFA from New York State College of Ceramics, Alfred University, and currently works in New York City and Italy.
 'My work is American and European at the same time. It is also sculpture in its shape, and painting in the application of paint and use of shadow. On occasion it is also decorative – when used in architecture. The overall performance built up from these elements demonstrates a sense of movement; these shapes are evidence of the swift spirit of my absorption of historical and visual impressions.'

XIA De-Wu, China page 106
B. 1957 in Qingdao City, Shandong Province. In 1982 he went to Jingdezhen Ceramic College and received his MFA from the Central Fine Arts College in Beijing in 1989. He taught at Beijing Garment College, Industrial and Fine Arts Department, and now teaches at the Central Fine Arts College.
 'I feel I am lucky in my life, because I have a son and a daughter. I feel I am lucky in my career, because I will be living all my life creating art.'

Jose L. YAMUNAQUE, Peru back cover
B. 1951 in Chulucana, Peru, the son of a traditional potter. As a child, he learned pottery in his father's shop; later he studied in Argentina, Italy and the USA.
 'Art: infinite expression that springs from the man with charm, passion and life; to capture with deep freedom what he feels, thinks and projects.'

YAO Yong-Kang, China page 72
B. 1942 in Ningbo City, Zhejiang Province. He graduated in sculpture at the Fine Arts Department of the Jingdezhen Ceramic

Institute, 1964. He is Professor of Art at Jingdezhen Ceramic Institute.
 'I stress the skill of modelling and the opening up of ideas and thoughts to artistic creation. I observe the developing trends of Chinese and international arts, realizing my own self-creating experience to break through to the unique path of Eastern arts.'

Nancy YOUNGBLOOD-LUGO, USA page 146
B. 1955 in Fort Lewis, Washington, she is a granddaughter of Margaret Tafoya. She attended both the San Francisco Art Institute and the University of New Mexico art departments for short periods. Her work has earned a total of 256 awards. Her painstaking attention to detail has brought American Indian pottery to a new level. In 1997 she gained the Rotary Club International award for artistic contribution.
 'My mother said to take time to smell the roses and asked if I was willing to pay the price of such long hours of hard work. I am, I did. I have, and I still am. I think it is really because of my grandmother; she was such a strength for all of us. I use cornmeal before I get my clay and my sand, to pray before each firing. If I bought the clay and if I used a kiln, that would hold no drama for me. The way I do it, the pot is a part of me and preserves the Tafoya family traditional method.'

Alexander ZADORIN, Russia page 52
He lives and works in St Petersburg (formerly Leningrad); trained at the Mukhina Institute of Applied Arts and Industrial Design there. He has also been a visiting artist at various university departments in the USA.

ZUO Zheng-Yao, China page 132
B. 1960 in Japan, he received his BA from Guangdong Academy of Fine Arts, China. He is now Principal of Guangzhou Modern Ceramics School, China.
 'My piece is inspired by the culture surrounding Chinese script and symbols. Food for Thought depicts man's need for both physical as well as spiritual food in order to survive in this cultural reality.'

picture credits

The photographs in this book were taken by the artists themselves, otherwise by the photographers listed below. The author and publishers would like to thank them all for supplying the illustration material.

Autio: Chris Autio. Bacerra: Anthony Cuñha. Balistreri: Thomas Arledge. Bean: Linsay K. Rais. Bechtold: Anita de Jong. Björquist: Bengt Erwald. Bole: Heather Protz. Bova: Tim Barnwell. Cardew: Hugh Sainsbury. Caruso: Gianfranco Tomassini. Chabot: Balfour Walker. Chaleff: On Location, Poughkeepsie, NY. Coleman: O'Gara Photography. Currier: Brian Oglesbee. Danish: Robin Robin. Dehnert: Kulvinder Kaur Dhew. De Larios: Neil Carlos. Drysdale: Robert Frith. Ernkvist: Peder Björkegrew. Federighi: Fareed Almachat. Feliciano: Saverio Truglia. Ferguson: E.G. Schempf. Folk art of Africa: Robert Turner. Folk art of Southern India: Ray Meeker. Foulem: Raymonde Bergeron. Frimkess: R. De La Cruz. Furman: Michael Honer. Galassi: Tassinari. Garraza: Jesús Angel Miranda. Griffith: Ron Wilcox. Hedberg: Charlotte Hedberg. Henderson: Colin Mills. Henkelman: Erik Hesberg. Higby: Brian Oglesbee. Hodge: Michael Pinter. Hole:

Kristian Krogh. Horrell: Fred Marsh. Hwang: Cheng Fui-yun. Hyman: John Cummings. Inuzuka: Stuart Allen. Jacobsen: Udo Hesse. Karnes: Melville D. McLean. Katzer: Judith A. Hopkins. Larocque: Andrew Neuhart, Revolution Gallery. Lawrence: John Dixon. Lawton: Tim Sylvia. Lee: Michael Harvey. Leuthold: Eva Heyd. Levine: Richard Sargent. Lo: Chris Autio. McIntyre: Alan McCoy. Madola: Albert Cos/Maria Bofill. Malicka-Zamorska: Czeslaw Cnwiszczuk. Manz: Ole Akhoj. Marsh: Anthony Cuñha. Mason: Anthony Cuñha. Medicine Flower: Rob Orr. Milette: Raymonde Bergeron. Mortimer: Randy Bulmer. Naranjo-Morse: Craig Smith. Newman: Terry Heffernan. Odundo: Abbas Nazari. Oestreich: Peter Lee. Otis: Alan McCoy. Payce: Marc Hutchinson. Perez: Anthony Cuñha. Peterson, J.: Craig Smith. Peterson, S.: Craig Smith. Piker: William Seitz. Püschel: Bernd Kuhnert. Rady: Peter Bors. Regan: Anthony Cuñha. Rothman: Allen Lockmiller. Saxe: Anthony Cuñha. Severijns: John Hermans. Shaw: Schopplein Studio. Shimazu: Beth and Neal Cutler. Simon: Schopplein Studio. Smith, D.: Ireno Guerci. Smith: Allen Cheurront and associate. Stephenson, N.: John H. Stephenson. Stockmans: Noel

Allum. Suh: In-kyo Studio. Suul: Anders Bergersen. Suzuki: Gakuji Tanaka. Temple: Andy Rosenthal. Tetkowski: Eva Heyd. Thompson: Katrina Mojzesz. Tunick: Peter Mauss/Esto. Turner: Tim Thayer. Vaea: Brenda Luckin. Van den Heuvel: Anton Reijnders. Voulkos, A.: Schopplein Studio. Voulkos, P.: Schopplein Studio. Wapner: Andy Wainwright. Weiser: Anthony Cuñha. Winokur: John Carland. Wolkow: Joanne Schmaltz. Woodman: Dennis Cowley, courtesy Max Protetch Gallery. Youngblood-Lugo: Craig Smith

The following galleries were unfailingly helpful in supplying photographs and information:

Garth Clark Gallery, New York; Joan B. Mirviss Ltd, New York; Leedy-Voulkos Gallery, Kansas City, MO; Perimeter Gallery, Chicago, IL; Galerie Besson, London; Contemporary Applied Arts, London; Frank Lloyd Gallery, Los Angeles, CA; Max Protetch Gallery, New York; Wenford Bridge Pottery, Cornwall; Revolution Gallery; Detroit Institute of Arts; Barrett Marsden Gallery, London; Dorothy Weiss Gallery, San Francisco; Heard Museum, Phoenix, AZ.